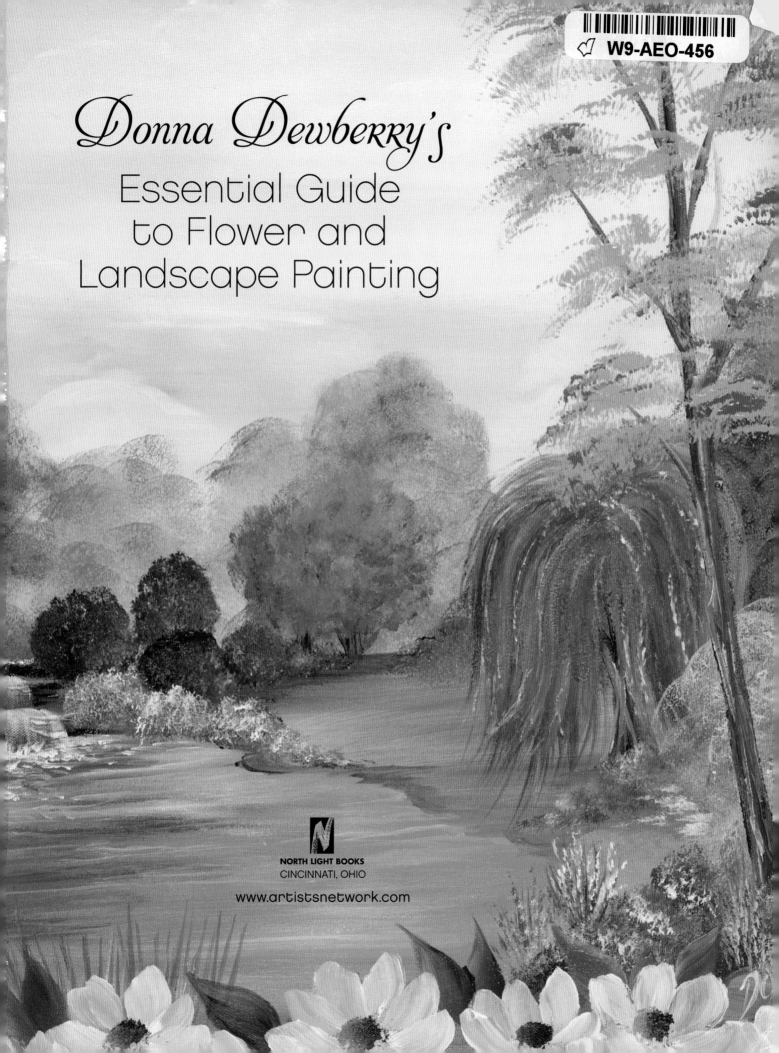

Donna Dewberry's
Essential Guide to Flower and Landscape Painting

NORTH LIGHT BOOKS
CINCINNATI, OHIO

www.artistsnetwork.com

table of contents

what you need

Surface

pre-stretched canvas, wooden plaques, wooden butterfly houses, large round clock, drinking glasses, enameled metal planter, white enameled mailbox, wooden window box

Acrylic Paints

Baby Blue, Basil Green, Berry Wine, Black Cherry, Burnt Umber, Butter Pecan, Engine Red, English Mustard, Fresh Foliage, Neon Purple, Heather, Italian Sage, Light Fuchsia, Light Lavender, Linen, Magenta, Maple Syrup, Navy Blue, Peony, Periwinkle, Purple Lilac, Rose Pink, School Bus Yellow, Soft Apple, Sunflower, Thicket, Vintage White, Violet Pansy, Wicker White

Artists' Pigments

Brilliant Ultramarine, Burnt Sienna, Burnt Umber, Dioxazine Purple, Pure Orange, Yellow Citron, Yellow Light, Yellow Ochre

Enamels

Cobalt, Engine Red, Fresh Foliage, Hauser Green Medium, Magenta, Pure Orange, School Bus Yellow, Thicket, Violet Pansy, Wicker White, Yellow Ochre

Outdoor Dimensionals

Fresh Foliage, Lemon Custard, Wicker White

Outdoor Opaques

Barnwood, Berry Wine, Burnt Umber, Cobalt, Engine Red, Fresh Foliage, Lemon Custard, Light Blue, Magenta, Pure Orange, Purple Lilac, School Bus Yellow, Soft Apple, Thicket, Violet Pansy, Wicker White, Yellow Light, Yellow Ochre

Outdoor Metallics

Metallic Blue Sapphire, Metallic Emerald Green

Mediums

FolkArt Floating Medium, FolkArt Glazing Medium, FolkArt Crackle Medium, FolkArt Outdoor Flow Medium, FolkArt Enamels Clear Medium, FolkArt HD Clear Medium

High Definition (HD) Paints

Burnt Umber, Butter Pecan, Calypso Sky, Engine Red, Forest Moss, Fresh Foliage, Green Forest, Lavender, Light Periwinkle, Magenta, Sunflower, Thicket, Pure Orange, Ultramarine Blue, Violet Pansy, Wicker White, Yellow Citron, Yellow Light, Yellow Ochre

Brushes

nos. 6, 8, 12 and 16 flats

¾-inch (19mm) flat

¼-inch (6mm), ¾-inch (19mm) and large scruffy

nos. 8, 10 filberts

⅝-inch (16mm) angular

½-inch (12mm) feather

no. 8 round

nos. 1, 2 script liners

Glass and Ceramics Brushes

no. 12 flat

⅜-inch (10mm) angular

⅛-inch (3mm) scruffy

no. 2 script liner

Brushes for Paper

no. 12 flat

no. 2 script liner

HD Brushes

no. 4 fan

¾-inch (19mm) and 1-inch (25mm) flats

nos. 10 and 16 flats

large scruffy

no. 2 script liner

Other Supplies

One Stroke Brush Caddy, 4-inch (10cm) foam paint roller, One Stroke finishing sponge, 1-inch (25mm) blue painter's tape, FolkArt One Stroke Paint Palette, 9-inch (23cm) disposable foam plates, One Stroke Double Loading Carousel, wide palette knife, narrow palette knife, sponge painters

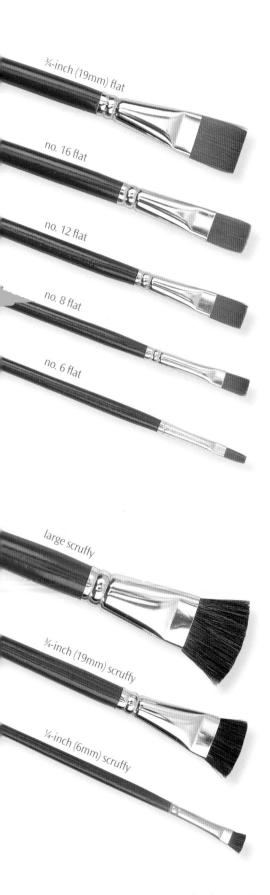

¾-inch (19mm) flat

no. 16 flat

no. 12 flat

no. 8 flat

no. 6 flat

large scruffy

¾-inch (19mm) scruffy

¼-inch (6mm) scruffy

PAINTS

ACRYLIC PAINTS

Plaid FolkArt acrylic colors are high-quality acrylic paints that come in handy 2-oz. (59ml) squeeze bottles. Their rich and creamy formulation and long open time make them perfect for decorative painting. They are offered in a wide range of wonderful pre-mixed colors.

ARTISTS' PIGMENTS

FolkArt Artists' Pigments are pure colors that are perfect for mixing your own shades. Their intense colors and creamy consistency are wonderful for blending, shading and highlighting. Because they're acrylic paints, they're easy to clean up and have no odor.

ENAMELS

FolkArt Enamels are the ultimate one-step, dishwasher-safe paints for glass, ceramics, metal and other slick reflective surfaces. These revolutionary paints are highly pigmented and go on rich and creamy. Don't use water to thin Enamels; use Clear Medium to moisten the bristles and to thin the paint. All Enamels painting must be completed within 24 hours of starting a project. Any paint applied after 24 hours or after baking will note fuse properly and will not have the same durability.

OUTDOOR PAINTS

FolkArt Outdoor Opaques and Dimensional paints can be used on a variety of surfaces: unpainted or pained metal, tin, terra cotta, wood, stone and concrete. Outdoor paint is made with a sealer in it. It has been lab tested to withstand normal weather conditions equivalent to 3–5 years. Do not mix water with this paint. Water will dilute the sealer and cause less durability. Instead, use Outdoor Flow Medium to moisten the brush or thin the paint. For more protection from the weather and sun, use a spray lacquer finish (satin or gloss) on any painted item that will be used in your garden or on an open-air patio or deck.

HIGH DEFINITION (HD) PAINT

For all of the landscape paintings, I used FolkArt High Definition (HD) Visual Texture acrylic paint. This paint was specially developed to be thicker and more robust than the usual acrylic paints. It allows artists to create beautifully realistic textures right on the canvas using a variety of tools.

BRUSHES

FLAT BRUSHES

Painting the One-Stroke technique requires the use of flat brushes. Flats are designed with longer bristles and less thickness in the body of the bristles to allow for a much sharper chisel edge. In the instructions for the flower painting projects in this book, I often say "begin on the chisel edge" or "lift back up to the chisel edge." A sharp chisel edge is essential to the success of your one-stroke painting.

FILBERT, ANGULAR AND FEATHER BRUSHES

A filbert brush is a flat brush with a chisel edge that has been cut into a curve. This brush creates a rounder outer edge on the petals of flowers such as daisies and lilacs. An angular brush is also a flat brush with a chisel edge, but its bristles are trimmed at an angle, making one side longer (the toe) than the other side (heel). The angular brush makes painting comma strokes much easier. The feather brush is a flat brush whose bristles thin out along the chisel edge. I love using this brush to paint feathery blossoms such as bottlebrush and even palm fronds.

SCRUFFY BRUSHES

Scruffy brushes come in several sizes from very large to very small. I use them to pounce on mosses, wisteria, flower centers, faux finishes and shading textures, among others. Do not use water when painting with scruffy brushes.

ROUND AND LINER BRUSHES

A round brush can be used to paint scrolls, flower petals, leaves and lettering. It holds a lot of paint and the roundness eliminates sharp edges, making elegant strokes easy. Liners are round brushes with very thin bristles. Use these with "inky" paint for curlicues and tendrils, and with regular paint to dot in flower centers.

HD BRUSHES

HD brushes (not pictured) were developed to be used with the High Definition paint. They are larger than the classic One-Stroke brushes and have longer handles and brass ferrules. Loading the HD brushes with paint is the same as for any other brush; however, the bristle area is larger to pick up and hold more paint, which lets you cover large areas of canvas in a few strokes. To remove a color from your brush, just wipe it off on a paper towel. Don't swish it out in water every time you want to change colors. Wait until you are finished painting, then clean them out with cool water and soap or brush cleaner.

GLASS AND CERAMICS BRUSHES

Developed for use with FolkArt Enamels paints, these brushes (not pictured) feature softer bristles and allow for smooth paint application on non-porous surfaces such as glass, china, ceramics and metal.

BRUSHES FOR PAPER

Stiffer bristles make these brushes (not pictured) ideal for painting on paper, but they are also perfect for painting on fabrics.

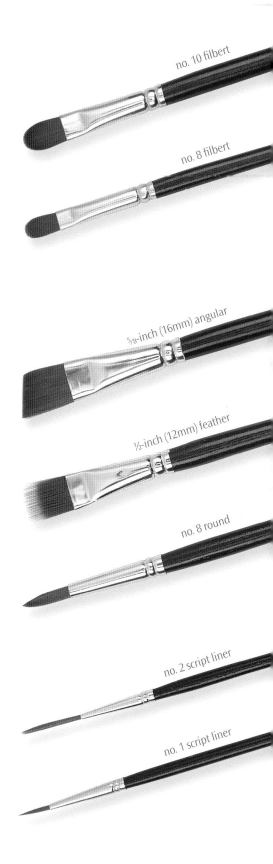

no. 10 filbert

no. 8 filbert

5/8-inch (16mm) angular

1/2-inch (12mm) feather

no. 8 round

no. 2 script liner

no. 1 script liner

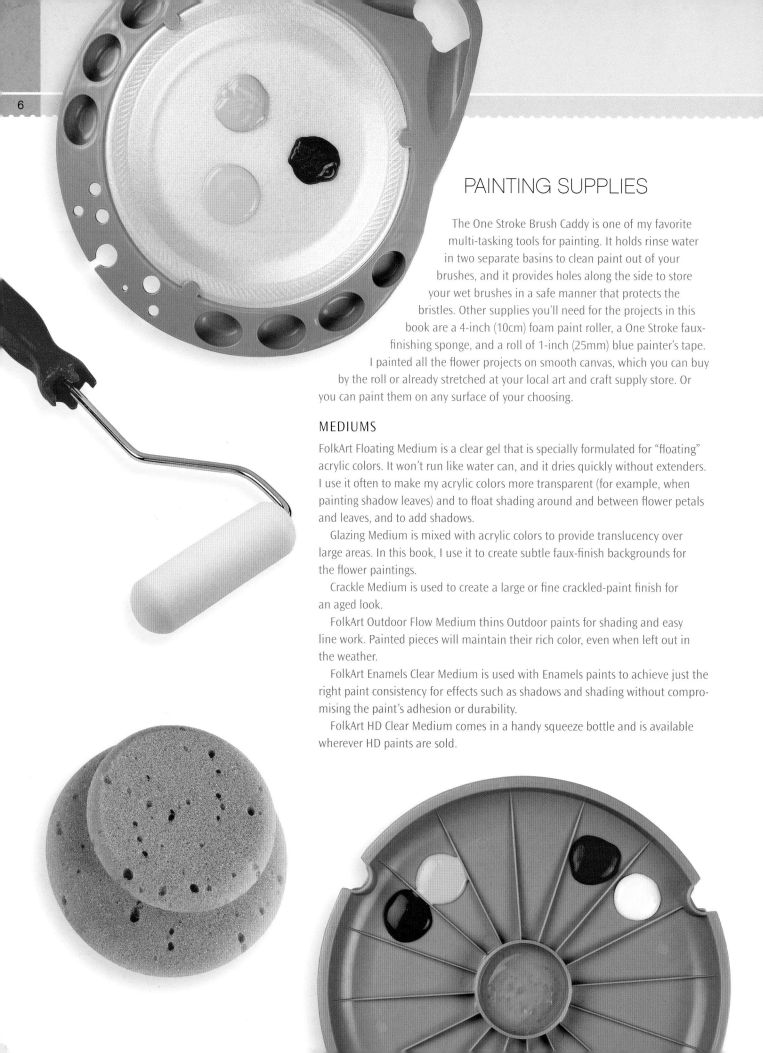

PAINTING SUPPLIES

The One Stroke Brush Caddy is one of my favorite multi-tasking tools for painting. It holds rinse water in two separate basins to clean paint out of your brushes, and it provides holes along the side to store your wet brushes in a safe manner that protects the bristles. Other supplies you'll need for the projects in this book are a 4-inch (10cm) foam paint roller, a One Stroke faux-finishing sponge, and a roll of 1-inch (25mm) blue painter's tape. I painted all the flower projects on smooth canvas, which you can buy by the roll or already stretched at your local art and craft supply store. Or you can paint them on any surface of your choosing.

MEDIUMS

FolkArt Floating Medium is a clear gel that is specially formulated for "floating" acrylic colors. It won't run like water can, and it dries quickly without extenders. I use it often to make my acrylic colors more transparent (for example, when painting shadow leaves) and to float shading around and between flower petals and leaves, and to add shadows.

Glazing Medium is mixed with acrylic colors to provide translucency over large areas. In this book, I use it to create subtle faux-finish backgrounds for the flower paintings.

Crackle Medium is used to create a large or fine crackled-paint finish for an aged look.

FolkArt Outdoor Flow Medium thins Outdoor paints for shading and easy line work. Painted pieces will maintain their rich color, even when left out in the weather.

FolkArt Enamels Clear Medium is used with Enamels paints to achieve just the right paint consistency for effects such as shadows and shading without compromising the paint's adhesion or durability.

FolkArt HD Clear Medium comes in a handy squeeze bottle and is available wherever HD paints are sold.

PALETTE

The FolkArt One Stroke Paint Palette is a circular palette with a number of paint wells for your colors and floating medium, holes for your brushes and a place for paper towels. I use 9-inch (23cm) disposable foam plates to put my paints on, and the tabs on the palette hold the plates in place. The palette is comfortable to hold and easy to clean.

DOUBLE-LOADING CAROUSEL

To make double-loading your brushes even easier, I designed the One Stroke Double Loading Carousel that allows you to pick up just the right amount of paint on your flat brushes. It has sixteen wedge-shaped wells for your colors, and a center well for floating medium. It comes with a sponge that can be dampened and a sealed lid to keep your acrylic paints fresh and moist longer. It even fits in the circular palette shown here.

PALETTE KNIVES AND SPONGE PAINTERS

If you have never before used a palette knife to paint with, you are in for a treat! Palette knives have thin, flexible metal blades in different shapes, sizes and lengths. In this book, I used both wide and narrow palette knives to apply paint thickly to the canvas and to move it around. One of the most fun things to do with a knife is to paint mountains. You can use the flat of the knife or you can use the edge and the tip to achieve all sorts of special effects. Palette knives have been used by artists for hundreds of years. The next time you visit an art museum, check out the landscapes painted by the Old Masters. You will see lots of thick paint that was applied and textured using palette knives.

Sponge painters are cellulose sponges that have either a rounded or pointed end and are available at art and craft supply stores. I use them with thinned paint to quickly cover large areas of canvas, such as skies, hillsides, lakes and oceans, among other things.

CANVAS

All the landscapes in this book were painted on pre-stretched canvases by Fredrix, available at art and craft supply stores everywhere. "Pre-stretched" means the canvas material has already been stretched flat and stapled to wooden stretcher bars, which lets you begin painting right away and saves you time and effort. The Fredrix Creative Edge canvases are made with especially wide edges that are staple-free, which allows you to continue your landscapes over the edges on all four sides. They are ready to hang when you are finished painting— no expensive frames are needed!

BASIC FLOWER COLORS USED

These are the colors used in the basic flower demonstrations in chapters 1–6. The garden and landscape demonstrations in chapters 7 and 8 include swatches with each individual project. Note: FolkArt occasionally retires colors. If you're unable to find a specific color, use the swatch to find a good substitute.

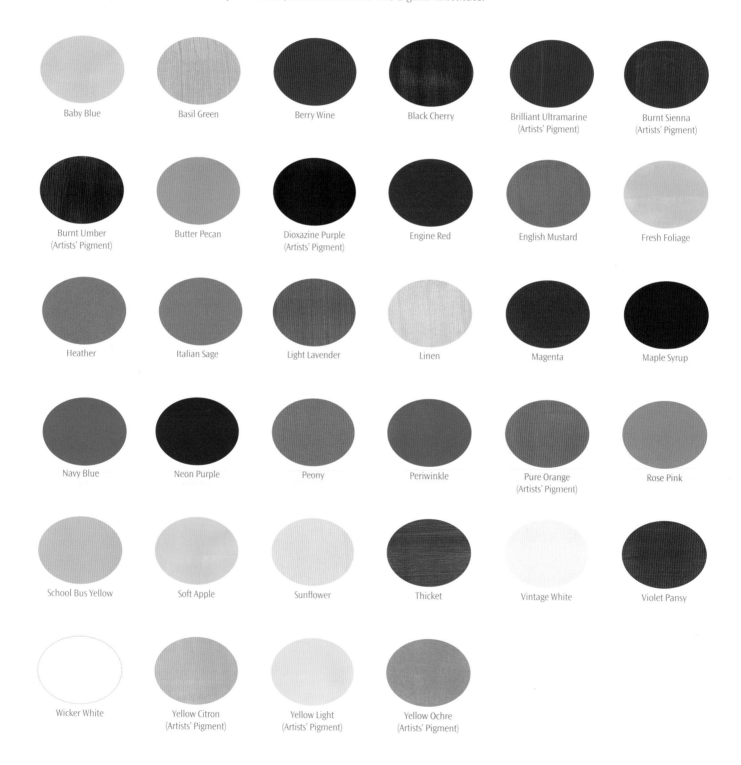

Baby Blue

Basil Green

Berry Wine

Black Cherry

Brilliant Ultramarine
(Artists' Pigment)

Burnt Sienna
(Artists' Pigment)

Burnt Umber
(Artists' Pigment)

Butter Pecan

Dioxazine Purple
(Artists' Pigment)

Engine Red

English Mustard

Fresh Foliage

Heather

Italian Sage

Light Lavender

Linen

Magenta

Maple Syrup

Navy Blue

Neon Purple

Peony

Periwinkle

Pure Orange
(Artists' Pigment)

Rose Pink

School Bus Yellow

Soft Apple

Sunflower

Thicket

Vintage White

Violet Pansy

Wicker White

Yellow Citron
(Artists' Pigment)

Yellow Light
(Artists' Pigment)

Yellow Ochre
(Artists' Pigment)

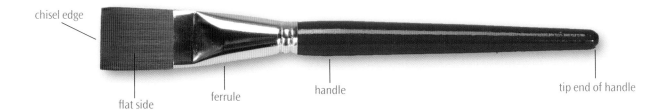

chisel edge

flat side

ferrule

handle

tip end of handle

DOUBLE-LOADING A FLAT BRUSH

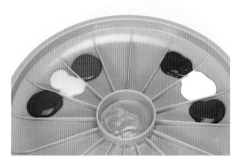

1. Using the Double Loading Carousel, place puddles of paint in the wedge-shaped sections of the carousel. Place the colors you'll be double-loading next to each other. Here, I've placed Neon Purple and Wicker White, but I'll also be double-loading Violet Pansy and Wicker White.

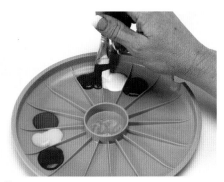

2. Stand the flat brush straight up with half the bristles in one color and half in the other. Slide back and forth to fill the bristles with paint. The carousel's divided wedges keep the colors separate for you.

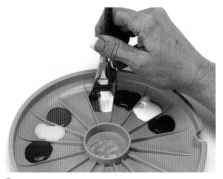

3. Move your brush to an open wedge and work the paint into the bristles. If you don't have any open wedges available, use your palette or a foam plate for this. Repeat this process each time you pick up more paint.

4. Keep your loading spot no more than 1½ inches (38mm) to 2 inches (51mm) long. Don't allow it to stretch longer and longer as you work the paint into the bristles.

5. This is a correctly loaded flat brush. Your bristles should be no more than two-thirds full with paint.

LOADING AN ANGULAR BRUSH

On an angular brush, the heel is the shorter side of the bristles. The toe is the longer side of the bristles. Hold the brush so the toe is at the top.

1. Dampen the brush. Stroke between the two puddles of color. Here, I'm loading Magenta onto the heel and Wicker White onto the toe.

2. Work the colors into the bristles. Pick up more paint as you stroke. It takes quite a few strokes to get the toe fully loaded with color.

3. This is how a properly loaded angular brush should look.

MULTI-LOADING

Double-load your brush. Then dip one corner into a third color. Add lighter colors to the light side of the brush and darker to the dark side.

SIDE-LOADING

1. To side-load your brush, begin by pulling some paint from the edge of the first paint puddle.

2. Stroke right next to the second color puddle to pick up a little paint on the edge of the brush.

LOADING A SCRIPT LINER

1. Add a few drops of clean water next to the puddle of paint. Pull a little paint into the water to thin it to an inky consistency.

2. As you pull the brush out, roll the brush in your fingers and drag the tip of the bristles on the palette to bring them to a point.

Curlicues

To paint curlicues and tendrils, brace your little finger on the surface and move your whole arm, not just your wrist.

DOUBLE-LOADING A FILBERT BRUSH

1. Dampen your filbert brush with water. Pull paint outward from the edge of your first puddle of color.

2. Flip the brush over to the other side. Pull the second color out from the edge of the puddle.

3. When you stroke with the loaded filbert, the key thing to remember is that the color facing upward is the dominant color. Here it's the orange.

4. But here the dominant color is the yellow because the yellow side of the brush is facing upward.

DOUBLE-LOADING A SCRUFFY BRUSH

 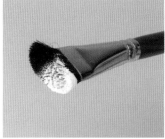 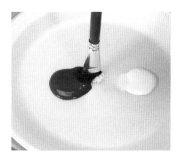 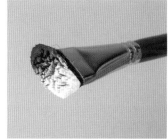

1. A scruffy brush is loaded differently than a flat. Never dampen it first with water, and never dip it into the middle of a paint puddle. Instead, pounce the scruffy at the edge of the puddle to load half of the brush with the first color.

2. This shows how only one-half of the bristles are loaded with paint so far.

3. Now pounce the other side of the scruffy into the edge of the puddle of the second color.

4. Now you can see how the brush is double-loaded evenly with the two colors.

LOADING A FEATHER BRUSH

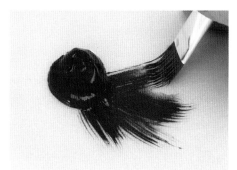

1. Dampen your feather brush with water. Pull paint out from the very edge of the puddle of color.

2. The feather brush is great for making a series of fine lines, like a bottlebrush flower or little palm fronds.

ADDING FLOATING MEDIUM

1. If your brush begins to feel dry when you're painting, add floating medium. Dip the loaded brush straight into the puddle of medium.

2. Work the medium into the bristles on your palette. Use floating medium only every third or fourth stroke.

LOADING THE BRUSH FOR FLOATING

 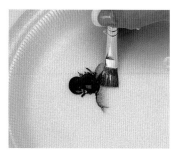

1. First load your brush with floating medium by pulling it out from the side of the puddle.

2. Side-load into your puddle of color ever so lightly on the corner of the brush.

DOTTING FLOWER CENTERS WITH THE HANDLE END

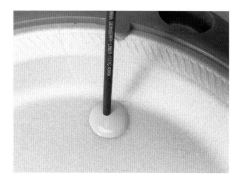 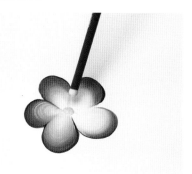

1. This is the easiest and fastest way to dot in the centers of flowers. Turn your brush upside down and dip the tip end of the handle into the paint, holding your brush straight up and down.

2. Touch the handle end to the center area of the flower and lift straight out. Don't turn or twist the handle or make a circular motion. And be careful not to smear the dot while it's drying.

MAKING STARTER STROKES

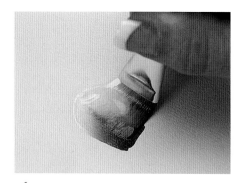 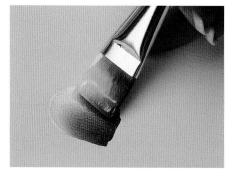

1. Every time you load your brush and before you apply a stroke to your painting, you need to do a starter stroke. A starter stroke is actually three or more strokes right on top of each other. To begin, touch and push down on the bristles.

2. Then lift and repeat three or more times until the color is the way you want it to be. The starter stroke spreads the bristles and blends the colors.

LOADING A WIDE PALETTE KNIFE

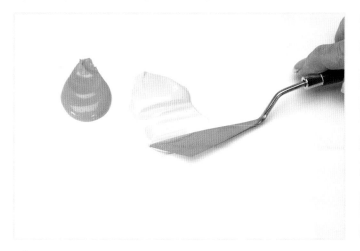

1. A wide palette knife has a flexible metal blade that is wider than usual and designed to pick up a lot of paint in one scoop. You can control how much paint you pick up by using the edge of the knife to first pull some paint out from the edge of the puddle.

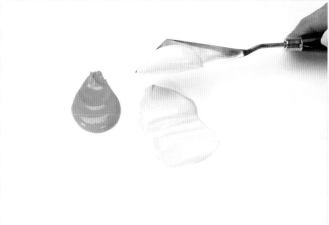

2. Scoop the paint onto the bottom of the blade from the edge of the puddle, not the middle. This is about how much paint should be on the blade if you are loading just a single color. Note that the blade is not entirely covered with paint—you can still see the pointed tips and the inside edge.

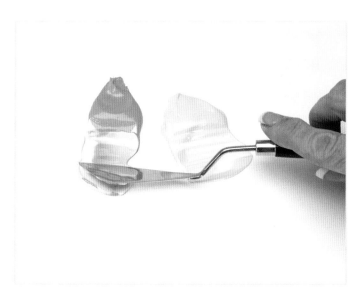

3. To double-load a wide palette knife, turn the blade back over and pull some paint out from the edge of the puddle of the second color, just as you did for the first color.

4. Now you can see the two colors properly loaded on the bottom of the blade. Because the High Definition paint we're using is thicker than regular acrylic paints, it won't drip or run off your knife. You can load your knife on the palette and move to the canvas without losing any paint!

LOADING A NARROW PALETTE KNIFE

1. I load a narrow palette knife differently than I do the wide knife simply because the blade is long and narrow and therefore holds less paint. First, tap the bottom of the blade into your first puddle of paint.

2. Tap all the way up to the tip so the entire bottom is covered. Again, the High Definition paint is thick enough that the paint won't run or drip off your knife.

3. If you want to double-load your narrow palette knife, turn the blade to its outside edge and pull from the edge of the second color using a gentle scraping motion of the tip end.

4. This is how a narrow palette knife looks when it is properly double-loaded. I use this technique to apply thick paint anywhere there is an area too small for a brush or the wide knife or where I need to add details. The rounded point of the tip makes it easy to get into tight places.

PALETTE KNIFE PAINTING TECHNIQUES

1. You can achieve several interesting effects using a palette knife because of its shape and the different kinds of edges it has. Here, I'm using one of the long thin edges to tap on narrow lines of paint, a great way to create distant hills or fields or waves in water.

2. To add texture to a painted area, while the paint is still wet, tap the bottom of the blade lightly into the paint to lift it up into little pebbles and points. Try this if you have large grassy areas that need some interest.

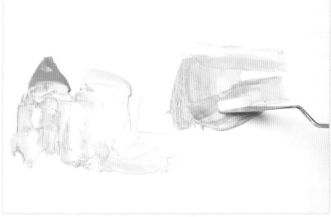

3. I often use a wide palette knife to blend large amounts of color on my palette—it's faster and easier than using a brush because you can scrape up the paint and turn it over and over until it is smooth and evenly blended, much like using a spatula in a bowl of batter.

4. Once your colors are blended on the palette, wipe off the knife using a paper towel. Come back to your color mixture and pick up a small amount on the edge of the blade.

5. Use the edge of the wide palette knife to draw vertical or horizontal elements such as tree trunks and branches, tall flower stalks, and anything that needs to look rough and uneven.

CHISEL-EDGE PETAL STROKE

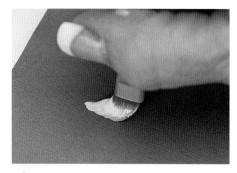 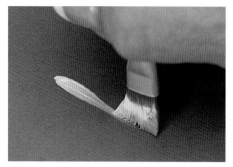 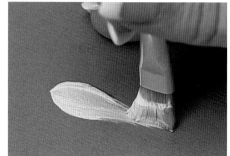

1. Double-load the brush with the two colors you need for your flower petals. Begin on the chisel edge and then lean.

2. Pull the length of the petal and lift back up to the chisel edge to finish the stroke.

3. For a thicker petal, touch down and lean, pushing down a little harder for the thickness you want. Then lift back up to the chisel.

COMMA STROKES

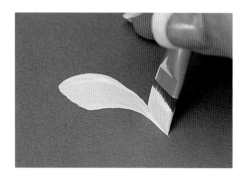 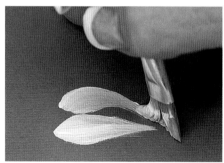 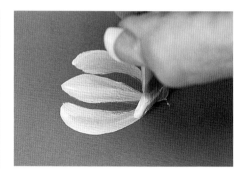

1. Begin on the chisel edge. Touch, push down on the bristles, pull a curving stroke, then lift back up to the chisel.

2. To make a series of petal strokes for a daisy-like flower, begin with a chisel-edge petal stroke, then add a comma stroke to one side.

3. Add another comma stroke to the other side of the chisel-edge petal stroke. Continue with more comma strokes to fill in.

SHELL STROKE

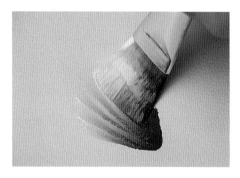

Double-load a flat brush and begin with a starter stroke. Wiggle out and slide back in halfway. Wiggle out for the next segment and slide back halfway. Wiggle out for the third segment, pivoting on the darker side of the brush, and slide back halfway. Continue wiggling out and sliding back until you have the size petal needed. Finish by sliding back all the way and lifting to the chisel.

JAGGED-EDGE PETAL

Double-load a flat brush. Start on the chisel edge, touch, and lean toward the flat side of the brush. Use quick zigzagging motions to create the jagged edge of the petal.

TEARDROP PETAL STROKE

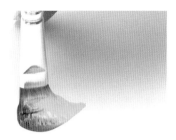 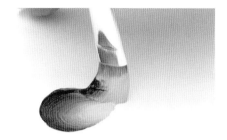

1. Start on the chisel edge. Press down so the bristles bend in the direction shown. Press down more and pivot the red edge of the brush. Don't slide the bristles—just pivot.

2. Lift back up to the chisel and slide to a point.

LAYERING A FIVE-PETAL FLOWER

1. A five-petal flower is a series of teardrop strokes all started from the same center. To layer them, start with a cluster of three or four teardrop strokes.

2. Then paint a complete five-petal flower overlapping the first set of strokes. To make a large cluster for hydrangea blossoms, continue painting three-, four- and five-petal florets that overlap each other.

POINTED SINGLE-STROKE PETAL

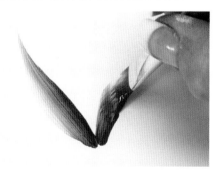 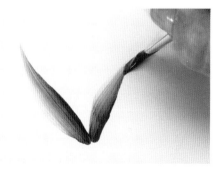

1. Double-load a flat brush. Start at the base of the petal, lean down on the chisel and start sliding up towards the tip.

2. As you stand back up on the chisel, twist the brush in whichever direction you want the petal to turn.

3. This is how a flower made up of long, pointed petals looks. This is a great stroke for making orchids or lilies or any flower with long, slender petals that radiate out from the center.

PETALS WITH A RUFFLED EDGE

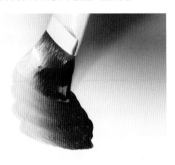

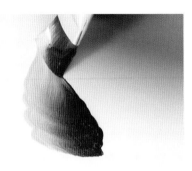

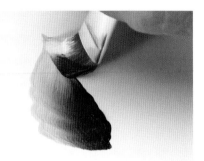

1. Petals with a ruffled side edge are found in many different flowers such as irises, parrot tulips, and orchids. To begin, double-load a flat brush with your two petal colors. Start at the base of the petal, push down on the bristles and wiggle up.

2. Stop wiggling the brush as you near the tip. Slide smoothly the rest of the way to the tip and lift back up to the chisel edge. This will give the tip its pointed shape.

3. Without turning or lifting your brush from the surface, reverse the direction of the bristles and begin leaning down on them. Compare the position of the bristles in this photo with the bristles in Step 2.

OUTLINING PETALS

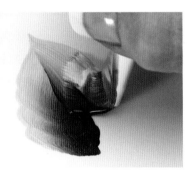

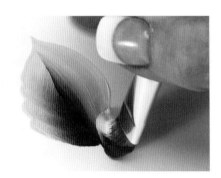

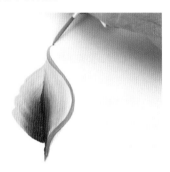

4. Apply more pressure on the brush as you start to slide smoothly back down to the base of the petal.

5. Lift back up to the chisel edge to end the stroke at the base of the petal. Notice that the darker side of the brush is in the same position as it was when you started the stroke.

Here's a quick tip for adding interest to a petal or leaf. Outline one side of it with a darker shade. Load a script liner with inky paint and pull a smooth line following the shape from base to tip, lifting off to come to a point.

PETALS WITH RUFFLED TOP EDGES

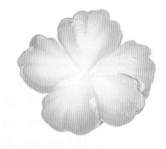

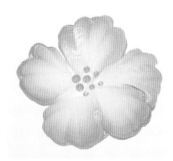

1. Double-load a flat with Yellow Ochre and Wicker White. Start on the chisel and wiggle out a few times to paint a single petal.

2. Slide back to the pointed base and lift back up to the chisel.

3. Paint a series of ruffled-edge petals all radiating outward from a center point. Turn your surface to make painting easier.

4. Dot the center with Fresh Foliage on the tip end of the brush handle.

TRUMPET FLOWER PETALS

1. Begin by painting the base of the trumpet. Double-load a flat brush. Keeping the darker side of the brush to the outside, stroke upward toward the base of the trumpet, watching the outer edge as you stroke.

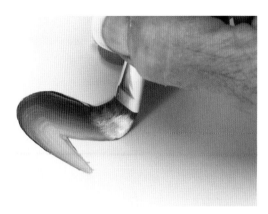

2. Pivot the brush at the base of the trumpet and slide back down the other side. Lift back up to the chisel. Don't worry about filling in the center—it will be covered by the next strokes.

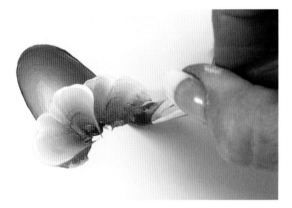

3. Double-load your flat brush again with the same colors, but this time turn the brush so the lighter side is to the outside edge. Add the upper part of the ruffled opening with a series of little shell strokes.

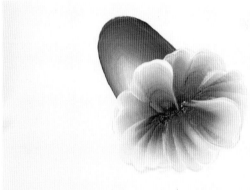

4. Continue with little shell strokes for the lower part of the ruffled opening, turning your work so it's easier to stroke and keeping the lighter side of the brush to the outside edge.

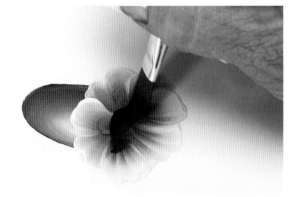

5. To shade and deepen the throat of the trumpet, load a flat brush with floating medium, then side-load into your darker paint color. Start your stroke on the left and pull across to the right side, creating a wavy shape that is pointed on both sides and wider in the middle.

6. Using the chisel edge of the same brush, pull little streaks out from the shading onto the lower part of the ruffled petals. Keep the upper edge of the shaded area sharp and distinct to create the illusion of depth to the trumpet.

FLOAT-SHADING

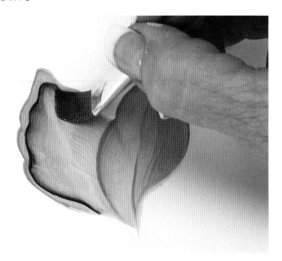

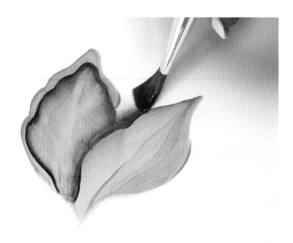

1. Float-shading is an easy way to give shape and dimension to your flower petals. I use this technique when painting magnolia blossoms and other cupped flower petals. Let your petals dry, then load a flat brush with floating medium and side-load into Burnt Umber. With the Burnt Umber side of the brush next to the edge of the petal, paint along the inside edge as shown. This gives the effect of the petal's edge turning inward.

2. To separate the upper petal from the lower one, load a flat brush with floating medium and side-load into Burnt Umber. With the Burnt Umber side of the brush next to the outside edge of the lower petal, paint along the petal's edge as shown. Continue shading all around the petal to separate it from the background.

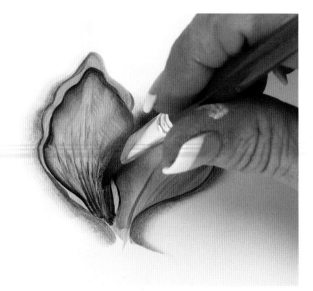

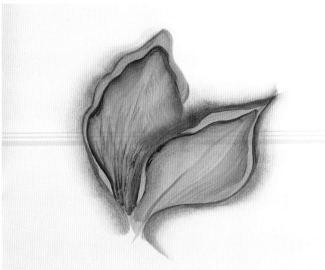

3. Float-shade around the left side of the back petal to separate it from the background. Using the same brush, pull little chisel-edge streaks upward from the base of the petal to deepen the shading within.

4. The key to successful float-shading is to load your brush properly and to follow along the edges of the petal or leaf you are shading. If your shading seems too dark, you can always pick up more floating medium on your brush and soften the shading.

BASIC ONE-STROKE LEAF

 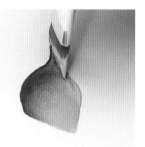

1. Double-load a flat brush with a darker green and a lighter green or yellow. Touch the chisel edge of the brush to the surface to make two guidelines for the start and end of the one-stroke leaf.

2. Place the chisel edge on the left guideline and press down on the bristles so the flat of the brush is laying on the surface.

3. Turn the darker green side of the brush slightly so it is parallel with the right guideline.

4. Slide forward at the same time as you release the pressure and lift to the chisel, ending the stroke at the right guideline.

LONG, WIDE LEAF

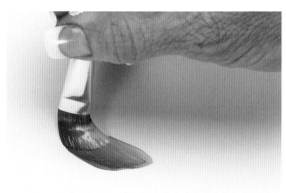 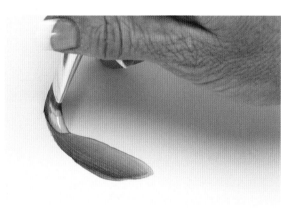

1. Double-load a flat brush with green and yellow. Begin at the base of the leaf and stroke with the flat of your brush to make the wide part of the leaf.

2. Twist the brush in your fingers so the green side of the brush is leading, and pull to the tip, lifting to the chisel as you go.

 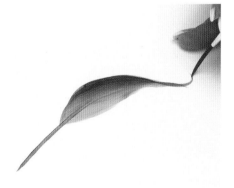 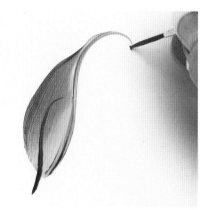

3. Pull a stem partway into the center of the leaf using the chisel edge of your brush.

4. As an added touch, try outlining one side of the leaf. Load a script liner with inky green paint and pull a line up the entire side of the leaf from base to tip. This will redefine that edge.

5. Here's a variation on the long, wide leaf. Outline the yellow side of the leaf from base to tip with inky green paint and a script liner. Extend the tip into a long, graceful curve.

LONG LEAF WITH SCALLOPED EDGE

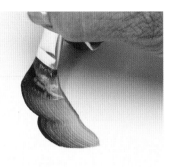

1. This leaf has one edge that is smooth and one edge that is scalloped. Double-load a flat brush with a dark green and a yellow. Paint the scallop-edge side of the leaf using the flat of the brush and leading with the green side.

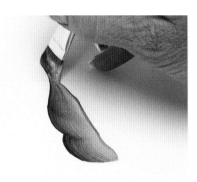

2. Lift back up to the chisel and slide smoothly the rest of the way to the tip.

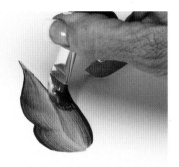

3. For the other half of the leaf, turn the brush so you are leading with the yellow side. Stroke smoothly upward from the base, putting pressure on your brush at the base and releasing pressure gradually as you stroke upward.

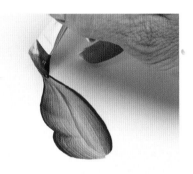

4. Slide smoothly to the tip, lifting back up to the chisel.

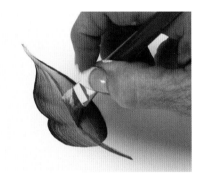

5. Finish by pulling a stem halfway in to the center of the leaf, using the chisel edge of the brush and leading with the yellow side.

WIGGLE-EDGE, SMOOTH-SIDED LEAF

1. Double-load a flat brush with dark green and yellow. Start at the base of the leaf. Apply pressure to the flat of the brush and wiggle up to the tip of the leaf, turning the green side of the brush slightly towards the tip.

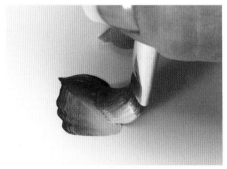

2. Reverse the direction of the bristles without lifting your brush off the surface. Apply pressure and slide smoothly back down to the base.

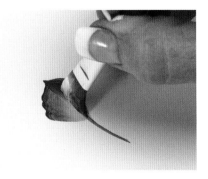

3. Pull a stem halfway in to the center of the leaf, using the chisel edge of the brush and leading with the yellow side.

FOLDED TULIP LEAF

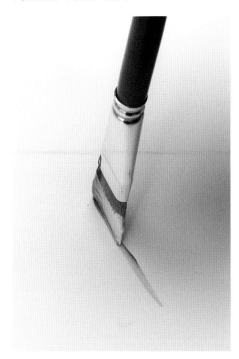

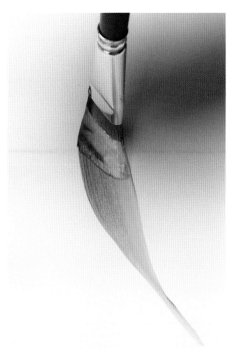

1. The long pointed leaves that surround spring-flowering tulips often fold over on themselves as they age. Here's how to achieve that look with one smooth motion. Double-load a large flat brush with a dark green and a lighter green. Start by pulling the stroke upward from the base, staying up on the chisel edge and leading with the darker green side of the brush.

2. Press down on the brush to widen the stroke as you slide the brush at a slightly diagonal angle.

3. Make a gently curved hook at the top, then lift up to the chisel and turn, reversing your direction.

4. Press down again on the bristles to widen the stroke.

5. Slide down, then lift back up to the chisel and slide to the tip. To delineate the leaf edge, turn your brush so the dark green side is to the left and re-stroke the folded-over part of the leaf.

FERNS

1. There are two kinds of ferns I like to paint as fillers for my floral compositions. One has wider leaves that are close together along the stem. The other fern has airy, lacy-looking fronds with tiny leaflets. For both ferns, start by painting a long curving stem, staying up on the chisel edge and leading with the lighter color. On the lacy fern stem, add smaller branches that have even smaller branches attached to them.

2. On the wide-leaf fern, add two rows of one-stroke leaves. On the lacy fern, the tiny leaves are painted using short, light chisel-edge strokes, pulling inward toward the stems.

3. When the wide-leaf fern is finished, pull a new stem up the center to clean up the edges. Finish the lacy fern with more leaflets to fill in the frond.

PAINTING GRASS WITH AN ANGULAR BRUSH

1. Grass blades of varying heights and thickness are quick and easy to paint with an angular brush. Load a dark green onto the toe of the brush, and a light yellow onto the heel. Stroke upward, leading with the heel (the yellow side) and dragging the toe. Stay up on the chisel and lift off at the tip of each grass blade to create a point.

2. Double-loading the angular brush makes it easy to shade and highlight each blade of grass in one stroke.

PAINTING GRAPEVINES WITH AN ANGULAR BRUSH

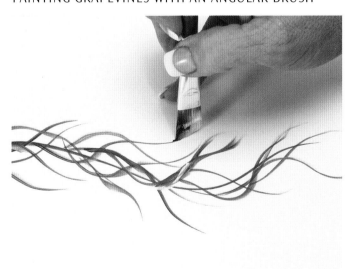

Vines and grapevines are also easy to paint with an angular brush. Load Burnt Umber on the toe and Wicker White on the heel. Starting at the left, paint the main vine with a gently curving line, leading with the heel (the Wicker White side) and dragging the toe. Stay up on the chisel edge. For the crossing vines, always start at the main vine and pull smaller, curving vines across from one side to the other.

Continue pulling shorter vines, weaving back and forth over the main vine as you go. Don't do too much—keep your grapevines light and airy.

For the flower painting demonstrations in this book, I have created a variety of interesting and attractive backgrounds you can use that coordinate with and enhance your flower portraits. These backgrounds are very easy to do and require only a few supplies, such as sponges, glazing medium, crackle medium, or brushes.

LACE PAPER DOILY

This background can make a strong statement depending on what color you use. For a softer background use a color closer to white, such as Vintage White or Linen.

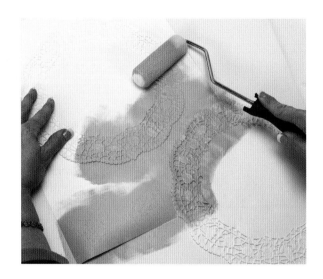

1. For this background you'll need a packet of 10½ inch (27cm) wide lace paper doilies from a craft or party supply store, a spray-on, low-tack adhesive, and a 4-inch (10cm) foam roller. Spray one side of the paper doily with a light coating of adhesive and place the doily where you want it on your painting surface. Make sure all the little edges and holes are pressed down to the paper or canvas. Load the foam roller with Basil Green and roll over the entire painting surface all the way out to the edges.

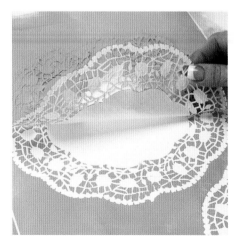

2. Carefully remove the doily while the paint is still wet by lifting it straight off the surface.

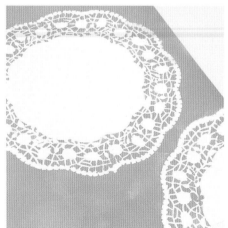

3. Let the paint dry completely before you begin painting the floral design you've chosen. Don't worry if some of the areas are not perfect—you can always paint over them with your flowers or leaves.

TONE ON TONE

This is a sponged-on background that uses two closely-related colors to create very subtle tones and textures.

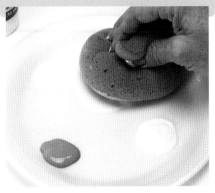

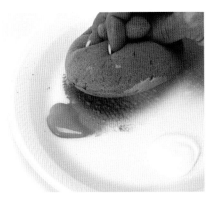

1. Place puddles of glazing medium, Butter Pecan, and Wicker White on your palette. Dampen a faux-finish sponge in clean water and pounce evenly into the puddle of glazing medium.

2. With the glazing medium on your sponge, pounce into the edge of the puddle of Butter Pecan.

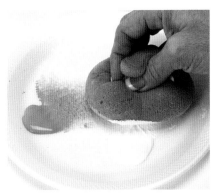

3. Turn your sponge slightly and pounce into the edge of the puddle of Wicker White.

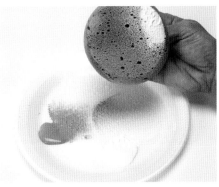

4. This is how your sponge should look when it's properly loaded. Notice that the Butter Pecan and the Wicker White are on different areas of the sponge, not right on top of each other.

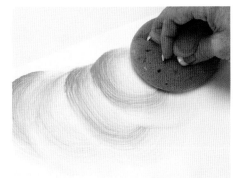

5. Now move to your canvas or paper and begin applying your background colors with a circular motion to one small area at a time.

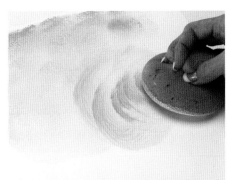

6. Pounce the area you just applied in Step 5, moving the sponge around in random motions. Reload the sponge with glazing medium and the two colors and work on the next area. Begin with circular motions, then pounce it out. Anyplace you feel you've lost one of the colors, you can go back and re-load and re-sponge that area.

SKY AND CLOUDS

This is a sponged-on background that uses three pale colors over a light blue basecoat to create a feeling of the sky at sunset.

1. Place puddles of Baby Blue, Wicker White and glazing medium on your palette. Pounce a faux-finish sponge into the glazing medium, then into the Baby Blue and Wicker White. Sponge a pale blue basecoat onto your canvas or paper and let dry. Using 1-inch (25mm) low-tack painter's tape, tape off all four sides of your surface.

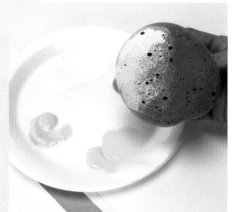

2. Using the same palette as in step 1, add a puddle of Sunflower and a puddle of Heather. Pounce your sponge into glazing medium, then pick up Sunflower and Wicker White. This is how your sponge will look if it's loaded correctly.

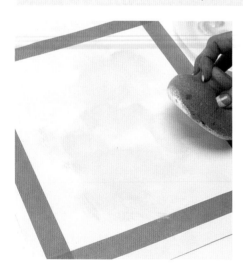

3. Pounce the sponge randomly over the pale blue basecoat. Don't try to cover all areas, just pounce the yellow here and there.

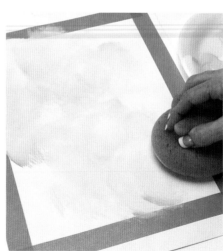

4. Pick up more glazing medium, then Baby Blue and Heather on the sponge. Pounce randomly over the surface, allowing areas of yellow and blue to show through.

5. Blend with the sponge so there are no hard edges anywhere, but don't overblend so your colors get muddy. You should still be able to see areas of blue, white, yellow and lavender.

SHADOW LEAVES

Shadow leaves make a beautiful background for flower paintings because they reflect the natural shapes and colors of the leaves in your design. Shadow leaves can be done in any color; for this demo I'm using a light green.

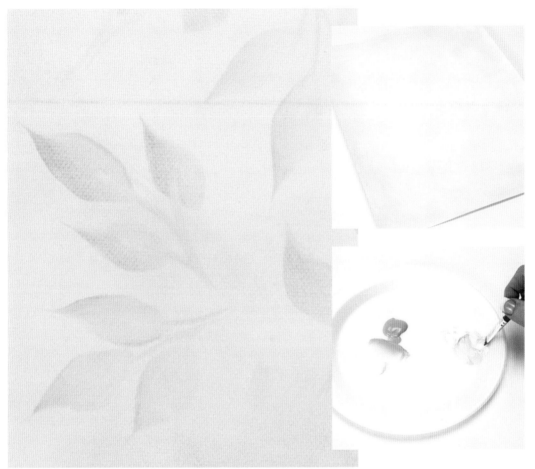

1. Place puddles of Fresh Foliage, Wicker White and glazing medium on your palette. Pounce a faux-finish sponge into the glazing medium, then into the Fresh Foliage and Wicker White. Sponge on a pale green basecoat onto your canvas or paper and let dry.

2. Double-load a no. 12 flat with Wicker White and Fresh Foliage. Work the brush into a puddle of floating medium to make the color very soft and translucent.

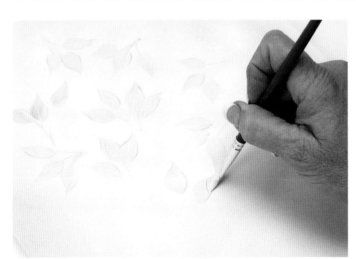

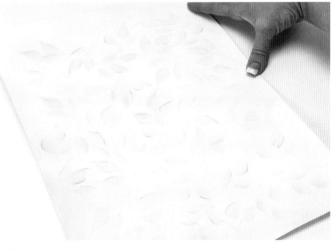

3. Paint little one-stroke leaves and stems, usually in clusters of three or more leaves, all over the sponged-on background. Turn your surface constantly so your leaves face in different directions, but keep them roughly the same size.

4. Let your shadow leaf background dry completely before painting your flower design on it. Notice that the shadow leaves are not uniform in color—some are lighter and some a bit darker. The more floating medium you have in your brush, the more translucent the leaves will be.

ALLOVER CRACKLE

An allover crackled background can give a rustic or antique look to your painting, depending on how large or fine the crackling is. Be sure to follow the manufacturer's directions on the bottle of crackle medium.

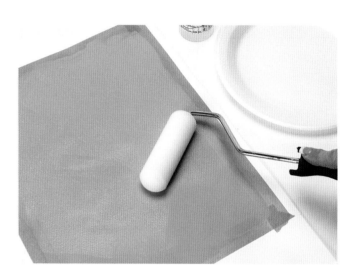

1. For this background you'll need a bottle of crackle medium, a roll of 1-inch (25mm) low-tack painter's tape, and a 4-inch (10cm) foam roller. Tape off the edges of your canvas or paper with painter's tape and basecoat the surface with Basil Green. Let dry. Place a puddle of crackle medium on your palette. Dampen the foam roller, load into the crackle medium and roll over the entire painting surface all the way out to the edges. Crackle medium is clear so check your surface to make sure it's completely covered. Let the crackle medium dry to the touch.

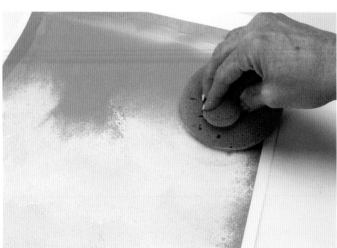

2. Dampen a faux-finish sponge and pounce into a puddle of Vintage White. Pounce the sponge onto the dried crackle medium starting at one end and working across. Don't go back over your pounced areas or you'll just pick up the paint. The thinner the paint layer, the finer the crackle.

3. As soon as you've finished pouncing the paint on, remove the painter's tape before the paint dries so you don't pull the paint off with the tape. As you can see, the Vintage White has crackled just enough that you can see bits of the Basil Green basecoat underneath. It's important that your basecoat color be harmonious with your flower colors because it will show.

CRACKLED FRAME

In this background, only the outer edges are crackled to give the illusion of an old painted wooden frame that's seen better days. Any time you use a crackling medium, be sure to read and follow the manufacturer's directions.

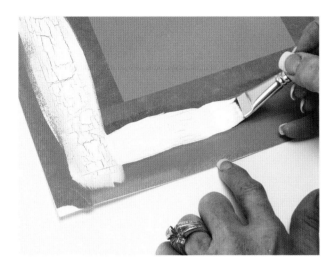

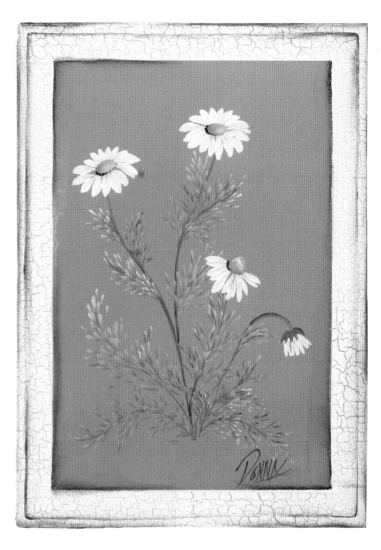

1. Tape off your canvas or paper along the outermost edges with 1-inch (25mm) painter's tape. Basecoat with your chosen color and let dry. Decide how wide you want your crackled frame to be, then measure in that distance from the inner edge of the painter's tape on all four sides. Place four more strips of tape. Be sure these pieces are straight and the corners form 90-degree angles. Dampen a 1-inch (25mm) flat, then load it into a puddle of crackle medium on your palette. Apply a heavy coat of crackle medium to the space between the tape along all four sides, and let the crackle medium dry to the touch.

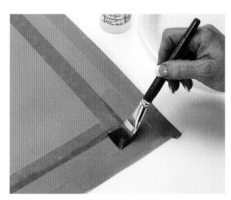

2. Load Wicker White on a 1-inch (25mm) flat and paint over the area where you've applied the crackle medium. Work quickly and don't go back over any areas that have already started to crackle or you'll lift it off. Apply the paint heavily if you want a large, noticeable crackle pattern, as shown here.

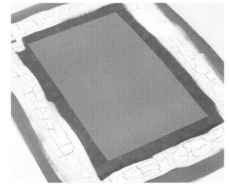

3. Here you can see the crackled effect forming all the way around.

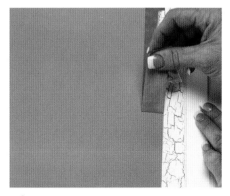

4. Before the paint dries, remove all the painter's tape by pulling slowly and steadily straight up. If you wait until the paint has dried, you could pull some of it off when you lift the tape.

FAUX LEATHER

This leather-look background is very dramatic with its deep, rich colors and realistic texture. It provides an interesting, almost masculine contrast to the delicate look of flowers.

1. Begin by taping off the edges of your canvas or paper with low-tack painter's tape and basecoating it with Burnt Umber. Let dry. Dampen a 4-inch (10cm) foam roller and roll it into a puddle of glazing medium on your palette.

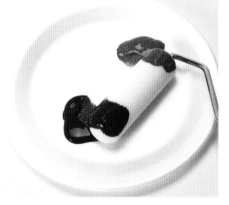

2. With the glazing medium on your roller, load one side with Burnt Sienna and the other side with English Mustard.

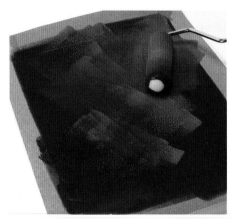

3. Roll on the colors and glazing medium in a random pattern here and there on your basecoated surface. Don't cover the Burnt Umber basecoat entirely—allow it to show through in several areas.

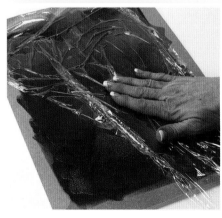

4. Place a large piece of clear plastic wrap over the wet paint, allowing it to wrinkle up naturally. Press down but don't try to smooth out the wrinkles.

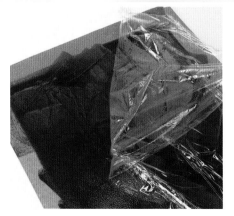

5. Before the paint dries, pull off the plastic wrap. Here you can see how the wrinkles in the plastic wrap create a leathery-looking texture.

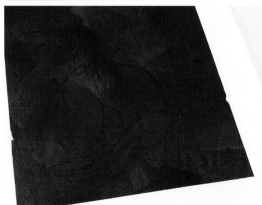

6. Now remove the painter's tape from the edges of your surface before the paint dries so you don't pull any of it off. If there are any bad spots along the edges, just touch them up with straight Burnt Umber paint. The leather effect shows up best when the paint is totally dry.

ANTIQUED

This is a sponged-on background that uses three subdued colors to create old-world tones and textures. This background will give instant age to your paintings.

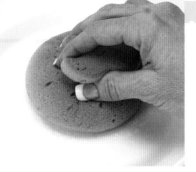

1. Begin by dampening a faux-finish sponge, then loading it into a puddle of glazing medium on your palette.

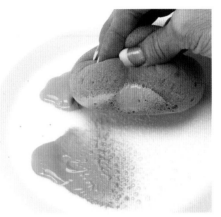

2. With the glazing medium on your sponge, load one side into Butter Pecan and the other side into Italian Sage.

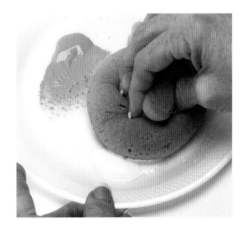

3. Now load another area of the sponge with Wicker White. Check your sponge—you should see three distinct areas of color: Butter Pecan, Italian Sage and Wicker White.

4. Move to your canvas or paper surface and begin making smooth circular motions with the sponge.

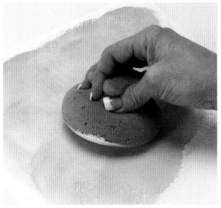

5. Lightly pounce over the surface for a subtle texture. Reload the sponge into glazing medium, then into the three colors separately. Continue painting with circular motions, then pouncing the sponge in random patterns.

6. Keep pouncing the sponge until there are no more hard edges, but don't overblend the colors. You want to see areas of brown, green and white showing through, which helps give your painting a softly aged look.

PATCHWORK SQUARES

This is the most complex looking background design but the individual squares are still very easy and fun to paint. Choose your paint colors so they harmonize with your flower and leaf colors.

1. Start by making a template of different size squares and rectangles. First decide the overall size of your background, then take a piece of cardstock that size and cut it up into the shapes you want. Place these templates on your canvas or paper and arrange them as you wish into a patchwork design. Having the individual templates makes it easy to move them around until you're satisfied with the layout.

2. With a sharp pencil, trace lightly around each separate template on your painting surface.

3. Check your traced pattern to see if you like it.

4. Tape off your different colored areas with low-tack painter's tape and burnish the edges of the tape so the paint doesn't seep underneath. Mix Wicker White and Rose Pink and basecoat one of the squares. While that's drying, double-load a large 1-inch (25mm) scruffy into the same two colors and pounce a mottled design into another square.

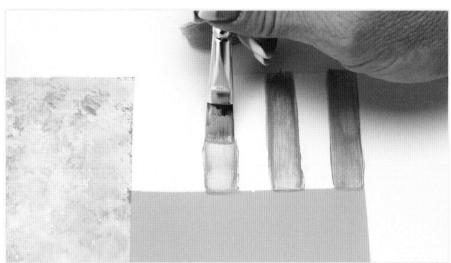

5. Remove the tape before the paint dries on the section you've just painted. Then let those sections dry. To paint the next section, tape off around it, making sure your previously painted sections are dry or the tape will pick up the wet paint. In this design, I've basecoated the rectangle with Butter Pecan and the square with Basil Green, and I've left the upper right corner just plain white.

6. In the plain white square you can paint floated stripes. Load a no. 12 flat with Butter Pecan and dip into floating medium. Paint freehand stripes, using your little finger to brace your hand. If you feel your hands aren't steady enough, just tape off the stripes and paint between the pieces of tape.

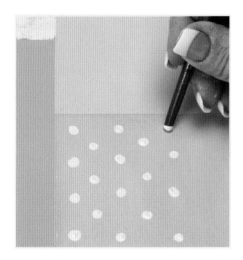

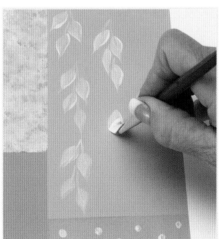

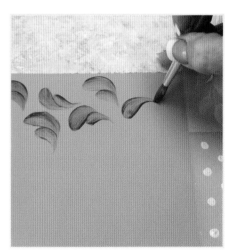

7. For a polka-dot square, load the tip end of a brush handle into a light pink mixed from Rose Pink and Wicker White. Dot on in even rows, four dots in one row, three in the next, and so on. Let these dry so you don't accidentally smear them with your hand when you're painting the next square.

8. For the shadow leaves, double-load a no. 12 flat with floating medium and a color that is in the same color family as the background color. Here I'm using Linen for the shadow leaves on a Butter Pecan background.

9. In the final patchwork square, try painting some nested comma strokes. Again, keep the comma strokes in the same color family as the background. Here, I've double-loaded Thicket and a small amount of floating medium on a no. 8 round. To paint nested commas, start with a large one, then add a smaller one that is nested into the curve of the large one. Let everything dry completely before painting any flowers on this background.

2 CANVASES SIDE BY SIDE

1. To make a bold statement with your landscape paintings, try painting them across two, three or even four canvases! Start with two vertical canvases like these. Each one is 18" × 24" (46cm × 61cm).

2. Push them together so you can see the final size and shape.

3. Sponge on your background colors across both canvases.

3 CANVASES SIDE BY SIDE

4. If your canvases have staple-free edges like these, continue sponging paint over all four edges of each canvas. This gives a finished, gallery-style look to your artwork and no frames are needed.

1. If you want to paint a panoramic scene such as an ocean, you can make an extremely horizontal shape using three square canvases. These three are each 16" (41cm) square.

2. Push them together to see the final size and shape. (If you want to create a tall, narrow painting, stack the three canvases vertically.)

3. Sponge on your background colors carrying them across all three canvases.

4. If your canvases have staple-free edges like these, continue sponging paint over the edges on both sides, and the top and bottom of each canvas. This gives a finished look to your painting.

4 CANVASES ARRANGED IN A SQUARE

1. Here's a great way to get a fresh and updated look to your home decor. Take four square canvases like these and arrange them into one larger square, leaving a little open space between each canvas. Each of these is 14" (36cm) square.

2. Push them together, side by side and top to bottom, to make painting across them easier. Don't worry about little gaps along the edges—these will not show when your artwork is hung on a wall with a bit of space between each canvas.

3. Sponge on your background colors across the canvases. For better design, don't use the horizontal division between the upper and lower canvases as your horizon line. Place it either above or below the division. Offset your focal point from the vertical division, too.

4. If your canvases have staple-free edges like these, continue sponging paint over the edges on both sides, top and bottom of each canvas. This gives a finished look to your painting and allows you to display the canvases without any frames.

cottage garden flowers

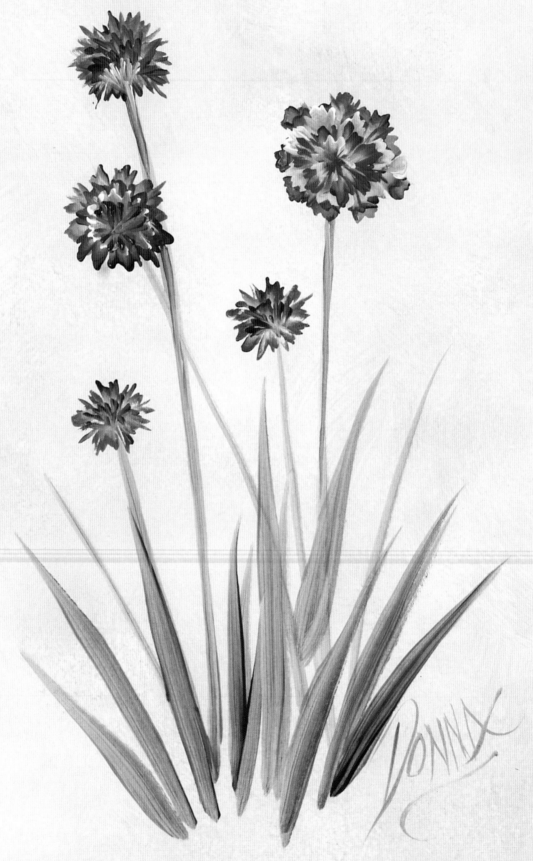

1. Start with a Tone-on-Tone background sponged on with Butter Pecan and Wicker White. Let dry. Double-load a no. 16 flat with Thicket and Yellow Citron and paint the tall stems and grassy leaves.

2. Double-load a no. 8 flat with Brilliant Ultramarine and Wicker White and paint the first layer of petals. The outer edge of each petal is notched.

3. Pick up more Brilliant Ultramarine on your brush and detail the outer edges of each petal.

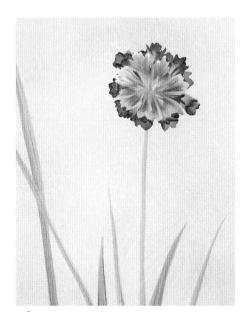

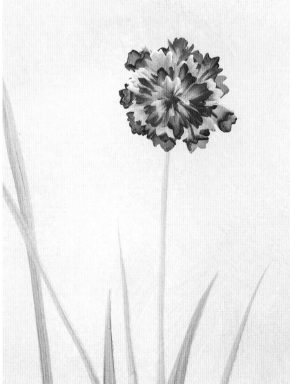

5. Continue adding more layers of petals, picking up more Brilliant Ultramarine to darken the petals in the center mound. The blossoms seen from the side in the distance are less detailed and look like little balls of spiky petals. Cornflowers are also known as Bachelor's Buttons and their deep blue color often adds depth and contrast to compositions of lighter flowers. Try painting them with bright red and sunny yellow flowers for a pretty French country bouquet.

4. Now pick up more Wicker White on your brush and add another smaller layer of petals that is a bit lighter than the first layer.

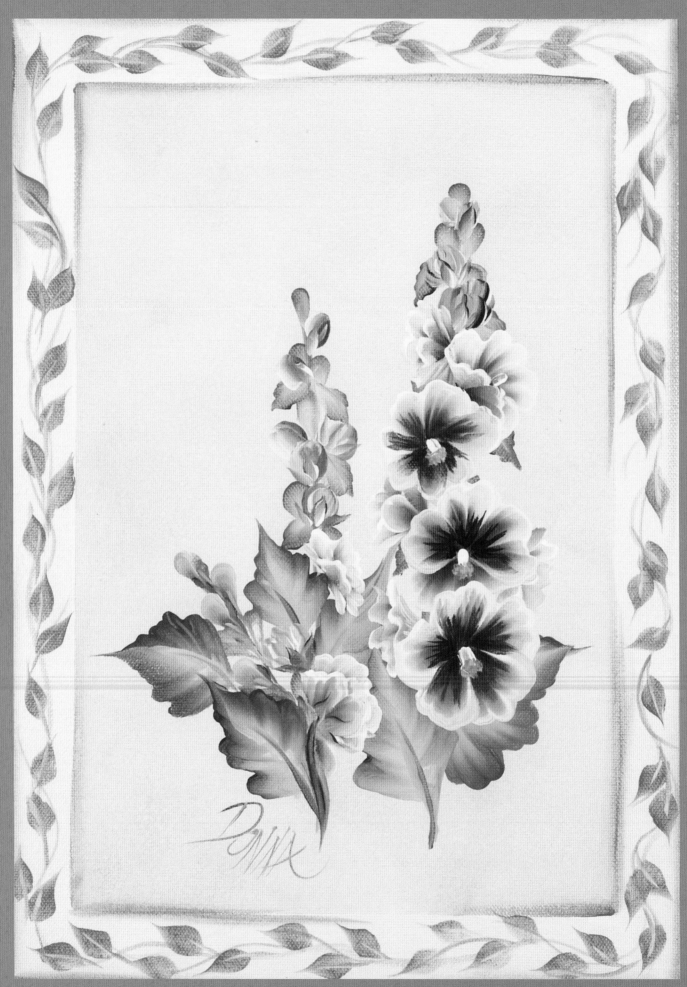

HOLLYHOCK

brushes
¾-inch (19mm) flat · no. 10 flat · no. 12 flat

colors
Thicket · Wicker White · Yellow Light
Magenta · Butter Pecan

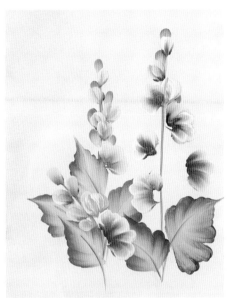

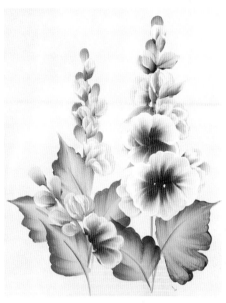

1. Begin by taping off a frame with 1-inch (25mm) painter's tape. Sponge on a light blue background using glazing medium, Baby Blue and Wicker White. Let dry. Double-load a ¾-inch (19mm) flat with Thicket, Wicker White and a little Yellow Light. Paint the large leaves. The long stems and unopened green buds are Wicker White and a little Thicket on a no. 12 flat.

2. Double-load a no. 12 flat with Magenta and Wicker White. Paint the opening buds with three comma strokes layered on top of each other. With the same brush and colors, paint the back petal layers of the sideview blossoms.

3. Paint the large open petals of the hollyhocks using Magenta and Wicker White. Each large circular petal is made up of about five to six sections. Keep the Magenta side of the brush toward the center of the petals.

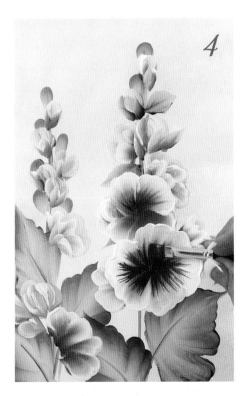

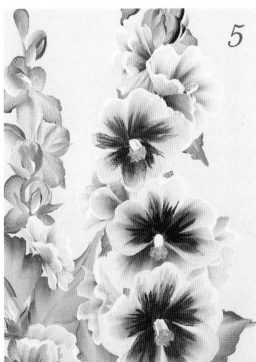

4. To shade and add depth to the flower centers, load a no. 10 flat with straight Magenta and paint little chisel-edge streaks, moving the brush outward from the center.

5. Stroke in the stamens in the open blossoms with a no. 10 flat and Wicker White. Pick up Yellow Light on the corner of the brush and tap on the rounded yellow pollen dots. To finish, remove the painter's tape from the frame. Load a no. 12 flat with floating medium and Butter Pecan. Paint a border of shadow leaves in the frame, then outline the frame on both sides with the same brush and colors. Note that the leaves are all carried around the frame in a clockwise direction.

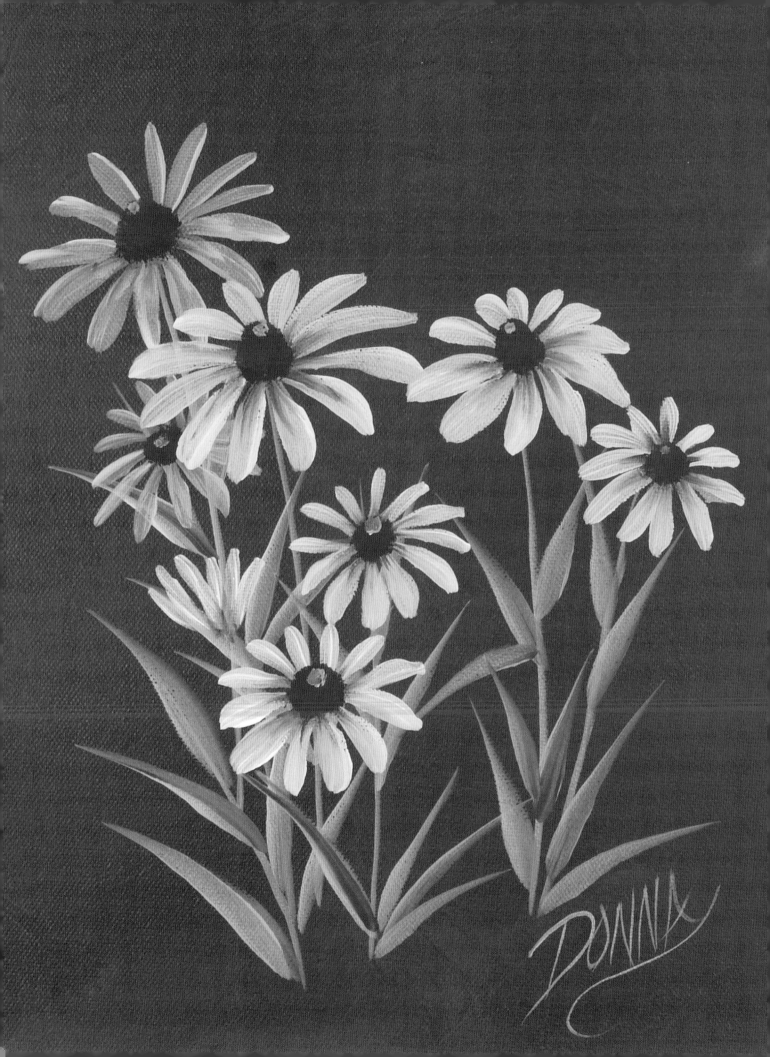

BLACK-EYED SUSAN

brushes

no. 12 flat • ¼-inch (6mm) scruffy

colors

Thicket • Fresh Foliage • Yellow Light
Burnt Sienna • Black Cherry • Rose Pink

1. Create a Faux Leather background following the instructions in the techniques section. Let dry. Paint the stems and long thin leaves with Thicket and Fresh Foliage double-loaded on a no. 12 flat. Occasionally pick up Yellow Light to vary the colors of the leaves.

2. Begin the blossoms with the background flowers and opening bud. Load Yellow Light on a no. 12 flat, sometimes picking up a little Burnt Sienna to shade the petals. Paint each petal by starting at the outer tip and pulling toward the center.

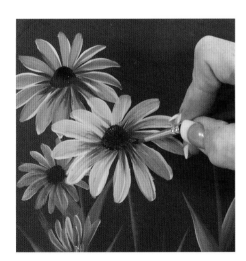

3. For the foreground blossoms, load a no. 12 flat with Yellow Light and pull the back petals first. The petals are shorter in the back and get longer as they come around the sides. The front petals are longest. To paint the center cones, load a ¼-inch (6mm) scruffy with Black Cherry. Pounce on the centers of the open blossoms. While the Black Cherry is still wet, pull little streaks out onto the petals with a no. 12 flat and Burnt Sienna.

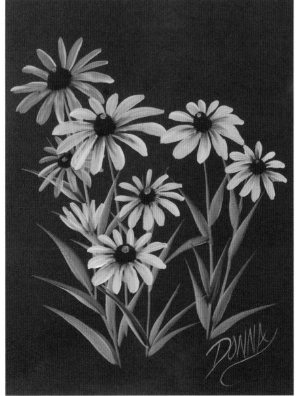

4. Clean up the edges of the cones with dots of Black Cherry. Highlight the tips of the cones with Rose Pink on a no. 12 flat.

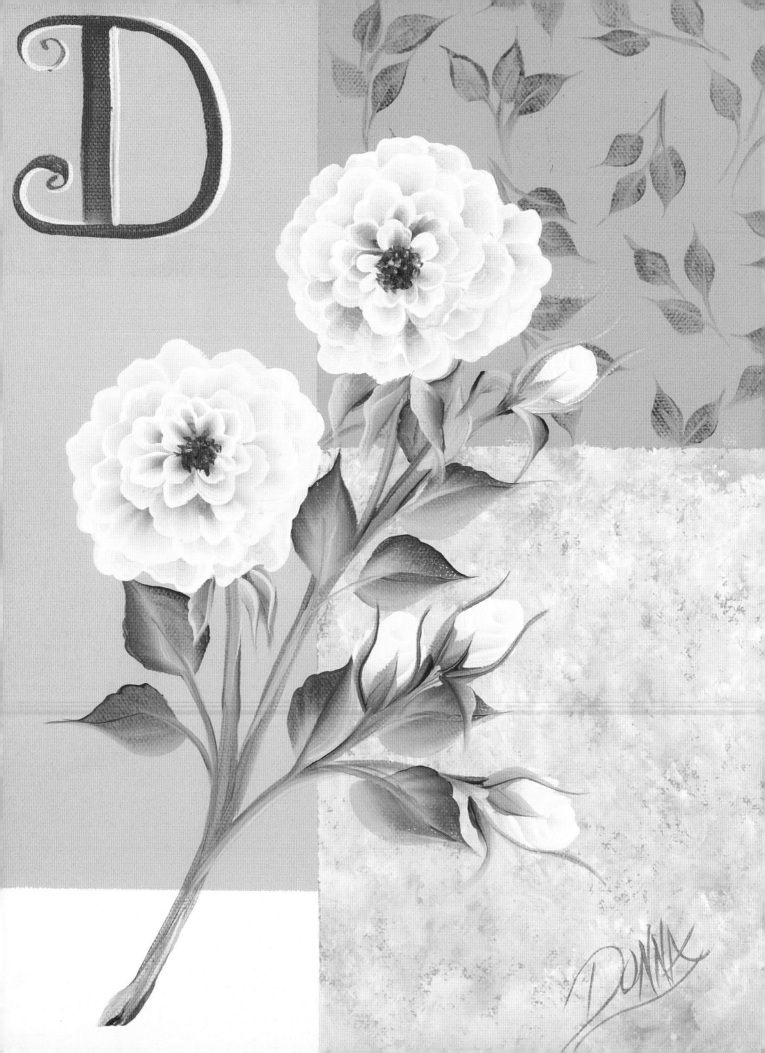

ENGLISH ROSE

brushes
no. 10 flat • no. 16 flat • no. 1 script liner

colors
Thicket • Soft Apple • Rose Pink • Wicker White
Peony • Berry Wine • Yellow Light

1. Create a Patchwork Squares background following the instructions in the techniques section, leaving off the stripes and polka dots. Let dry. Double-load a no. 16 flat with Thicket and Soft Apple and paint the stems and leaves. Add the flower stems and open calyxes with the same colors.

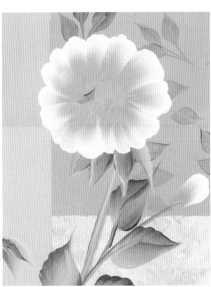

2. Double-load a no. 16 flat with Rose Pink and Wicker White and begin painting the upper back petal of the rosebuds and the outermost layer of the open rose. I placed the rose against the green patchwork square because it provides the most contrast to the white edges of the rose petals.

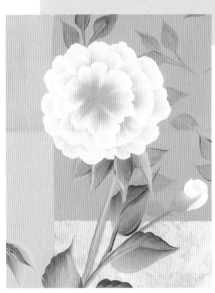

3. With the same brush and colors, continue painting the second and third layers of the open rose, and add the front petal (a U-stroke) to the upper rosebud.

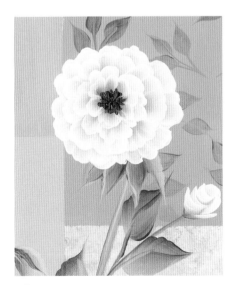

4. To shade and add depth to the rose center, double-load a no. 10 flat with Rose Pink and Wicker White, plus a little Peony on the Rose Pink side. Paint the centermost petals of the rose and the final petals of the bud. Load a no. 1 script liner with Berry Wine and pull little stamen strokes out from the center of the open rose.

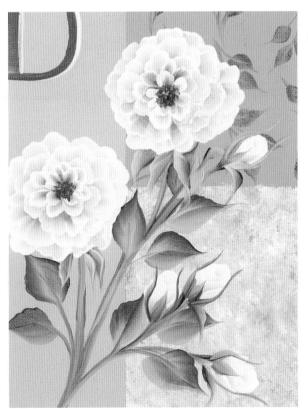

5. Following steps 2–4, paint the lower rose and finish the lower rosebud petals. With Yellow Light on a no. 1 script liner, add little pollen dots to the stamens of the open roses. Double-load a no. 10 flat with Thicket and Soft Apple and stroke calyxes over all the rosebuds. If you wish to add a monogram to your design, find a lettering stencil you like and trace the letter onto the upper left corner patchwork square. Paint it with Peony and outline with Wicker White.

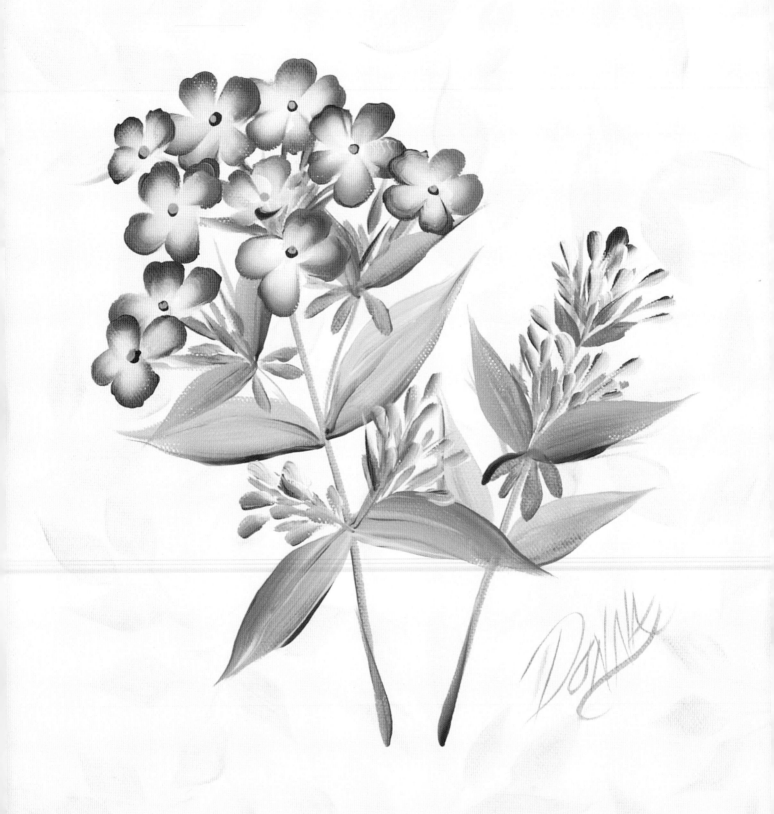

GARDEN PHLOX

brushes

no. 12 flat

colors

Thicket • Wicker White

Yellow Citron • Magenta

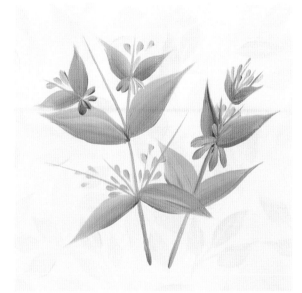

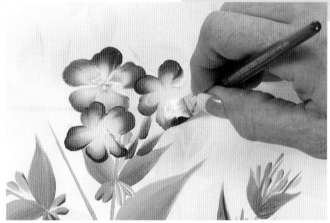

2. Double-load Magenta and Wicker White on a no. 12 flat and paint the five-petal florets, keeping the Magenta to the outside edges of the petals. Add a few little pink flower buds in among the fully open petals.

1. Create a Shadow Leaves background following the instructions in the techniques section. The sponged background colors are Wicker White and Violet Pansy, and the shadow leaves are Wicker White and Light Lavender. Let the background dry. To paint the phlox leaves and pods, double-load a no. 12 flat with Thicket and Wicker White and pick up a little Yellow Citron on the white side. Paint the stems first for placement, then the large leaves and little pods.

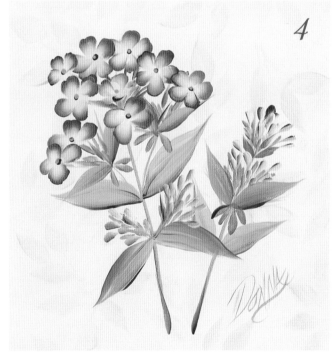

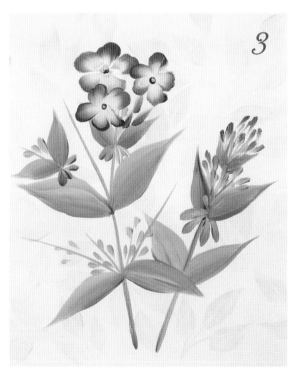

3. Using the same brush and colors, fill in the buds on the lower right stem with little comma strokes and chisel-edge petal strokes. Dot in the centers of the open petals with Magenta, then highlight the center dots with smaller dots of Yellow Citron.

4. Continue filling in with more flower buds and open florets. Be sure to layer the five-petal flowers by overlapping the florets. Keep the Magenta to the outside, and dot in the centers with Magenta, then highlight with Yellow Citron.

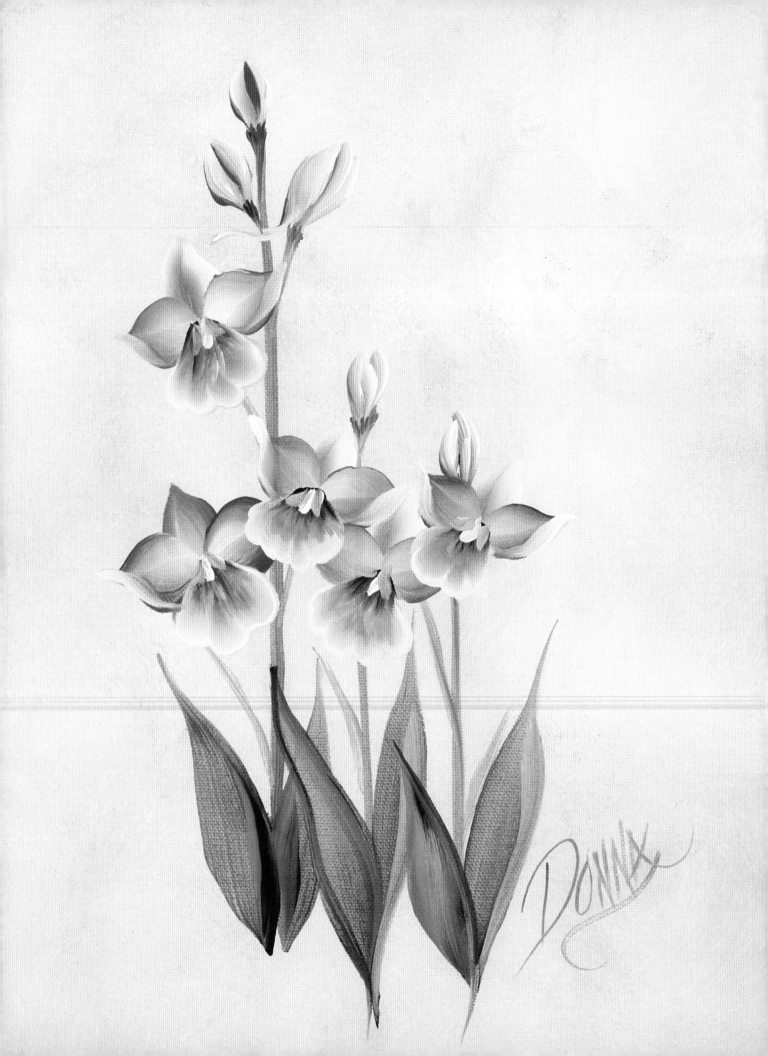

brushes

no. 8 flat • no. 16 flat

colors

Thicket • Fresh Foliage • Dioxazine Purple
Wicker White • Violet Pansy • Yellow Light

1. Create a Tone-on-Tone background using Butter Pecan and Wicker White. Let dry. Double-load Thicket and Fresh Foliage on a no. 16 flat. Place the tall stems and the smaller stems branching off. Paint long thin leaves at the base of the stems starting on the chisel; touch, push down on the bristles and slide, then lift back up to the chisel.

2. Double-load a no. 16 flat with Dioxazine Purple and Wicker White. Occasionally pick up a little Violet Pansy on the purple side for variation. Stroke in the buds with three or four side-by-side comma strokes. Add a little tail to the largest bud with Yellow Light and Wicker White.

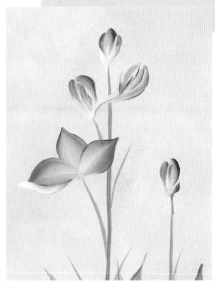

3. Double-load a no. 16 flat with Dioxazine Purple and Wicker White and stroke the three back petals of the open blossom.

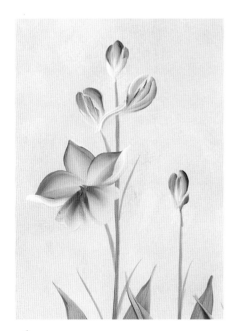

4. With the same brush and colors, paint the lower petals using a shell stroke for each petal.

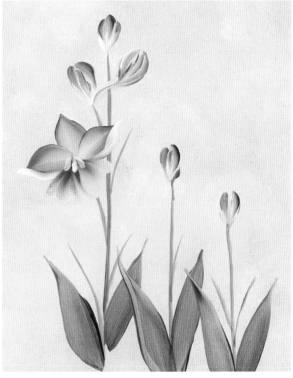

5. Double-load a no. 8 flat with Yellow Light and Wicker White and paint three yellow stamens in the center of the open blossom. Go over the middle stamen with Wicker White. To finish your larkspur composition, add four more open blossoms below the two buds on the right. Before painting the stamens, shade the centers if needed with chisel-edge streaks of Dioxazine Purple.

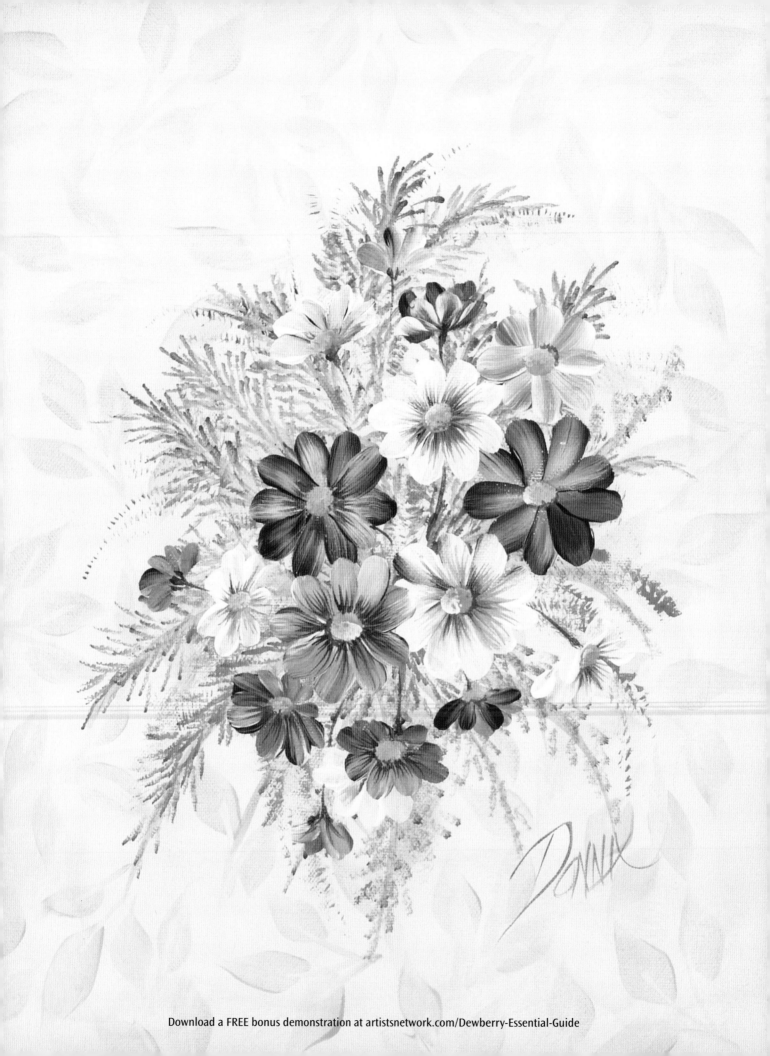

COSMOS

brushes

no. 12 flat • no. 8 filbert

¼-inch (6mm) scruffy • no. 2 script liner

colors

Fresh Foliage • Thicket • Yellow Citron

Magenta • Wicker White • School Bus Yellow

Yellow Light

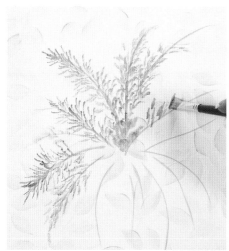

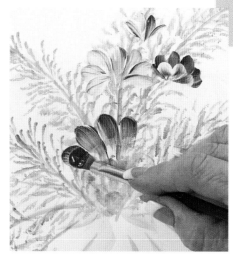

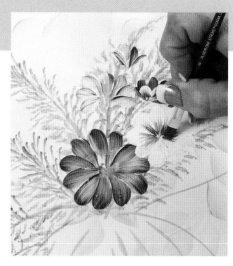

1. Create a Shadow Leaves background following the directions in the techniques section and using Fresh Foliage and Wicker White for the background and shadow leaves. Let dry. Double-load a no. 12 flat with Fresh Foliage and Thicket and pull light curving stems radiating outward from the center. Stay up on the chisel edge to keep your stems thin and delicate. Re-load your brush, picking up a little Yellow Citron on the lighter green side of the brush. The little feathery leaves are tapped on with the chisel edge, angled upward along the stems.

2. Double-load a no. 8 filbert with Magenta and Wicker White. Start with the sideview buds at the top of the bouquet. To get the color variations, flip the filbert brush over so the Magenta is on the other side and paint the front petals of the buds. Using the same brush and colors, start with the back petals of the large pink cosmos, pulling each petal toward the center.

3. Finish the pink cosmos petals, pulling each one toward the center and turning your surface as you go to make painting easier. The white cosmos is painted the same way, using Wicker White on a no. 8 filbert. Load a no. 12 flat with Magenta and pull some chisel-edge streaks out from the center to shade and detail the petals.

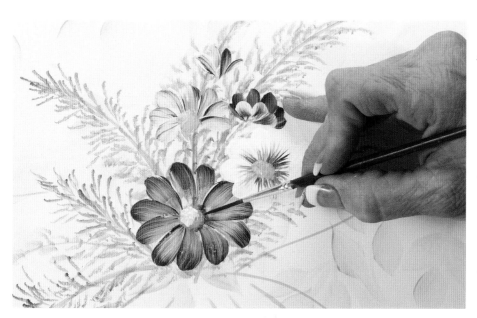

4. Double-load a ¼-inch (6mm) scruffy with School Bus Yellow and Yellow Light, plus a touch of Wicker White. Pounce on the flower centers. Go back and pick up a little more Wicker White on the scruffy and pounce a highlight on one side of the flower centers. Shade the opposite side of the flower centers with Thicket on a no. 2 script liner. To finish your cosmos bouquet, add several more open blossoms and sideview buds here and there, allowing the feathery green leaves and stems to show through. Vary your petal colors by picking up either more Magenta or more Wicker White on your no. 8 filbert. Don't forget to pull streaks out from the flower centers using the chisel edge of your flat brush.

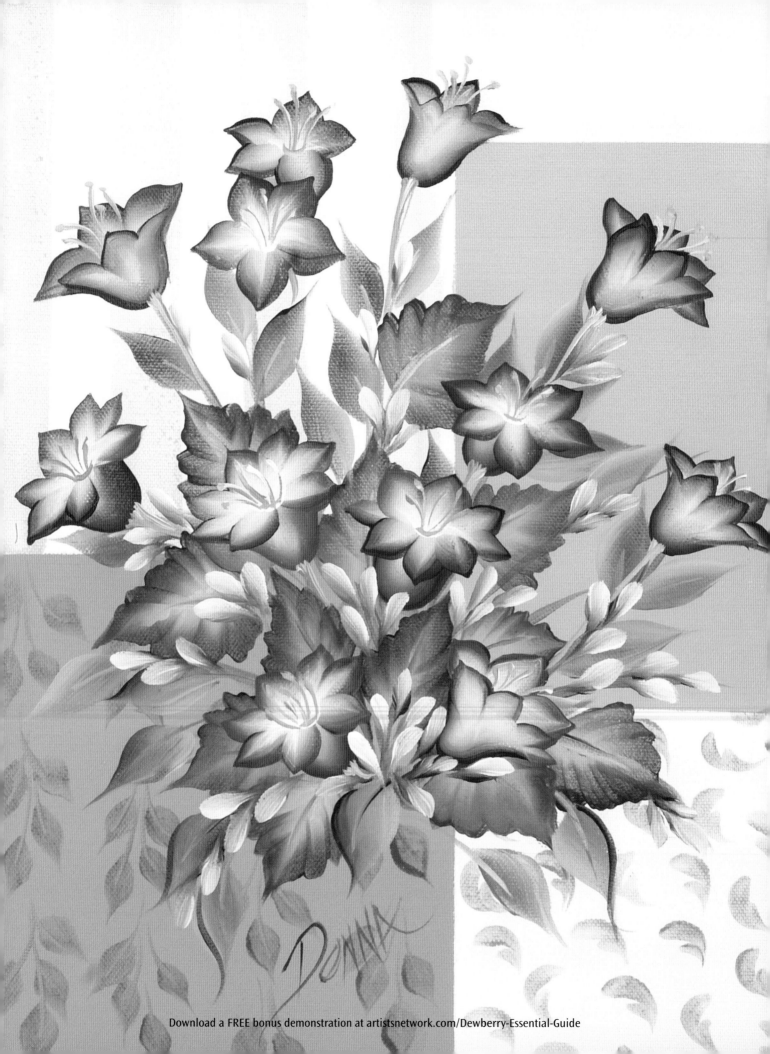

BELLFLOWER

brushes

no. 12 flat • no. 16 flat • no. 2 script liner

colors

Thicket • Fresh Foliage • Wicker White
Violet Pansy • Yellow Light

1. Create a Patchwork Squares background following the directions in the techniques section. The colors for this background are Linen, Wicker White and Basil Green. Let dry. Double-load a no. 16 flat with Thicket and Fresh Foliage, plus a little Wicker White occasionally. Paint the stems and the smaller one-stroke leaves.

2. With the same brush and colors, paint the larger wiggle-edge leaves, keeping the Thicket to the outside. Pull stems partway into the centers of the leaves.

3. Double-load a no. 12 flat with Violet Pansy and Wicker White. Begin painting the petals of the bellflowers, keeping the Violet Pansy to the outside. Begin with large C-strokes for the base, then add the pointed petal edges.

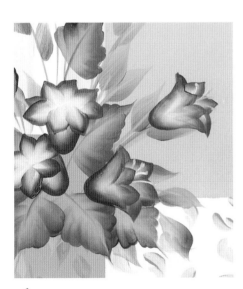

4. In the sideview blossoms, paint little stamens with Fresh Foliage and Wicker White on a no. 2 script liner. Dot the ends with Yellow Light. Double-load a no. 12 flat with Violet Pansy and Wicker White. Paint the top petals of the trumpet shape on each bellflower facing toward you.

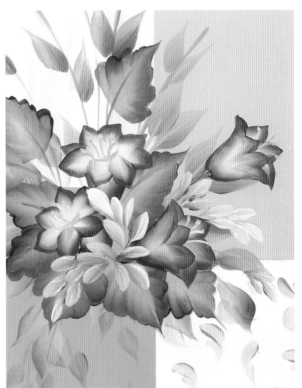

5. Using the same brush and colors, stroke in a lot of little buds to fill in among the bellflowers. Use a daisy-petal touch-and-pull stroke, leading with the Violet Pansy side of the brush. Finish with stamens of Fresh Foliage and Wicker White on a no. 2 script liner. Dot the ends with Yellow Light.

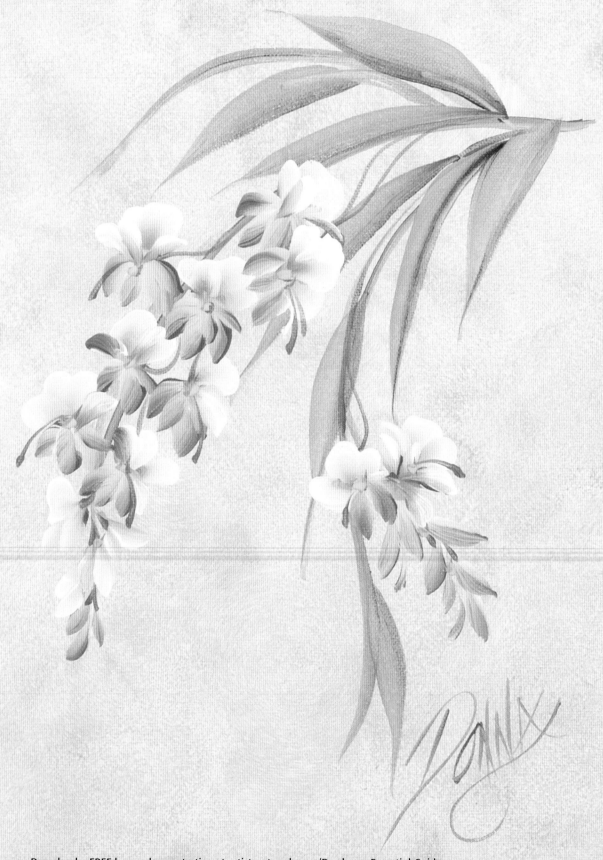

WISTERIA

brushes

no. 12 flat • no. 16 flat

colors

Thicket • Fresh Foliage • Heather

Wicker White • Violet Pansy • Yellow Light

1. Start with an Antiqued background following the directions in the techniques section. Let dry. Double-load a no. 16 flat with Thicket and Fresh Foliage and pick up some floating medium. Paint the long stems originating from the upper right corner, and add some smaller stems coming off the main ones. Paint the long thin leaves starting at the base on the chisel edge. Press down on the bristles to widen, then slide and lift back up to the chisel. Keep the leaves airy—let the background show through among the leaves and stems.

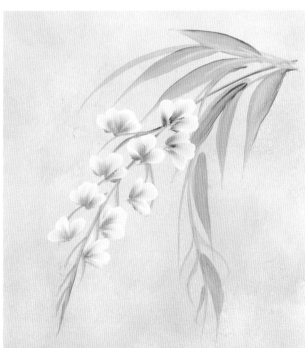

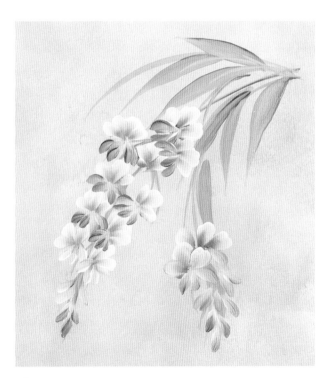

2. Double-load a no. 12 flat with Heather and Wicker White and paint all the back petals of the wisteria blossoms, occasionally picking up Violet Pansy. These little petals are made up of three, four or five small comma strokes or daisy-petal strokes side by side. Touch, lean the bristles in the directions you're painting, and lift to the tip. Don't turn your brush—make sure the Wicker White side is always to the outside edge of the petals.

3. With the same brush and colors, add the front petals, stroking toward the center. Again, pick up Violet Pansy on the Heather side of the brush every once in a while for color variations in the petals. Add the hanging buds with single comma strokes. To finish, dot in the flower centers with Yellow Light, and chisel edge some small skinny buds with Fresh Foliage. Add a couple more leaves to fill in around the wisteria blossoms if needed.

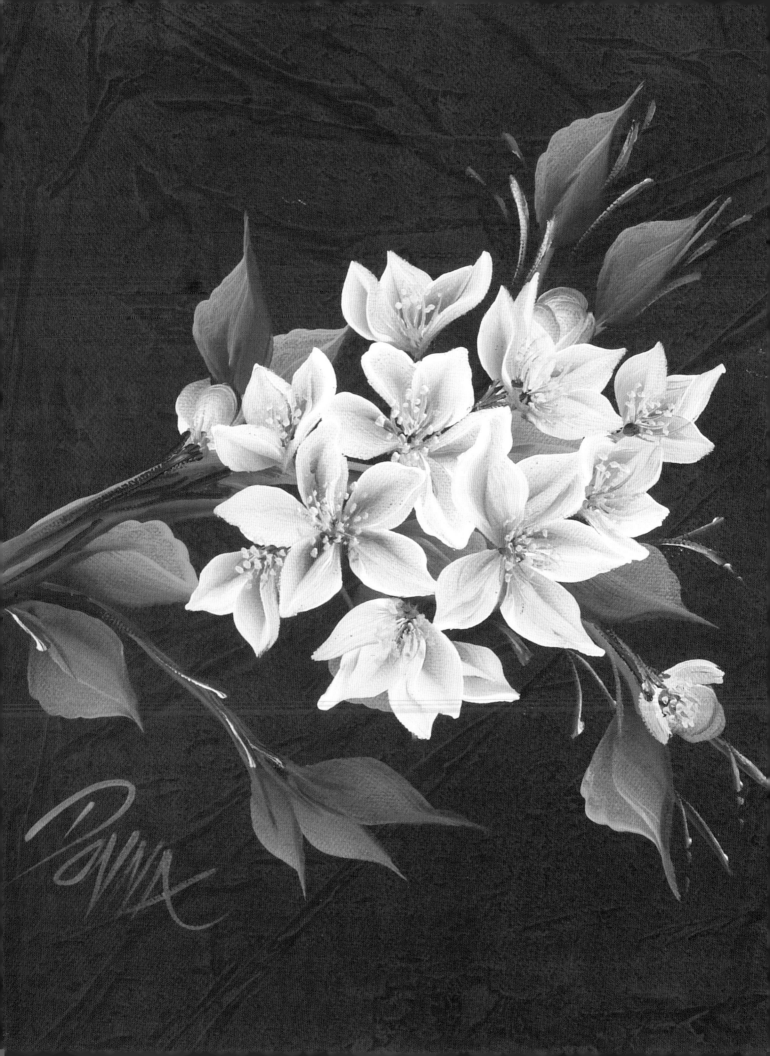

APPLE TREE BLOSSOMS

brushes

no. 12 flat • no. 16 flat • no. 2 script liner

colors

Burnt Umber • Wicker White

Thicket • Fresh Foliage • Magenta

Soft Apple • Yellow Light

1. Begin by creating a Faux Leather background following the directions in the techniques section. Let dry completely. Double-load a no. 16 flat with Burnt Umber and Wicker White and paint the branches of the apple tree. The leaves are painted with Thicket and Fresh Foliage double-loaded on a no. 16 flat. The larger leaves have one wiggle side and one smooth side. The smaller leaves are one-stroke leaves.

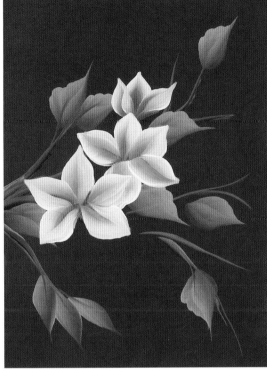

2. Double-load a no. 12 flat with Magenta and Wicker White. Begin painting the apple blossom petals. These are all pointed single-stroke petals. Keep the Magenta side of the brush toward the center of the petals. With the same brush and colors, paint the three petals of the sideview blossom in back.

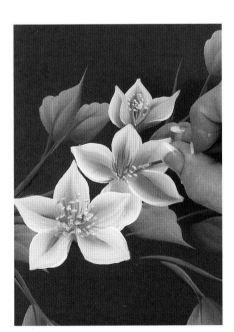

3. Load a no. 2 script liner with inky Thicket, then stroke through a little Soft Apple on your palette. Paint the stamens, then dot the anthers with Yellow Light and Wicker White.

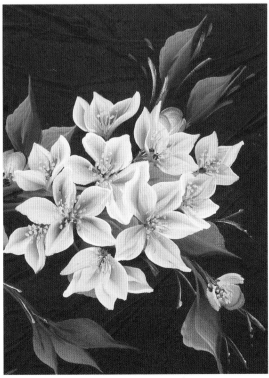

4. Continue painting apple blossoms to fill out the cluster on the branch. Load a no. 2 script liner with inky Burnt Umber, then stroke through Wicker White on your palette. Paint the tiny twigs extending out from the branches, filling in around the leaves as needed.

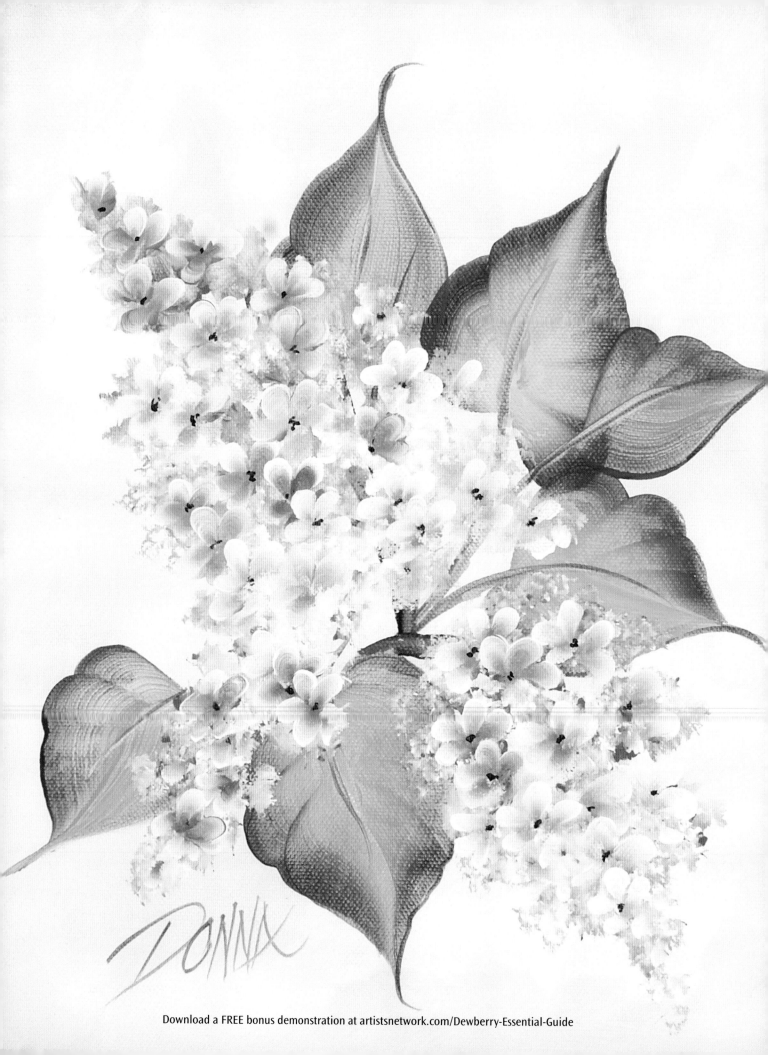

LILAC

brushes

no. 10 flat • ¾-inch (19mm) flat

¾-inch (19mm) scruffy • no. 2 script liner

59

colors

Thicket • Fresh Foliage

Burnt Umber • Wicker White

Violet Pansy • Dioxazine Purple

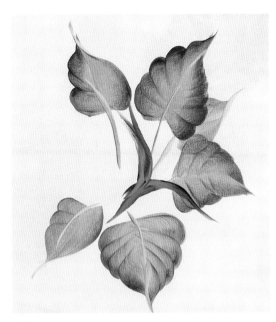

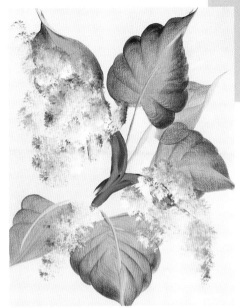

1. Create a Sky and Clouds background following the instructions in the techniques section. Let dry. Paint the stems and leaves with Thicket and Fresh Foliage double-loaded on a ¾-inch (19mm) flat. Add a few tree branches among the leaves with Burnt Umber and Wicker White on a no. 10 flat.

2. Establish the general shape of the lilacs using a ¾-inch (19mm) scruffy double-loaded with Violet Pansy and Wicker White. Lilac blossoms are wider at the stem and narrow down to a point at the end.

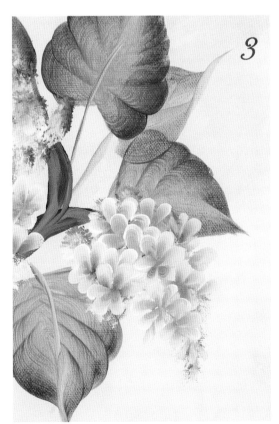

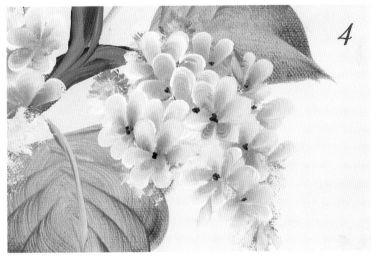

3. Lilac blossoms are large clusters of individual petals or florets that are painted right over the shapes you pounced on in step 2. Double-load a no. 10 flat with Violet Pansy and Wicker White and begin painting the individual five-petal florets, overlapping them as shown. As you approach the bottom tip, load more Wicker White on your brush to make the petals a little lighter in color.

4. The flower centers are inky Dioxazine Purple dotted on with a no. 2 script liner.

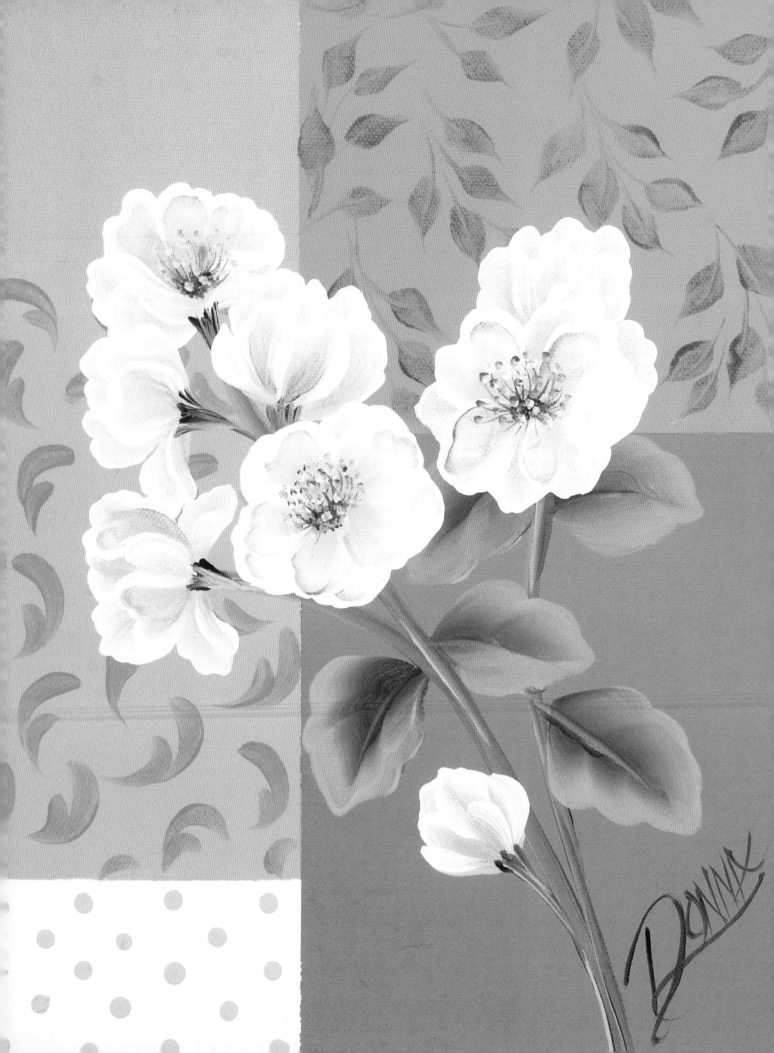

PEAR TREE BLOSSOMS

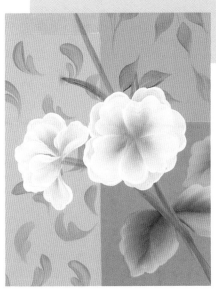

1. Create a Patchwork Squares background following the instructions in the techniques section, leaving off the stripes. Let dry. Double-load a no. 16 flat with Thicket and Soft Apple and paint the stems and leaves. Keep the Soft Apple to the outsides of the leaves.

2. Load a no. 16 flat with Wicker White and side-load into just a touch of Thicket. Pear blossoms are white but you need a bit of color for shading and depth. Paint the sideview blossom and the outer layer of the open blossom.

3. With the same brush and colors, continue painting the next layer of the open blossom, making it a little smaller than the first layer. Add the lower petals to the sideview blossom. Keep the Wicker White to the outside so the green shades the center.

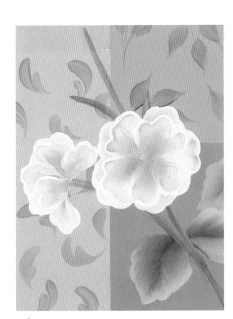

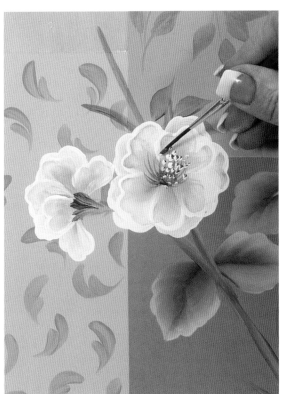

5. Paint the base of the sideview blossom where it connects to the stem with Thicket and Soft Apple on a no. 10 flat. For the centers of the open blossoms, load a no. 2 script liner with inky Thicket and dot the centers, then pull fine curving lines outward for the stamens. Stroke the liner through Wicker White, dip the tip into Magenta, and dot the ends of the stamens. To finish your pear blossom painting, add more open and sideview blossoms and a bud lower down on the branch. Use your brush handle to add Soft Apple polka dots to the lower left patchwork square.

4. To shape the outer edges of the petals and make them seem as if they are curling upward, float shading around the inner edge of each petal by loading a little more Thicket onto your no. 10 flat. See the techniques section for complete instructions on how to float-shade a flower petal.

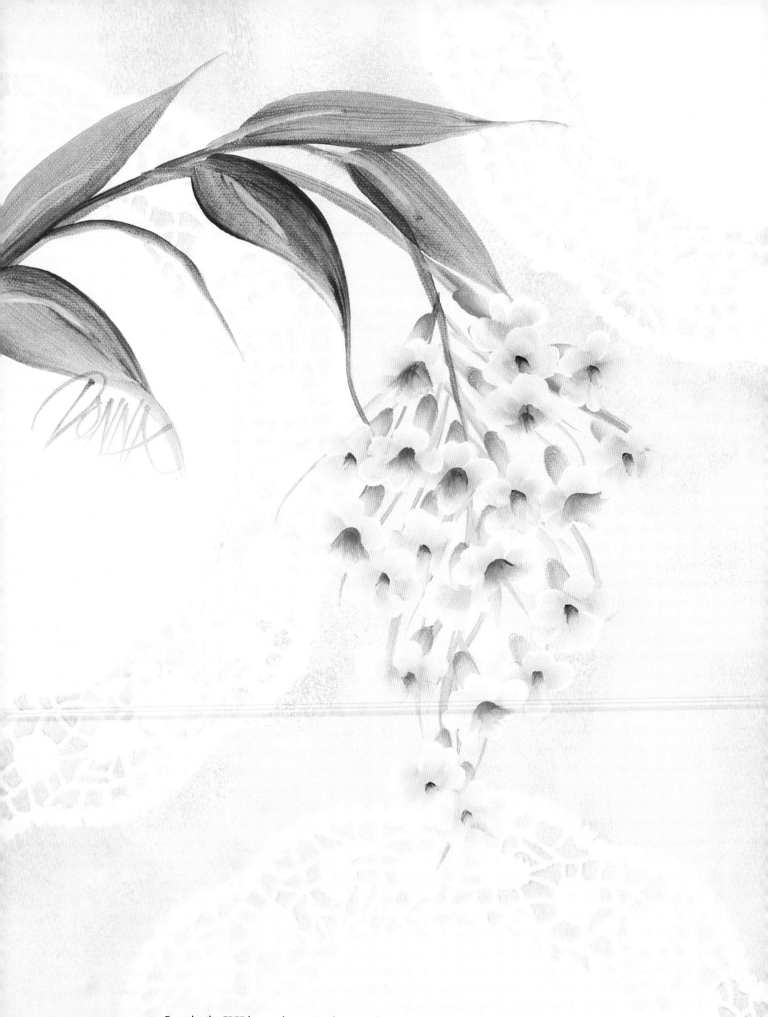

brushes

¾-inch (19mm) flat • no. 10 flat

colors

Fresh Foliage • Burnt Umber • Heather
Wicker White • Dioxazine Purple

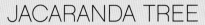

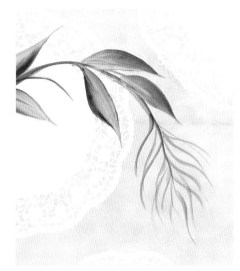

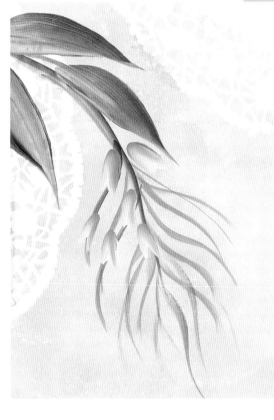

2. Jacaranda blossoms are clusters of little trumpet-shaped flowers. Double-load a no. 10 flat with Heather and Wicker White and paint the trumpet-shaped base of each flower using a tight C-stroke.

1. The background for the jacaranda tree is the Lace Paper Doily. Follow the instructions in the techniques section but change the colors to Linen and Wicker White. Let dry. Double-load a ¾-inch (19mm) flat with Fresh Foliage and Burnt Umber. Paint the long, curving main stem and large leaves. Pick up Fresh Foliage on your dirty brush and add the finer hairlike stems at the end.

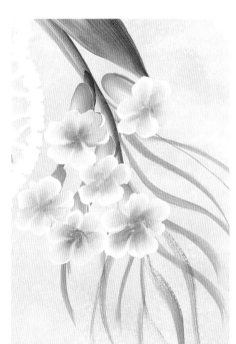

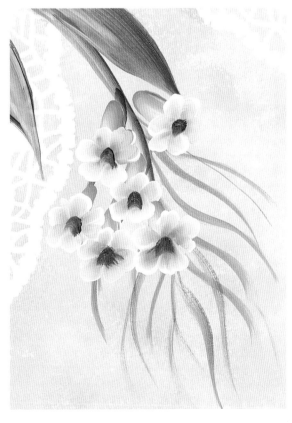

4. Load a no. 10 flat with Dioxazine Purple and shade the throats of the blossoms with a little open C-stroke. Pull out some tiny chisel-edge streaks on a few of the petals.

3. With the same brush and colors but picking up a little more Wicker White, paint the ruffled-edge petals that overlay the trumpet-shaped base at the top.

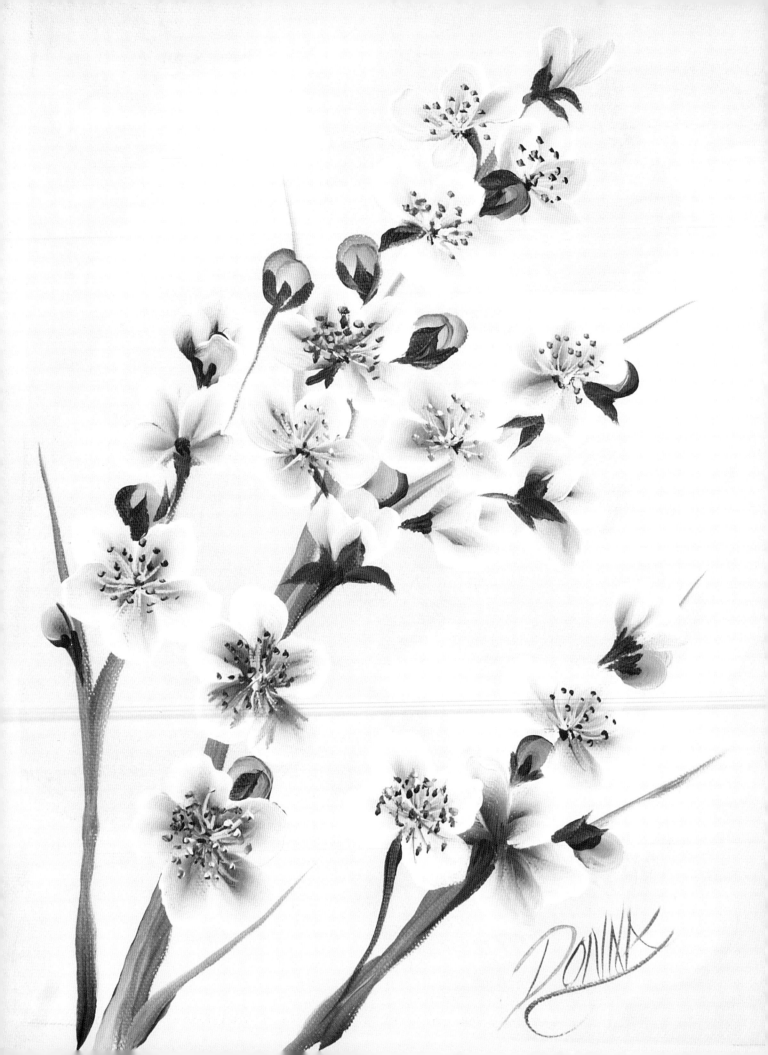

CHERRY TREE BLOSSOMS

brushes

no. 8 flat • no. 12 flat • no. 16 flat

no. 2 script liner

colors

Burnt Umber • Butter Pecan • Wicker White

Peony • Berry Wine • Yellow Light

1. Create a Sky and Clouds background following the directions in the techniques section. Let dry. Double-load Burnt Umber and Butter Pecan on a no. 16 flat. Pick up Wicker White to highlight. Paint the main tree branches and the smaller ones branching off, using the chisel edge of the brush. Cherry trees blossom before their leaves come out, so there are no leaves to paint!

2. Double-load a no. 12 flat with Peony and Wicker White. Begin with the open petals. These are painted like a pointed single-stroke petal, but the tips are rounded instead of pointed. Keep the Wicker White to the outside as you stroke these petals. Stroke in the buds with two or three overlapping comma strokes, turning the brush so the Peony is now on the outside. Load a no. 8 flat with Berry Wine and stroke some calyxes over the bud.

3. Continue painting buds and open blossoms down the branch. Shade the centers using the chisel edge of the no. 8 flat and Peony. Pull the calyxes with Berry Wine.

4. Load a no. 2 script liner with Wicker White and pull fine curving lines out from the centers for stamens. Pick up Berry Wine on the liner and dip into Yellow Light. Dot on the anthers and pollen dots.

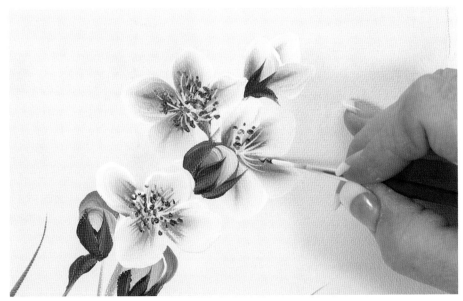

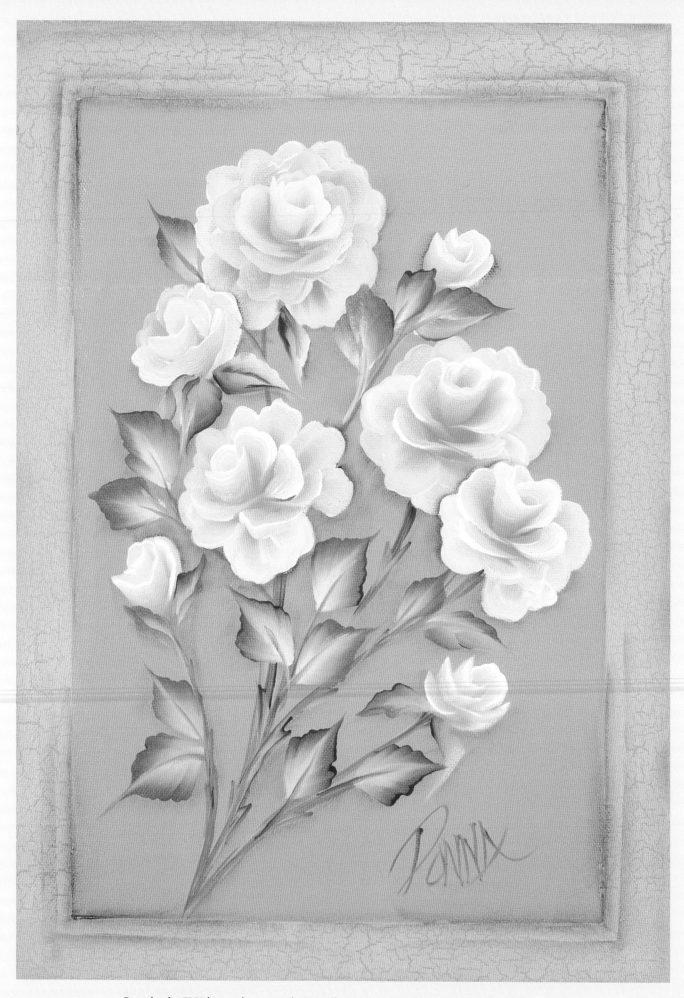

CLIMBING ROSE

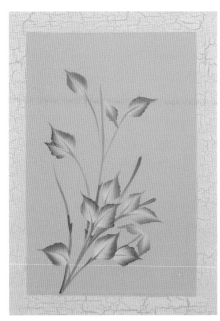

1. Create a Crackled Frame background following the directions in the techniques section. Here, the background center is Basil Green and the crackled frame is Linen. Let dry. Double-load a no. 16 flat with Thicket and Sunflower and paint the stems and leaves, keeping the Thicket to the outside. If you prefer lighter leaves, pick up a little Wicker White on the Sunflower side.

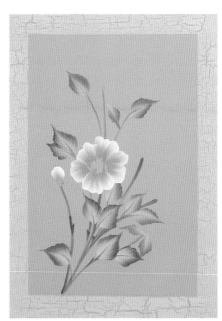

2. To begin the roses, double-load a no. 16 flat with Yellow Ochre and Wicker White (for lighter roses) or Yellow Ochre and Yellow Light (for bright yellow roses). Blend well on your palette. Start with the outer skirt of petals on the open rose and the back petal of the little rosebud (this is a C-stroke).

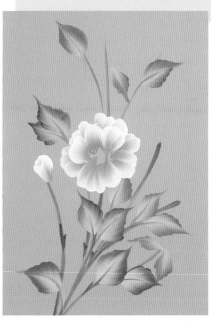

3. With the same brush and colors, add the side petals to the open rose and the front petal to the bud (this is a U-stroke).

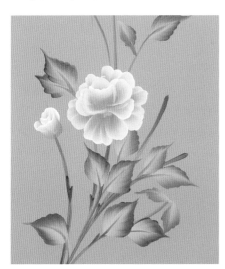

4. Paint the center bud in the open rose, then pull more side petals and petals that are starting to open out from the center. Add another layer of petals to the rosebud.

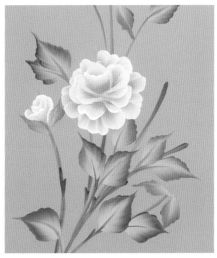

5. Fill in the rest of the petals on the open rose. Paint a calyx over the base of the rosebud with Thicket and Sunflower on a no. 10 flat.

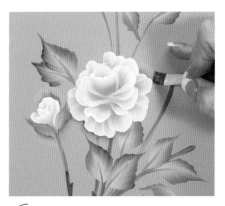

6. Load a no. 10 flat with floating medium, then side-load into a little Thicket. Float shading underneath and around the roses to separate them from the background. To finish, fill in with more leaves if needed in the spaces between the roses. To add dimension to the crackled frame, float-shade Thicket in the four corners of the frame.

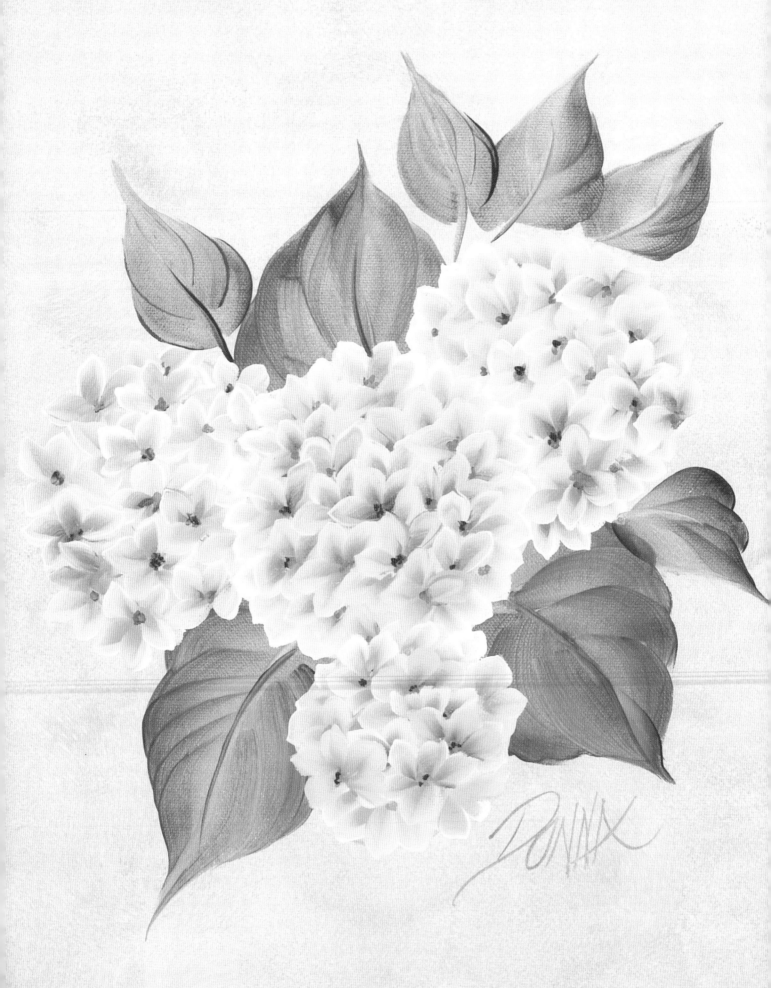

HYDRANGEA

brushes

no. 10 flat • ¾-inch (19mm) flat

no. 2 script liner

colors

Fresh Foliage • Thicket

Magenta • Wicker White

1. Create an Antiqued background following the directions in the techniques section. Let dry completely. Double-load a ¾-inch (19mm) flat with Fresh Foliage and Thicket. Paint the large ruffled-edge leaves and the smaller smooth-sided leaves in a roughly circular pattern as shown. As you reload your brush with color, dip into floating medium often to smooth out your strokes. Pull stems into the leaves using the chisel edge of the brush.

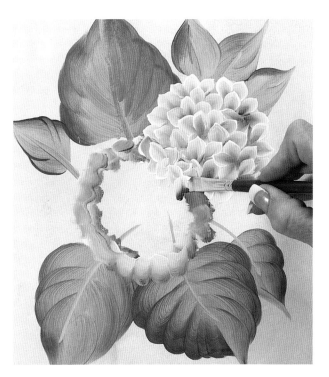

2. Hydrangeas have large round flowerheads that are clusters of smaller florets. Double-load a no. 10 flat with Magenta and Wicker White. Keeping the Wicker White to the outside, paint four-petal florets that have a somewhat pointed tip. Overlap the florets as you go to create a ball-shaped cluster. Vary the petal colors by picking up more Magenta sometimes, and more Wicker White other times.

3. For the foreground cluster, using the same brush and colors, dab in a circular shape for placement. Begin painting individual florets to fill in around the circle, then work inward toward the center. To finish, add a couple more clusters to fill out the design. Vary the sizes of your flowerheads for interest. In the finished painting, the lower cluster has a few florets that are tinged green with a little bit of Fresh Foliage; as hydrangea blossoms age, their petals turn more green. Dot in the centers of the florets with Fresh Foliage on a no. 2 script liner, picking up a little Magenta for some of them.

BUTTERFLY BUSH

brushes
no. 10 flat • no. 16 flat • no. 2 script liner

¾-inch (19mm) scruffy

colors
Thicket • Fresh Foliage • Burnt Umber

Dioxazine Purple • Wicker White • Violet Pansy

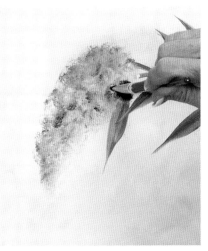

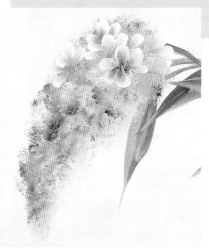

1. Create a Sky and Clouds background following the directions in the techniques section. Let dry. Double-load a no. 16 flat with Thicket and Fresh Foliage, plus a little Burnt Umber. Paint the stems and the long, slender leaves.

2. Pounce on the general shape of the blossom with a ¾-inch (19mm) scruffy double-loaded with Dioxazine Purple and Wicker White. Pick up a little Violet Pansy occasionally on the purple side of the scruffy for color variation. Don't overblend—leave some areas dark and some almost white.

3. Double-load a no. 10 flat with Violet Pansy and Wicker White. Begin painting the individual florets, keeping the Wicker White to the outside. Leave some open spaces between the florets so the background colors show through. To vary the colors of the florets, pick up some Dioxazine Purple sometimes, and more Wicker White other times.

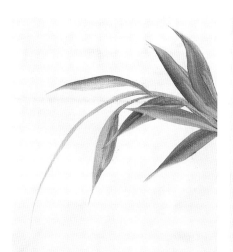

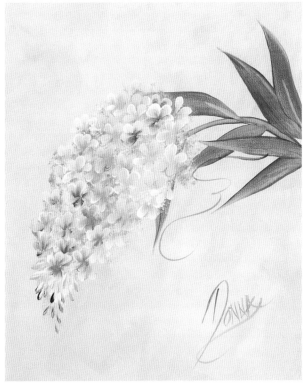

5. Using the same brush and colors, stroke in a lot of little five-petal florets to fill in the blossom. Remember to vary the colors you pick up on your brush as you did in step 3. Finish with a couple of curlicues or tendrils using inky Fresh Foliage on a no. 2 script liner.

4. The blossoms of the butterfly bush come to a point at the bottom where the buds are forming. To paint the buds, chisel edge little teardrop strokes extending downward from the main part, using a no. 10 flat double-loaded with Dioxazine Purple and Wicker White.

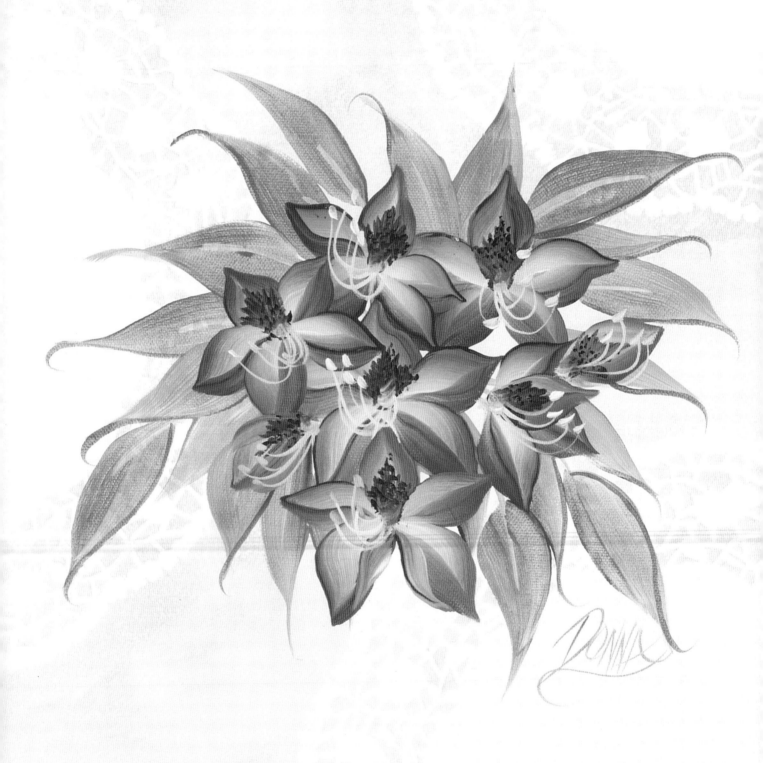

RHODODENDRON

brushes

no. 10 flat • no. 16 flat • no. 2 script liner

colors

Thicket • Yellow Citron • Magenta
Wicker White • Dioxazine Purple • Yellow Light

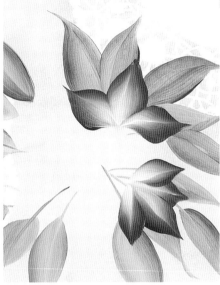

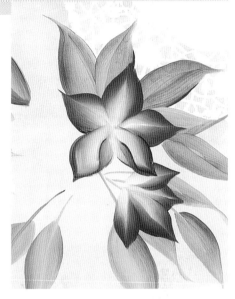

1. Create a Lace Paper Doily background following the directions in the techniques section, but using Linen and Wicker White. Let dry. Double-load a no. 16 flat with Thicket and Yellow Citron. The long slender leaves are placed in a somewhat circular design to echo the roundness of the doilies. To paint these leaves, start at the base, push down on the bristles, slide and turn the brush to make half the leaf with a long tip. Then push, slide and turn to connect the second half of the leaf to the first.

2. Double-load a no. 16 flat with Magenta and Wicker White and begin to paint the rhododendron petals. Start at the base of the petal on the chisel, lay the bristles down, slide out and then lift to the pointed tip. Without lifting your brush off the surface, slide back down to the base. Keep the Magenta side of the brush to the outside of the petals. Make some of your petals wider, and some a little narrower.

3. Add the two front petals on the open blossom. Note that the edges of these petals are rolled on one side. As you slide your brush back down to the base, turn it so the Magenta side curves inward toward the center.

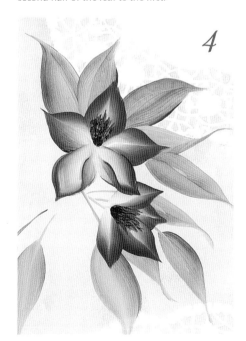

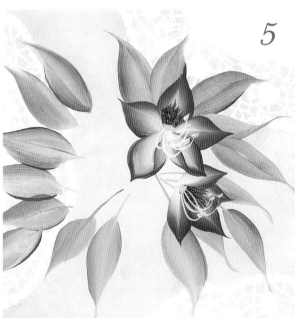

4. Darken the throat with little chisel-edge strokes pulled upward from the center, using a no. 10 flat and Magenta. Pick up Dioxazine Purple and dot over the centers.

5. Load a no. 2 script liner with inky Wicker White and pull long curving stamens outward from the center. Dot on anthers with Yellow Light.

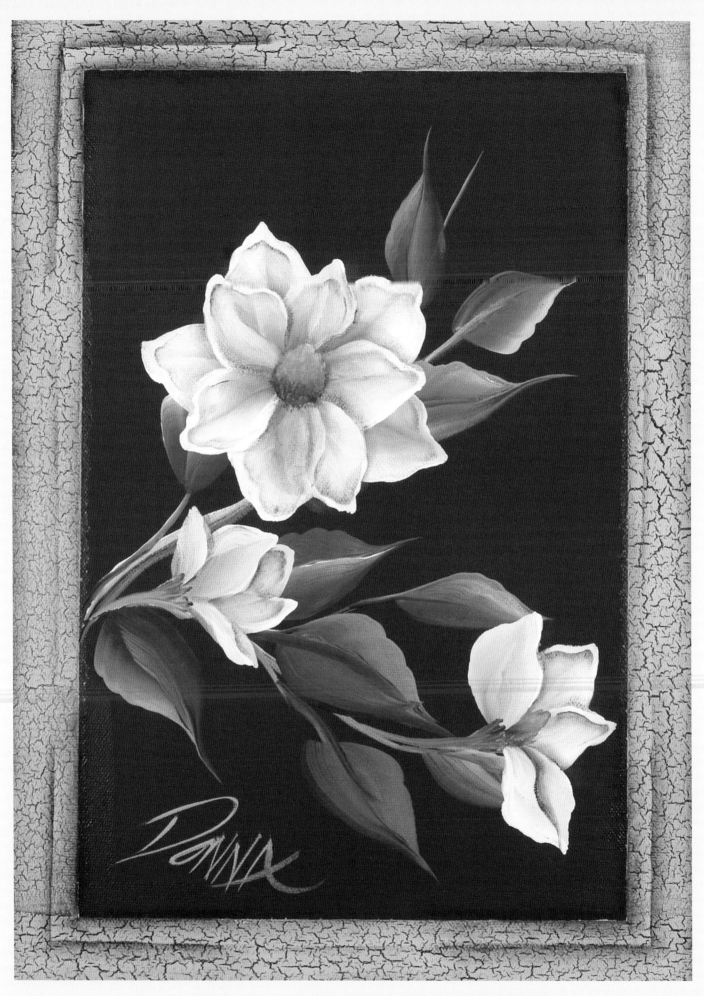

MAGNOLIA

brushes

no. 10 flat • no. 12 flat • ¾-inch (19mm) flat

colors

Burnt Umber • Wicker White

Thicket • Fresh Foliage • Butter Pecan

Yellow Ochre • Yellow Light

1. Create a Crackled Frame background following the directions in the techniques section. Here, the center color is Maple Syrup; the crackled frame is Linen. Let dry. Paint the branches with Burnt Umber and Wicker White on a ¾-inch (19mm) flat. Double-load the same flat with Thicket and Fresh Foliage, and work in some Burnt Umber on the Thicket side. Paint the leaves, keeping the Fresh Foliage to the outside.

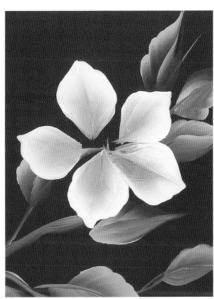

2. Load a ¾-inch (19mm) flat with Wicker White, side-load into a little Butter Pecan and dip the brush into floating medium. Begin the magnolia blossom with the outer layer of five large petals. Keep the Wicker White to the outside.

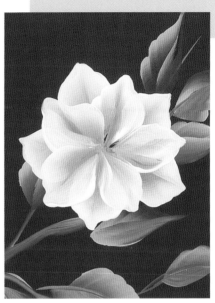

3. Using the same brush and colors, paint the second, slightly smaller layer of five petals, offsetting them from the first layer as shown.

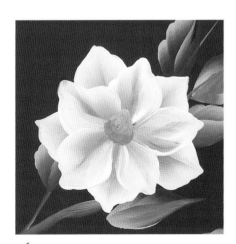

4. Double-load a no. 10 flat with Yellow Ochre and Yellow Light and tap in the cone-shaped center with the chisel edge of the brush.

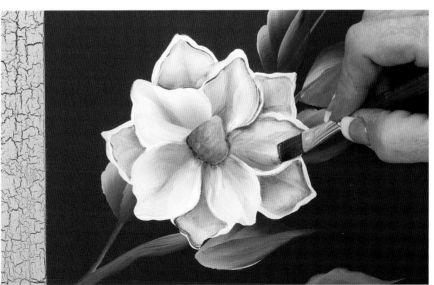

5. Load a no. 12 flat with floating medium, then side-load ever so slightly into Burnt Umber. Float shading around the center cone to separate it from the petals. Then float shading just inside the outer edges of the petals. To separate the lower layer of petals from the upper layer, float shading on the lower petals. To add shape and dimension to the crackled frame, load a ¾-inch (19mm) flat with floating medium and side-load into Burnt Umber. Float shading along the inside edge of the frame on all four sides, then float shading on the corners of the crackled frame itself.

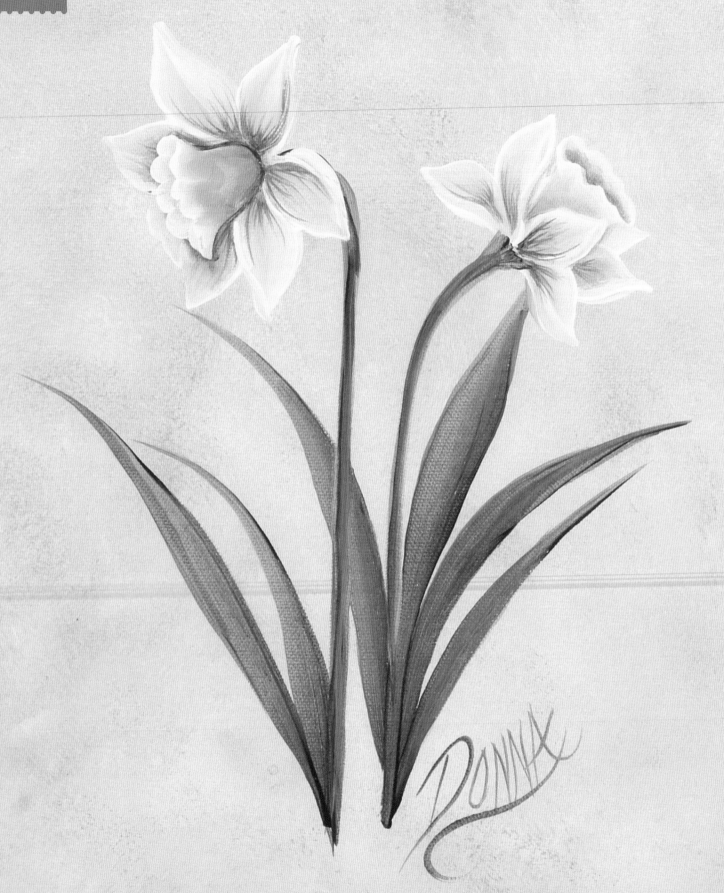

Donna

JONQUIL

brushes

no. 10 flat • no. 16 flat

colors

Thicket • Yellow Citron • Wicker White

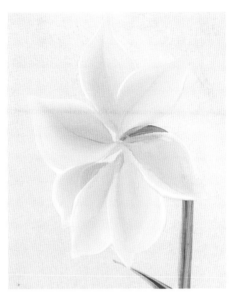

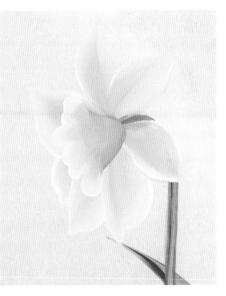

1. Begin by creating a Tone-on-Tone background following the directions in the techniques section. Let dry completely. Double-load a no. 16 flat with Thicket and Yellow Citron and paint the leaves first, then the long straight stems. At the tops of the stems, curve them over where they will connect to the base of the blossom.

2. Double-load a no. 16 flat with Yellow Citron and Wicker White. Paint the petals of the skirt, keeping the Wicker White to the outside. Begin each petal at the base, push down on the bristles, slide up to the tip lifting back up to the chisel, then slide back down again to the base.

3. Re-load the brush with the same colors, but pick up more Yellow Citron this time. Paint the back part of the center trumpet. This is a petal with a ruffled top edge. Keep the Wicker White side of the brush to the top ruffled edge of the petal.

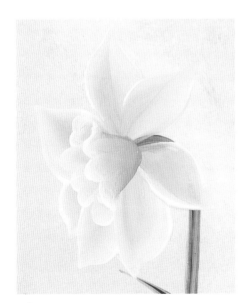

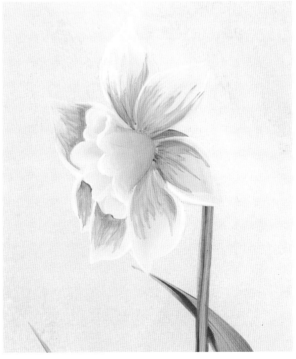

4. Paint the front part of the trumpet with the same colors. This is a smaller petal with a ruffled top edge.

5. Load a no. 10 flat with Thicket and chisel-edge some shading lines coming out from the base of the skirt petals. Work around the shape of the center trumpet. To finish, paint the second jonquil as more of a sideview blossom, using a no. 16 flat double-loaded with Yellow Citron and Wicker White. Again, keep the Wicker White to the outside edge of the petals and trumpet. Load a no. 10 flat with floating medium and side-load into Thicket. Float shading around the trumpet of the open blossom to separate it from the skirt petals. Also float shading in the inner part of the trumpet on the sideview blossom if needed.

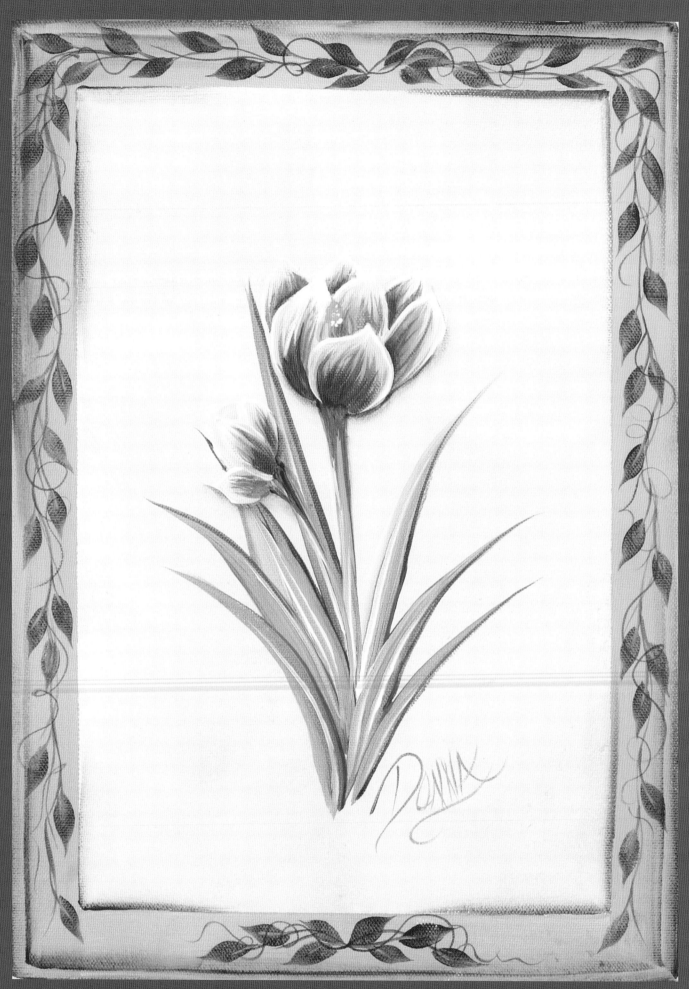

CROCUS

brushes

no. 2 flat • no. 16 flat • no. 2 script liner

colors

Thicket • Fresh Foliage • Wicker White

Violet Pansy • Yellow Light

School Bus Yellow • Maple Syrup

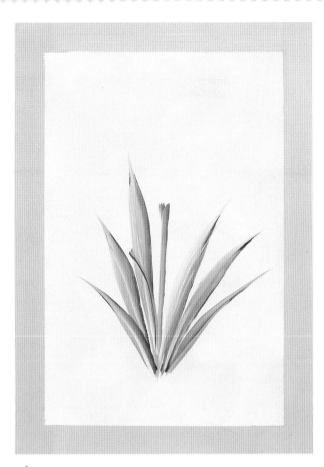

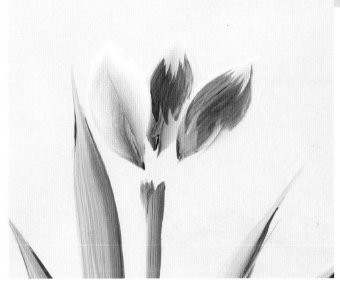

1. For the background, tape off the outer edges with 1-inch (25mm) painter's tape. Sponge on a soft blue in the center with Baby Blue and Wicker White. Remove the tape and let dry. Paint the frame with Butter Pecan. Let dry. Load a no. 16 flat with Thicket and Fresh Foliage on one side and Wicker White on the other. Paint the long pointed leaves first, then the stem. For variegated leaf colors, pick up more Wicker White for some of your strokes.

2. Double-load a no. 16 flat with Violet Pansy and Wicker White. To paint the back three crocus petals, begin at the base of the petal, stroke up to the pointed tip, then slide back down to the base. Load the brush with inky Violet Pansy and add streaks using the chisel edge of the brush.

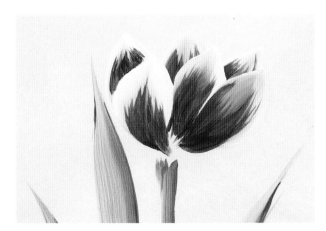

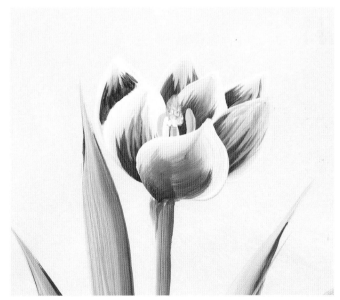

3. The next three petals are painted the same way as the step 2 petals, with Violet Pansy and Wicker White on a no. 16 flat. Chisel-edge the streaky lines with inky Violet Pansy.

4. The center stamens are tapped on with Yellow Light and School Bus Yellow on a no. 2 flat. Let these dry, then paint the final front petal. To finish the frame, float shading in the four corners using floating medium and Maple Syrup. With the same brush, paint shadow leaves starting at the top center and coming down both sides. Finish with Maple Syrup tendrils using a no. 2 script liner.

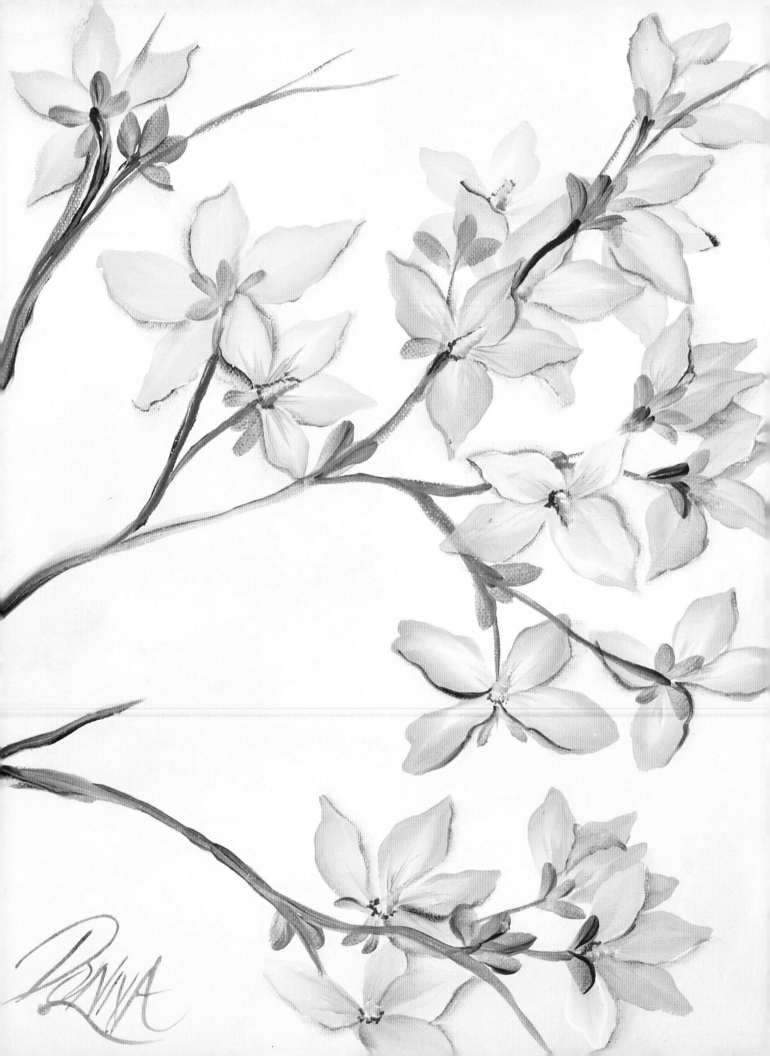

brushes
no. 2 flat • no. 10 flat • no. 12 flat

colors
Burnt Umber • Wicker White

School Bus Yellow • Yellow Light

Yellow Citron • Thicket • Yellow Ochre

1. Create a Sky and Clouds background following the instructions in the techniques section. Let dry. Double-load a no. 12 flat with Burnt Umber and Wicker White and paint the main forsythia branches, then the smaller branches coming off. Stay up on the chisel edge of the brush.

2. Forsythia shrubs blossom in the spring before their leaves come out. The little yellow blossoms are made up of tiny petals that open from buds that are all around and up and down each branch. Begin painting the pointed petals with a no. 12 flat multi-loaded with School Bus Yellow, Yellow Light and Wicker White.

3. Re-establish some of the small branches on top of a few of the blossoms. Chisel-edge some Yellow Citron shading in the centers of the petals.

4. Paint the little green sepals at the base of the petals with Thicket and Yellow Citron on a no. 10 flat. The little stamens in the centers are tapped on with a no. 2 flat using Yellow Light, Wicker White and a touch of Yellow Ochre. Shade the base of the stamen with Burnt Umber. To finish, continue adding blossoms all along the smaller branches. Vary them so some are fully open, some are seen from the side, and some are seen from the back. When all petals are painted, load a no. 10 flat with floating medium and side-load into Burnt Umber. Float shading all around each petal to separate it from other petals and from the background.

brushes

no. 12 flat • no. 10 filbert

colors

Yellow Citron • Thicket • Wicker White

School Bus Yellow • Yellow Light

Yellow Ochre • Periwinkle

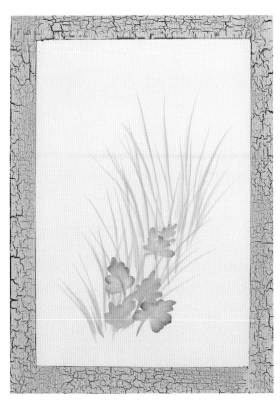

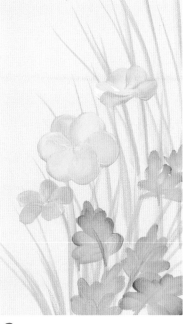

1. The background for the buttercups is the Crackled Frame. Follow the instructions in the techniques section, but change the colors to Baby Blue for the center, Maple Syrup for the frame's basecoat, and Linen for the crackled topcoat. Let dry. Double-load a no. 12 flat with Yellow Citron and Thicket, and pick up a little Wicker White on the yellow side. Paint the grass blades and leaves.

2. Double-load a no. 10 filbert with School Bus Yellow and Yellow Light, picking up some Wicker White on the Yellow Light side. (See the techniques section for directions on double-loading a filbert brush.) Paint the back petals of the buttercup, keeping the School Bus Yellow to the outside.

3. With the same brush and colors, paint the front petals. Buttercups face upwards from the grass in spring, so paint the petals in the back a little longer than the ones in front.

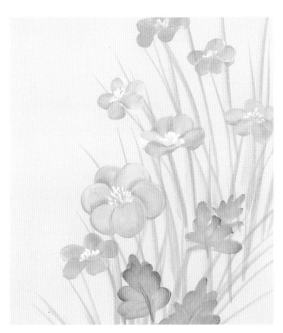

4. Load a no. 12 flat with floating medium and side-load into Yellow Ochre. Float shading around the petals to separate them. Pick up School Bus Yellow and Wicker White and tap in the center stamens using the chisel edge of the no. 12 flat. To finish, load a no. 12 flat with floating medium and side-load into a tiny bit of Periwinkle. Shade around the inner edge of the crackled frame on the blue background to separate the frame from the painting and create a cast shadow.

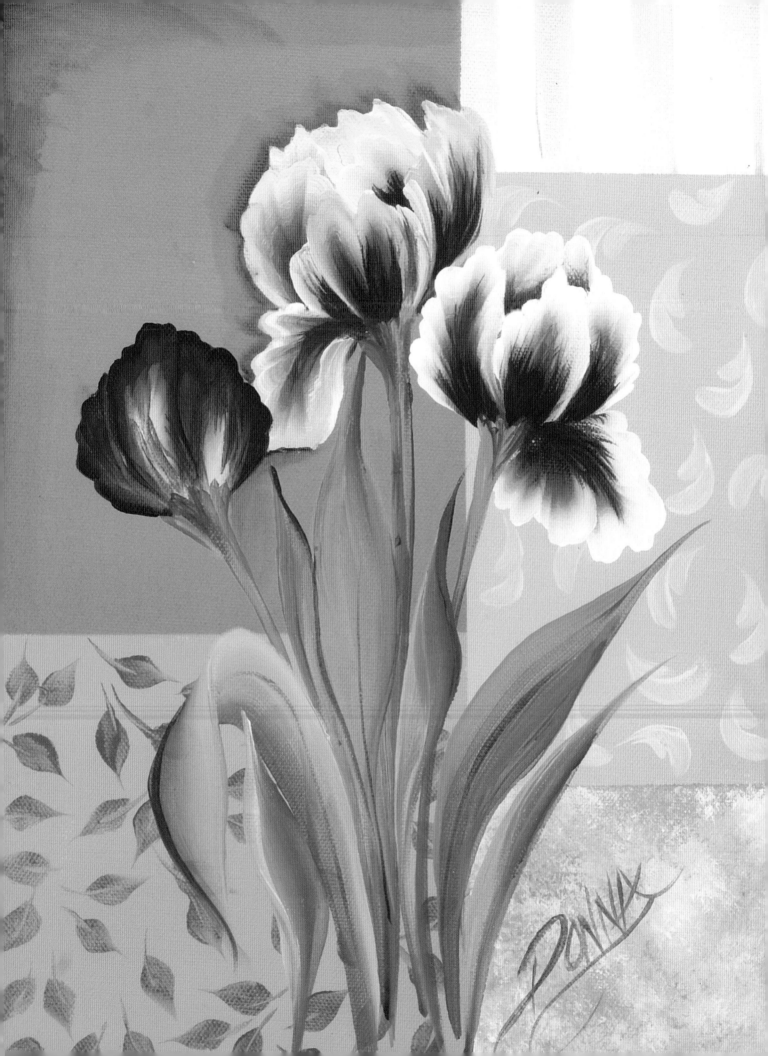

PARROT TULIPS

brushes
¾-inch (19mm) flat • ⅝-inch (16mm) angular

colors
Thicket • Fresh Foliage • Yellow Citron
Magenta • School Bus Yellow
Wicker White • Berry Wine

1. Create a Patchwork Squares background following the directions in the techniques section. For this painting, the shadow leaves in the green square are single leaves, not clusters, and are painted with Thicket and floating medium. Let dry. Double-load a ¾-inch (19mm) flat with Thicket and Fresh Foliage, plus a little Yellow Citron. Dip into lots of floating medium. Paint a thick cluster of long, spiky leaves and sturdy looking stems. For a natural look, paint a folded tulip leaf (see the techniques section). At the tops of the stems, paint the bases where the tulips connect to the stems.

2. Double-load a ¾-inch (19mm) flat with Magenta and School Bus Yellow plus a touch of Wicker White. Begin with the tallest tulip in the middle. Paint the back petals first. Since these are parrot tulips, the edges are ruffled (see the techniques section for directions on painting ruffled-edge petals). The pink and white tulip petals are painted with Magenta and Wicker White. Keep the Wicker White to the outside as you stroke these petals.

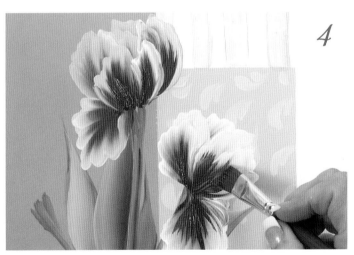

3. Using the same brush and colors, paint another layer of front petals and add a drooping petal to each of the open tulips. Turn your surface to make painting these easier.

4. Load Magenta onto a ⅝-inch (16mm) angular brush and chisel-edge some streaky lines on a few of the petals. To finish, paint a closed tulip blossom with Magenta and Berry Wine on a ¾-inch (19mm) flat, picking up a little Wicker White on one side. Float shading around the outside of each tulip and between the petals with floating medium and Magenta.

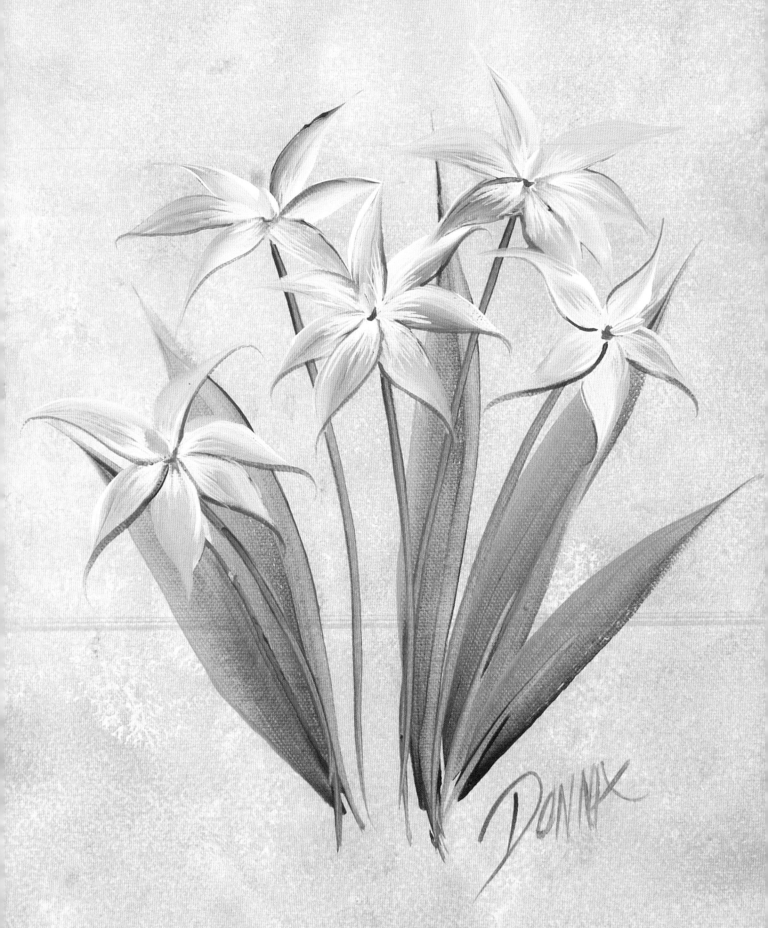

brushes

¾-inch (19mm) flat • no. 12 flat

no. 2 script liner

colors

Thicket • Fresh Foliage • Wicker White

Brilliant Ultramarine • Yellow Light

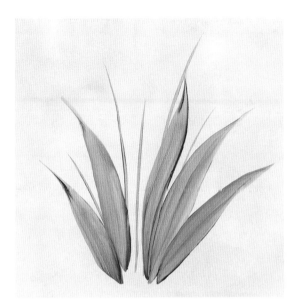

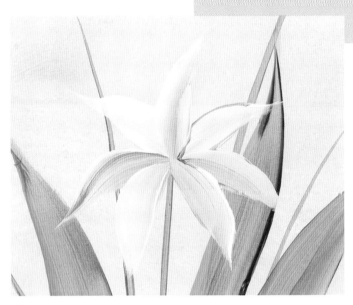

1. Create an Antiqued background following the directions in the techniques section. Let dry. Double-load a ¾-inch (19mm) flat with Thicket and Fresh Foliage and paint the stems and long slender leaves, keeping the Thicket to the outside. Extend the tips of the leaves into long points. If your brush starts to drag or feel dry, dip into floating medium after you've loaded your colors.

2. To begin the petals, double-load a no. 12 flat with Wicker White and Brilliant Ultramarine. Work a lot of the white into the blue before you start painting. Glory-of-the-Snow flowers are a light sky blue, not a deep blue. Paint the long, pointed single-stroke petals.

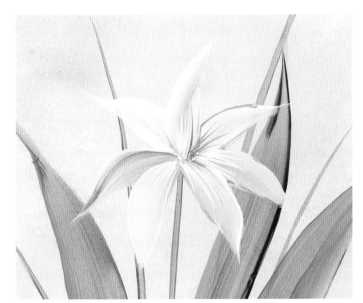

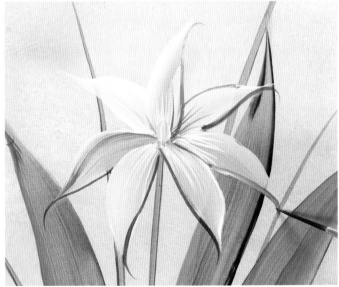

3. Pick up Wicker White on a no. 2 script liner and pull little white streaks out from the center on some of the petals. Pick up Brilliant Ultramarine on the liner and accent the streaks here and there.

4. Stroke in the center stamens with Yellow Light and Wicker White on a no. 12 flat. Load a no. 2 script liner with inky Brilliant Ultramarine and accent some of the edges of the blue petals, pulling the line to a curved, extended point.

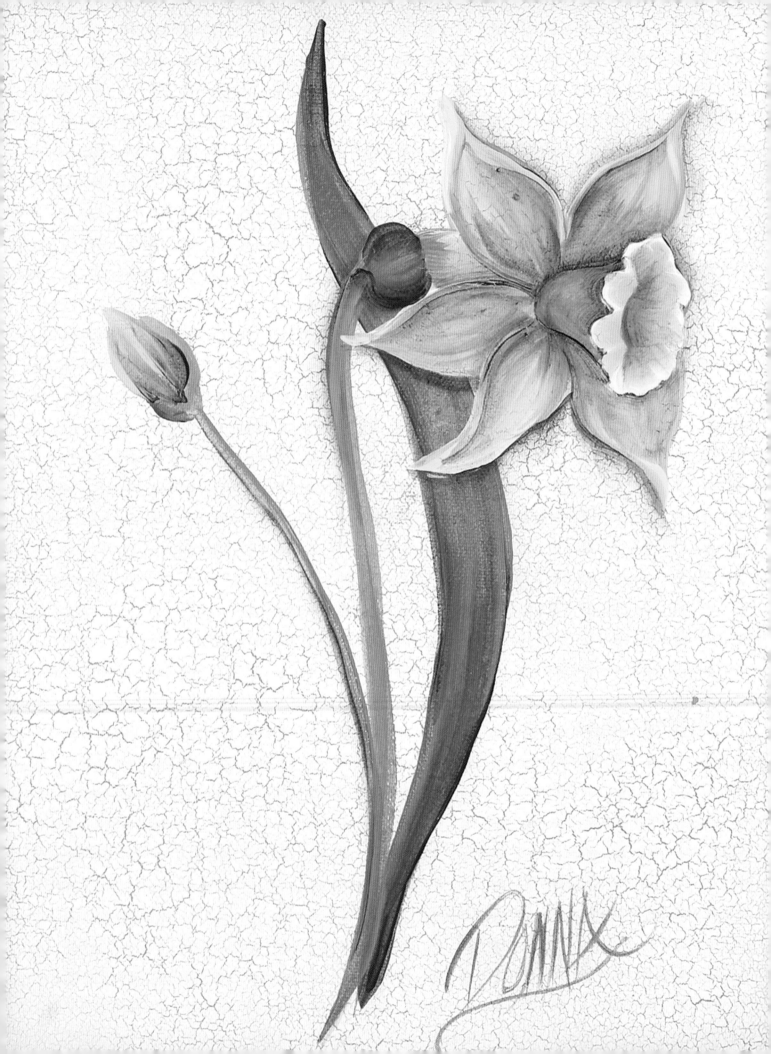

DAFFODIL

brushes
¾-inch (19mm) flat · no. 12 flat

colors
Yellow Citron · Thicket · Yellow Light
Yellow Ochre · Wicker White · Burnt Umber

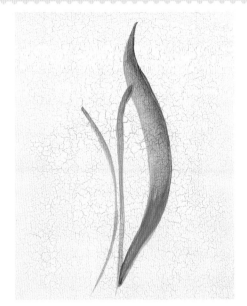

1. Create an Allover Crackled background following the directions in the techniques section. Let dry completely. Double-load a ¾-inch (19mm) flat with Yellow Citron and Thicket. Dip the brush into floating medium to make it easier to paint over the crackled background. Paint a large leaf and pull a couple of stems upward from the base using the chisel edge of the brush.

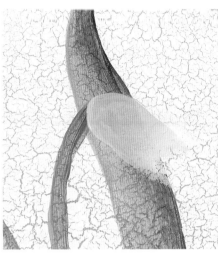

2. Double-load a ¾-inch (19mm) flat with Yellow Light and Yellow Ochre and paint the base of the daffodil blossom with a tight C-stroke.

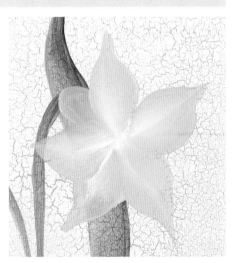

3. With the same brush and colors, paint the open petals, picking up Wicker White as needed on the Yellow Light side of the brush. Keep the Yellow Ochre side to the outside of the petals. Start each petal at the base, push down on the bristles, slide up and lift to the tip, then slide back down to the base.

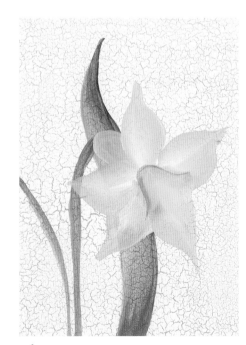

4. Double-load a ¾-inch (19mm) flat with Yellow Light and Yellow Ochre and paint the trumpet, keeping the Yellow Ochre to the outside to separate the base of the trumpet from the outside petals.

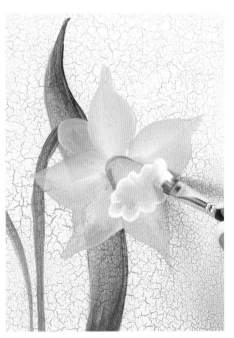

5. Double-load a no. 12 flat with Yellow Light and Wicker White and paint a ruffly circle for the opening of the trumpet.

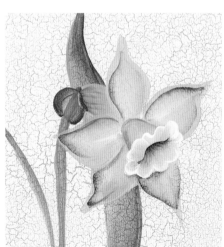

6. Load a no. 12 flat with floating medium and side-load into Burnt Umber. Float shade the inside edges of the petals and the throat of the trumpet. The pod at the base is Thicket and Yellow Citron. To finish, deepen the shading on the petals and trumpet base with Yellow Ochre and floating medium on a no. 12 flat. Add the closed bud on the other stem with the same colors: Yellow Light, Yellow Ochre and Burnt Umber.

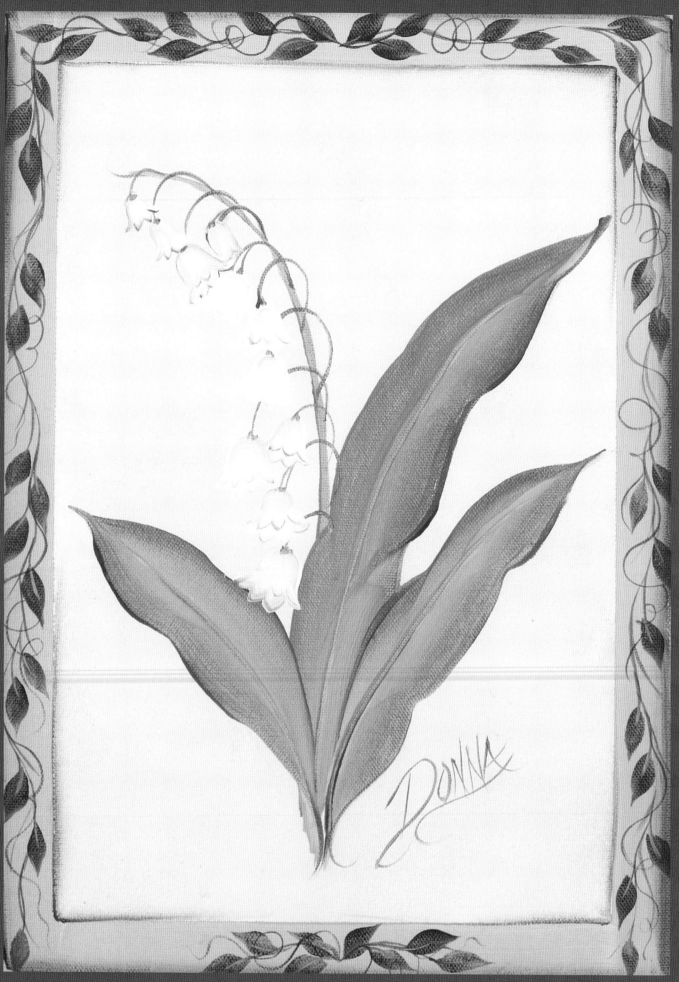

brushes

no. 6, 8 or 10 flat • no. 2 script liner

¾-inch (19mm) flat 91

colors

Thicket • Yellow Citron • Wicker White

Fresh Foliage • Maple Syrup

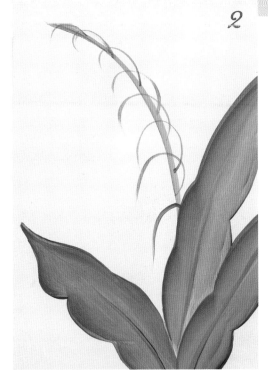

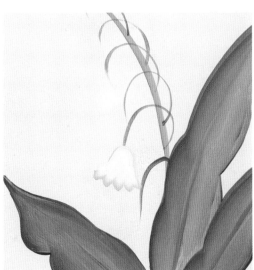

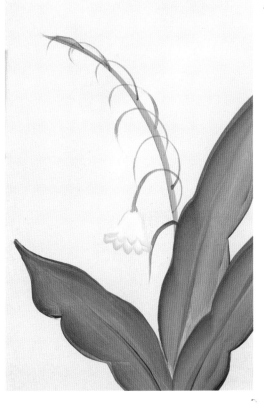

1. For the background, tape off the outer edges with 1-inch (25mm) painter's tape. Sponge on a soft blue in the center with Baby Blue and Wicker White. Remove the tape and let dry. Paint the frame with Butter Pecan. Let dry. Double-load a ¾-inch (19mm) flat with Thicket and Yellow Citron. Paint the stem and the long, slender leaves with scalloped edges.

2. Mix Thicket and Yellow Citron on your palette and use a no. 2 script liner to paint a series of curving stemlets coming off the main stem.

3. To paint the little white bell-shaped blossoms, choose a no. 6, 8 or 10 flat, depending on the size of your painting and the size of the bell. Load the brush with Wicker White, then side-load ever so slightly into Fresh Foliage. Stroke the back part of the bell. This is painted like a petal with a ruffled top edge (see techniques section for directions). Keep the green side of the brush to the outside.

4. The front part of the bell is painted the same way as the back part, only just a little shorter. Dot on the base of the bell where it connects to the stem with Fresh Foliage. To finish, paint a series of bells connecting to the little stemlets. For a natural look, don't paint them all hanging straight down. Let them hang at different angles and overlap sometimes. Also, vary the amount of Fresh Foliage you side-load onto your Wicker White brush—sometimes your bells will be whiter and sometimes they'll have more green around the edges. To finish the frame, float shading in the four corners using floating medium and Maple Syrup. With the same brush, paint shadow leaves starting at the top center and coming down both sides. Finish with Maple Syrup tendrils using a no. 2 script liner.

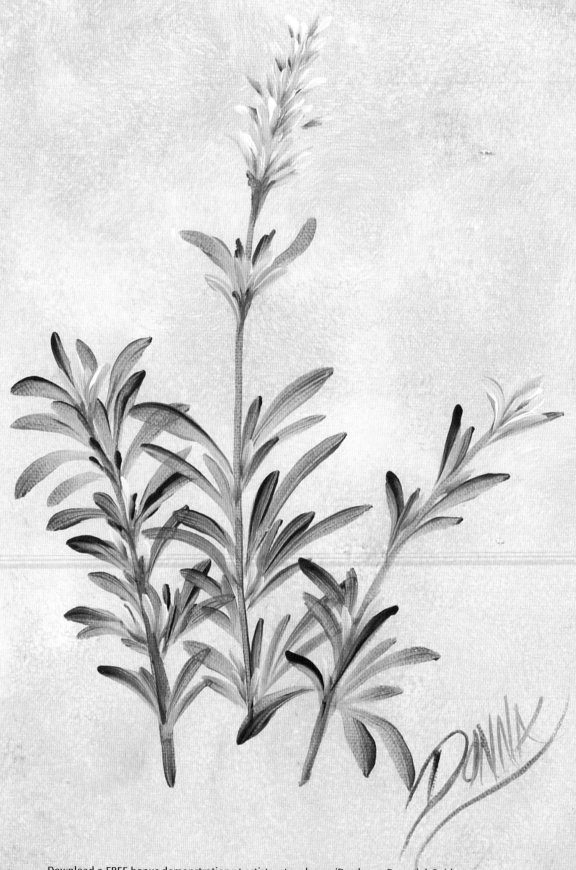

LAVENDER

brushes

no. 8 flat • no. 12 flat

colors

Thicket • Fresh Foliage

Light Lavender • Wicker White

1. Begin by creating an Antiqued background following the directions in the techniques section. Let dry completely. Double-load a no. 12 flat with Thicket and Fresh Foliage and place the stems using the chisel edge of the brush and stroking upward from the base. The leaves are made with little chisel-edge petal strokes pulled inward at an angle toward the stems. For a natural look, vary the leaf colors by picking up more Thicket sometimes and more Fresh Foliage other times. Also, leave some empty spaces along the stems as shown.

2. Double-load a no. 8 flat with Light Lavender and Wicker White. The lavender blossoms are made up of lots of tiny petals. Use a chisel-edge petal stroke for each petal and angle them toward the stem, just as you did for the leaves. Lead with the Wicker White side of the brush for the older petals, and with the Light Lavender side for the newer petals. Add single or double strokes of petal color here and there along the stem tucked in among the leaves.

3. Double-load a no. 8 flat with Fresh Foliage and Wicker White and add little green buds in among the petals of the upper blossom. To finish, add a few lavender petals lower on the stems closer to the base.

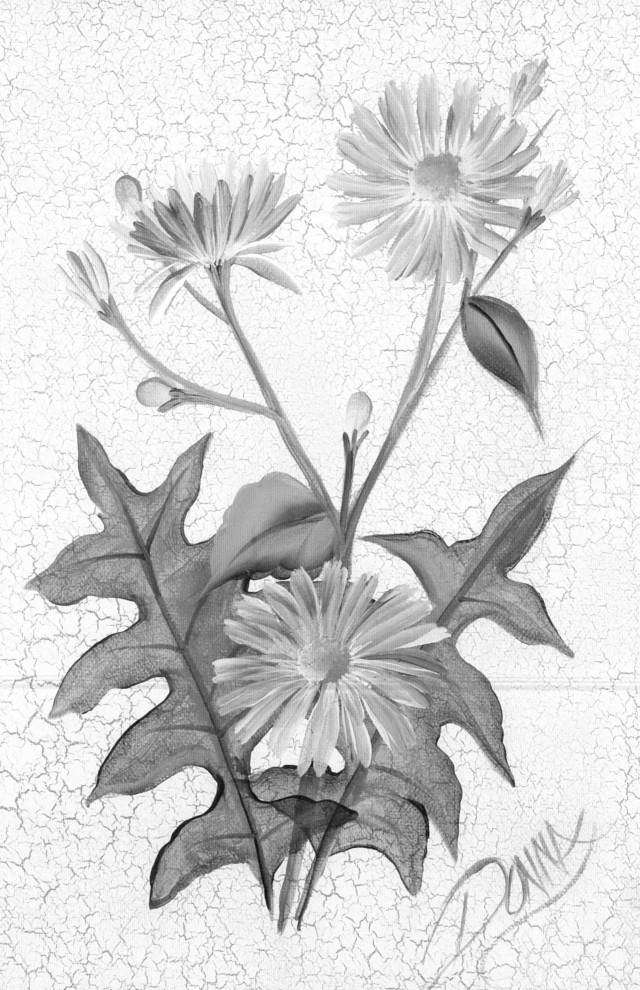

brushes

no. 12 flat • no. 16 flat • no. 2 script liner

¼-inch (6mm) scruffy

colors

Thicket • Yellow Citron • Navy Blue

Wicker White • Yellow Ochre • Yellow Light

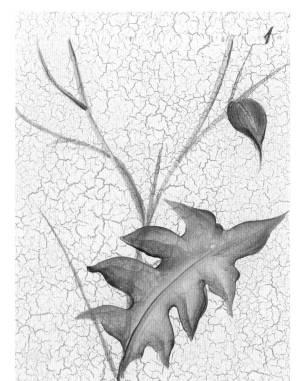

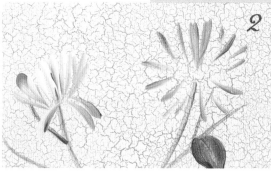

2. Begin painting the chicory blossoms with Navy Blue and Wicker White on a no. 12 flat. Stroke the back petals of the sideview blossom first, and lay out the open blossom with a circular pattern of chisel-edge strokes pulled inward toward the center.

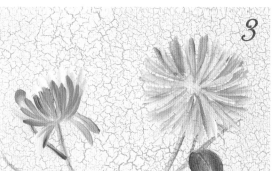

1. Create an Allover Crackled background following the instructions in the techniques section. Let dry. Double-load a no. 16 flat with Thicket and Yellow Citron and paint the main stems, then the smaller stems coming off. With the same colors, paint the lobed leaves and the small one-stroke leaf. Dip your brush into floating medium if it drags on the crackled background.

3. Pick up more Navy Blue on your brush and paint the front petals of the sideview blossom. Fill in with lots of chisel-edge petal strokes on the open blossoms. To get the jagged tips on these petals, pull a couple of side-by-side strokes for each petal.

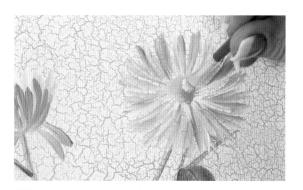

4. Load a no. 2 script liner with inky Wicker White and pull streaks from the center to highlight.

5. Load a ¼-inch (6mm) scruffy with Yellow Ochre and Wicker White and pounce in the centers. Highlight with Yellow Light.

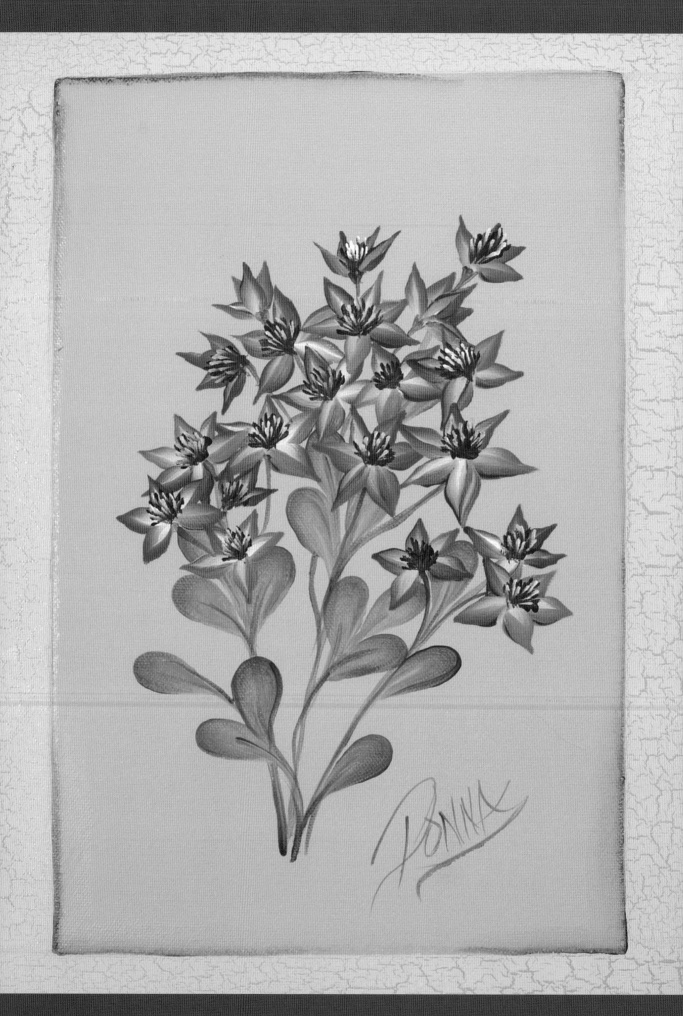

SEDUM

brushes

no. 8 flat • no. 10 flat • no. 16 flat

colors

Thicket • Fresh Foliage • Magenta

Wicker White • Berry Wine

1. Create a Crackled Frame background following the instructions in the techniques section. The basecoat is Basil Green and the crackled frame topcoat is Linen. Let dry. Double-load a no. 16 flat with Thicket and Fresh Foliage. Place the stems and paint clusters of three leaves with teardrop petal strokes, keeping the Thicket to the outside.

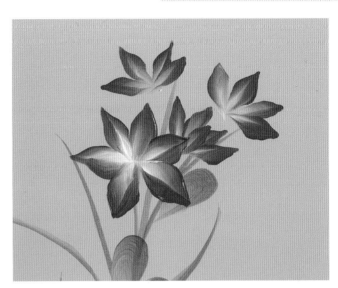

2. Double-load Magenta and Wicker White on a no. 10 flat. Paint small, very pointed petals for the sideview blossoms, and a star-shaped cluster of five- or six-pointed petals for the open blossoms. Start at the base of the petal, push down on the bristles, slide up to the point as you lift to the chisel, then slide back down to the base. Keep the Magenta to the outside on all the petals.

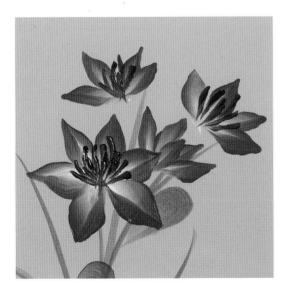

3. The centers are painted with Berry Wine and Magenta on a no. 8 flat. Use the chisel edge to pull little curving strokes for the stamens. Pull them inward toward the center.

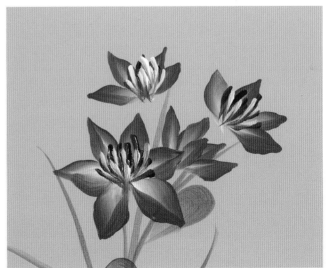

4. Pick up Wicker White on the same brush and paint a few lighter stamens among the darker ones. To complete the painting, add many more blossoms and make sure there are plenty of sideview blossoms. When the flowers are finished, float shading around the inner edge of the crackled frame to separate it from the background. Load a no. 16 flat with floating medium and side-load into a little bit of Thicket. Shade the corners and let it fade out along the sides.

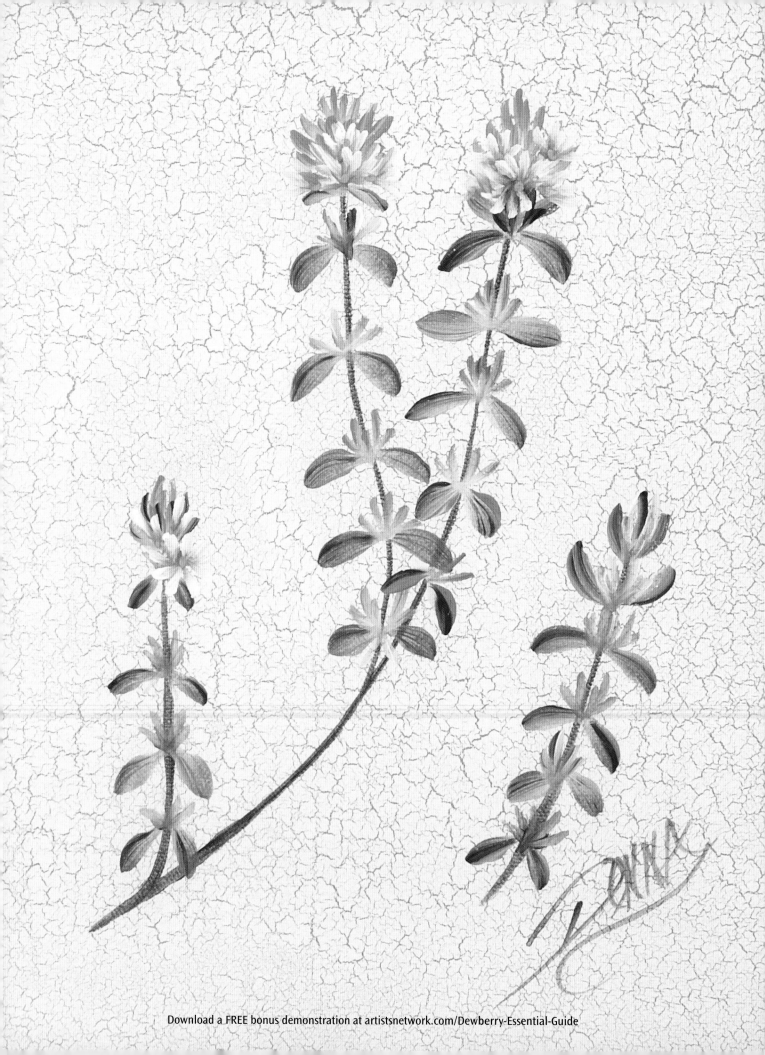

THYME

brushes
no. 8 flat • no. 12 flat

colors
Burnt Umber • Wicker White
Thicket • Yellow Citron • Violet Pansy
School Bus Yellow

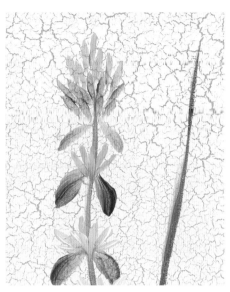

1. This painting of flowering thyme begins with an Allover Crackled background. Follow the instructions in the techniques section. Let dry. Double-load a no. 12 flat with Burnt Umber and Wicker White and place a few sparse stems. The leaves and new-growth buds at the top are painted with Thicket and Yellow Citron on a no. 8 flat. The leaves are little comma strokes that start at the tip and pull upward toward the stem.

2. Double-load a no. 8 flat with Yellow Citron and Wicker White. Paint more new-growth buds by pulling little upward strokes angled outward from the stem—longer in the middle, shorter on the outside. These buds are placed along the stem where the leaves connect.

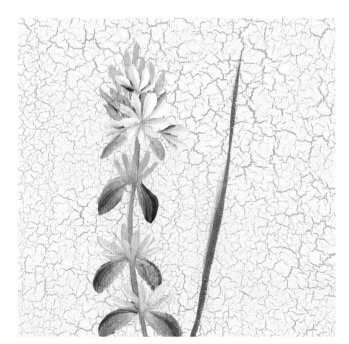

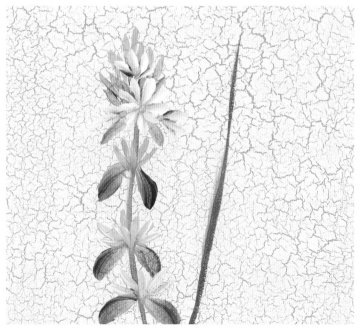

3. Double-load Violet Pansy and Wicker White on a no. 8 flat. The thyme blossoms are painted with little chisel-edge petal strokes pulled inward toward the center. Add some sideview blossoms around the open blossom.

4. Dot the centers with School Bus Yellow on the tip of your brush handle.

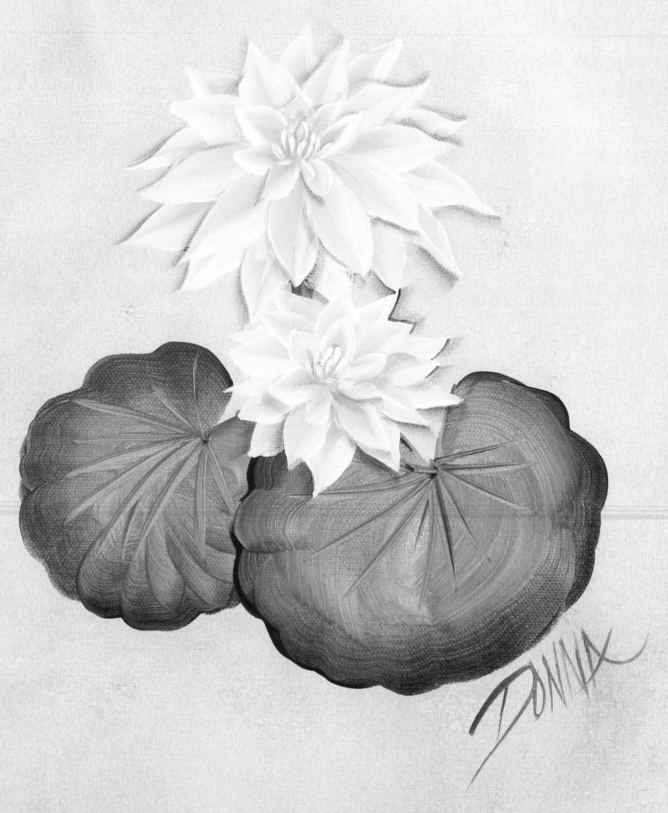

LOTUS BLOSSOM

brushes
no. 8 flat • no. 12 flat • no. 16 flat
¾-inch (19mm) flat

101

colors
Thicket • Fresh Foliage • Yellow Light
Wicker White • School Bus Yellow • Burnt Umber

1. Begin by creating a Tone-on-Tone background following the directions in the techniques section. Let dry completely. Double-load a ¾-inch (19mm) flat with Thicket and Fresh Foliage and pick up lots of floating medium to make painting easier. Use the chisel edge of your brush to make a V-shape guideline where the notch of the leaf will be. Start on one side of the V and draw the outside shape of the leaf. Fill in the center, then use the chisel edge to paint the veins.

2. Paint a thick straight stem coming up from behind the leaves. Double-load a no. 16 flat with Yellow Light and Wicker White and paint the outermost two layers of petals, keeping the white to the outside. If you want a bright yellow lotus blossom, pick up more Yellow Light. If you want lighter-colored blossoms, pick up more Wicker White. Paint the outermost layer of petals first, then the next, inner layer, offsetting the petals from the first layer.

3. Paint the final, smaller layer of petals using the same brush and colors. Offset these petals from the second layer. To paint the center stamens, double-load a no. 8 flat with School Bus Yellow and Wicker White and pull some tiny, curving chisel-edge strokes downward toward the center.

4. Load a no. 12 flat with lots of floating medium and side-load into a little bit of Burnt Umber. Float shading under and around the outermost petals to separate them from the background and to accent the pointed tips of the petals. Shade between the petal layers here and there to separate them as well. To finish, paint the smaller lotus blossom the same way. Allow some of the stem to peek through between the blossoms.

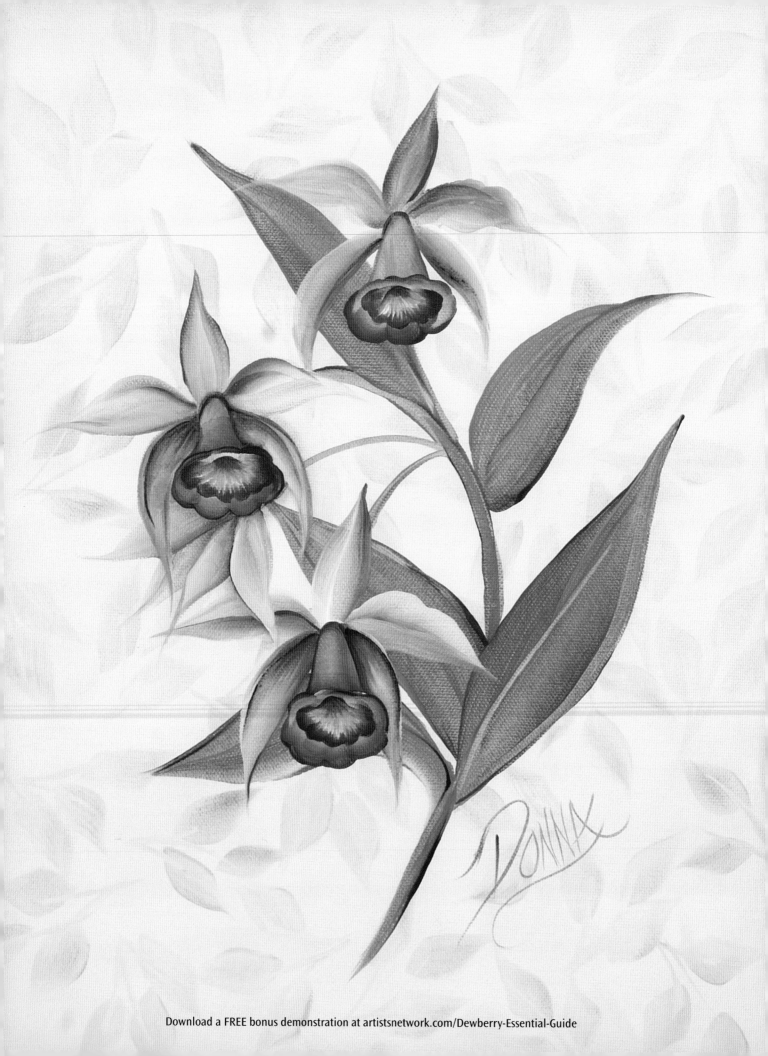

ORCHID

brushes

no. 8 flat • no. 12 flat • no. 16 flat

¾-inch (19mm) flat

colors

Thicket • Yellow Citron • Violet Pansy

Wicker White • Magenta • Dioxazine Purple

1. Create a Shadow Leaves background following the directions in the techniques section. In this painting, the basecoat color is Sunflower and Wicker White, and the shadow leaves are Yellow Ochre and Wicker White. Let dry. Double-load a ¾-inch (19mm) flat with Thicket and Yellow Citron and dip your brush into lots of floating medium. Paint the stems and leaves that attach directly to the main stem.

2. Double-load a no. 16 flat with Violet Pansy and Wicker White. Paint the top and two side petals with two strokes: slide up to a sharp point and slide back down to the base. The two drooping front petals are painted in one stroke from base to tip.

3. The base of the trumpet is painted with Violet Pansy and Wicker White double-loaded on a no. 12 flat. Stroke upward in a very tight, upside-down U-stroke, keeping the Violet Pansy to the outside.

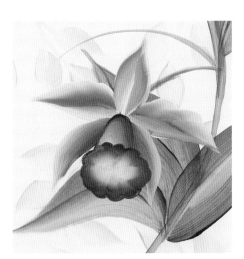

4. The opening of the trumpet is a ruffled circle painted with Violet Pansy and Wicker White, keeping the Violet Pansy to the outside edge (see the techniques section for directions on painting petals with a ruffled top edge).

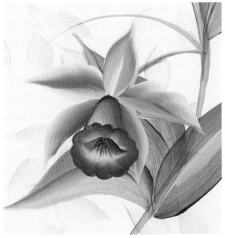

5. Side-load more Violet Pansy on a no. 12 flat and paint the throat of the trumpet with a stroke that is pointed on both ends and wider in the middle. Use the chisel edge to pull little hairlines downward and outward from the throat.

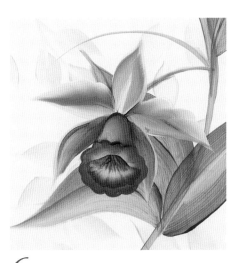

6. Load a no. 8 flat with floating medium and Magenta and detail the inside of the ruffled edges. With the same brush, pick up more floating medium and side-load into Dioxazine Purple. Define the outer edges of some of the petals better. Finish with a couple more orchid blossoms.

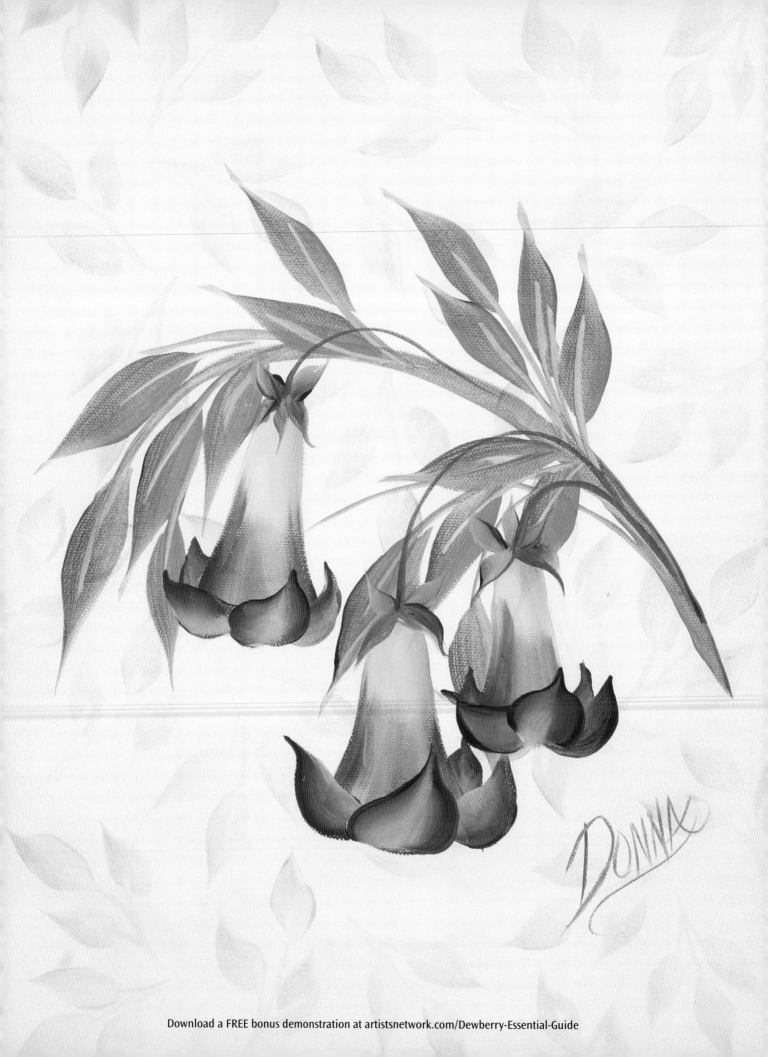

ANGEL'S TRUMPET

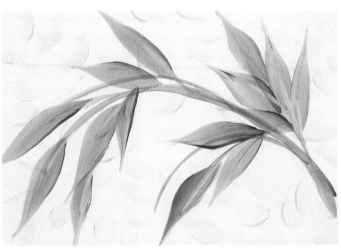

1. Create a Shadow Leaves background following the instructions in the techniques section. Let dry. Double-load a no. 16 flat with Thicket and Yellow Citron and pick up lots of floating medium. Paint the main stems. With the same colors, paint the leaves in clusters at the base and single towards the ends of the stems.

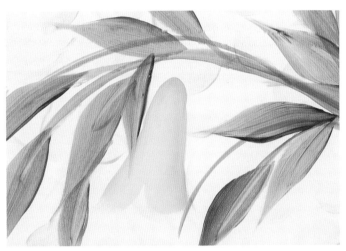

2. Double-load a no. 16 flat with Yellow Ochre and Wicker White, picking up a little Fresh Foliage on the white side of the brush. Paint the base of the trumpet by starting at one side of the outside edge, sliding up to the base, curving your brush around, and sliding back to the other outside edge. This is like a very elongated upside-down U-stroke.

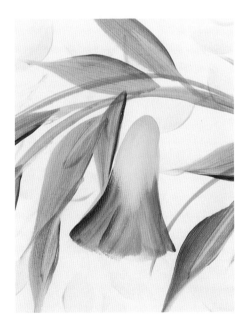

3. Pick up some School Bus Yellow and Engine Red on the same brush and dip into floating medium. Stroke the red upward onto the yellow trumpet.

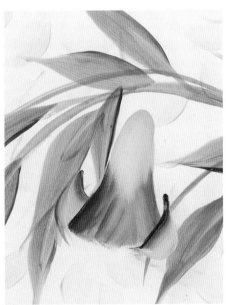

4. Double-load a no. 12 flat with School Bus Yellow and Wicker White and side-load into Engine Red. Paint the two turned outer edges of the trumpet where it opens up.

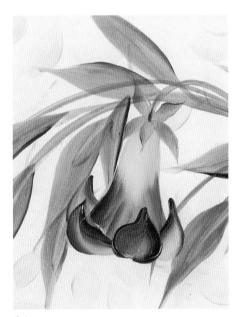

5. Pull the front two turned outer edges by starting at the point of each one and pulling downward on both sides. Finish with a calyx where the base of the trumpet connects to the stem, using Thicket and Yellow Citron on a no. 12 flat.

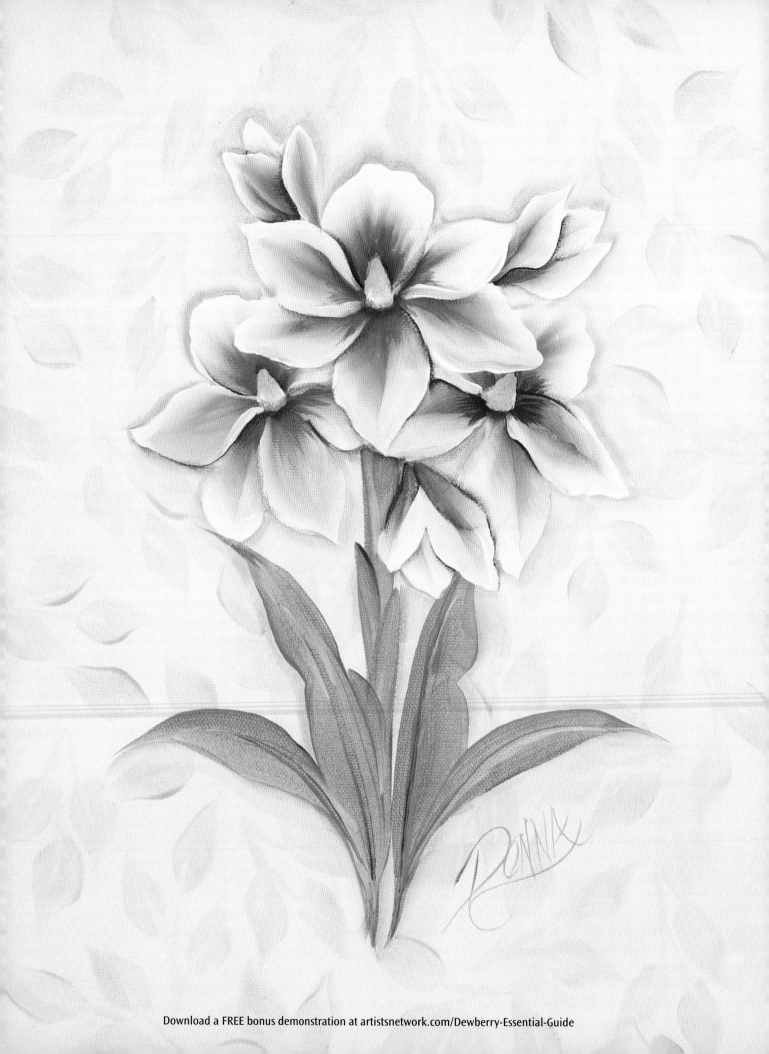

WATER HYACINTH

brushes

no. 10 flat • no. 16 flat

colors

Thicket • Yellow Citron • Violet Pansy
Wicker White • Yellow Light • Yellow Ochre

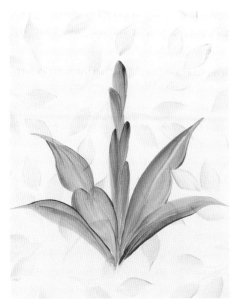

1. Create a Shadow Leaves background following the directions in the techniques section. In this painting, the basecoat color is Sunflower and Wicker White, and the shadow leaves are Yellow Ochre and Wicker White. Let dry. Double-load a no. 16 flat with Thicket and Yellow Citron and dip your brush into lots of floating medium. Paint the center stalk first, starting with the topmost segment and working down, then add the leaves.

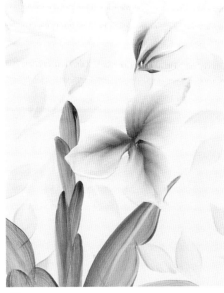

2. Double-load Violet Pansy and Wicker White on a no. 16 flat. Paint the back three petals of the open blossom, then the bud. Start at the base of the petal, push down on the bristles, slide up to the point as you lift to the chisel, then slide back down to the base. Keep the Wicker White to the outside on all the petals.

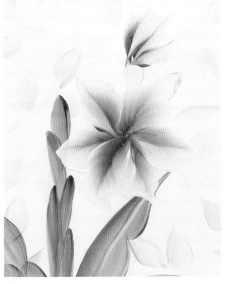

3. With the same brush and colors, add the next three petals to the open blossom, offsetting them from the first three.

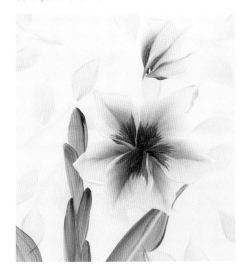

4. Load a no. 10 flat with floating medium and Violet Pansy. Using the chisel edge of the brush, shade the center of the open blossom by pulling little streaks outward from the center onto most of the petals.

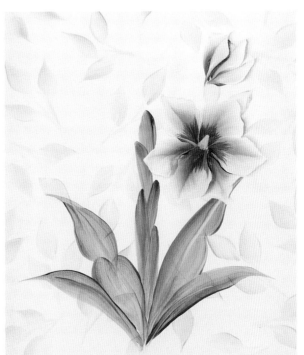

5. Double-load a no. 10 flat with Yellow Light and Yellow Citron and tap on the cone-shaped stamen using the chisel edge of the brush. To finish, load a no. 10 flat with floating medium and side-load into Violet Pansy. Paint the shading between the petals and where the petals turn. Load a no. 16 flat with floating medium and Yellow Ochre and float shade around all the flowers and leaves to separate them from the background.

TULIPS & SCROLLS

brushes
¾-inch (19mm) flat • no. 16 flat

colors
Yellow Citron •Thicket
Wicker White • Magenta

1. Pencil in a variety of scrolling lines on a piece of white paper to establish the placement of the main design. Allow some of the lines to continue off the edges of the design.

2. Add secondary lines curving off of the first ones. Always begin your secondary lines somewhere along the main lines—don't start them out in space and then try to connect them.

3. Pick out one of your designs and begin to pencil in a diagram of the tulip outlines and the leaves. Here I've darkened the main design lines so you can see them more easily. I also added another set of smaller curving lines coming off the left side. Compare this to the same area in step 2. Pencil in some comma strokes as well.

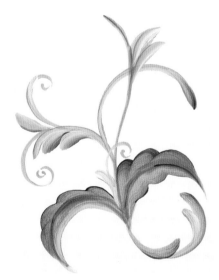

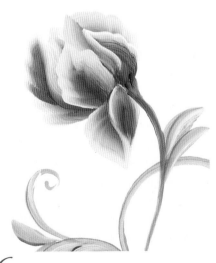

4. The background color for the design is Sunflower. Choose a background color for your design that works well with your tulip and scroll colors. Load a ¾-inch (19mm) flat with Yellow Citron and paint the basic curving shapes using the chisel edge of the brush.

5. Double-load the same brush with Thicket and Yellow Citron and paint the large, scalloped-edge leaves. Paint the scrolls and comma strokes with Yellow Citron and Wicker White. If your design is smaller than mine, switch to a no. 16 flat for the commas and scrolls.

6. Paint the pink parrot tulips with Magenta and Wicker White on a ¾-inch (19mm) flat. (Also see the parrot tulips demonstration.) Paint the base where the tulip attaches to the stem with short, chisel-edge strokes of Thicket and Yellow Citron.

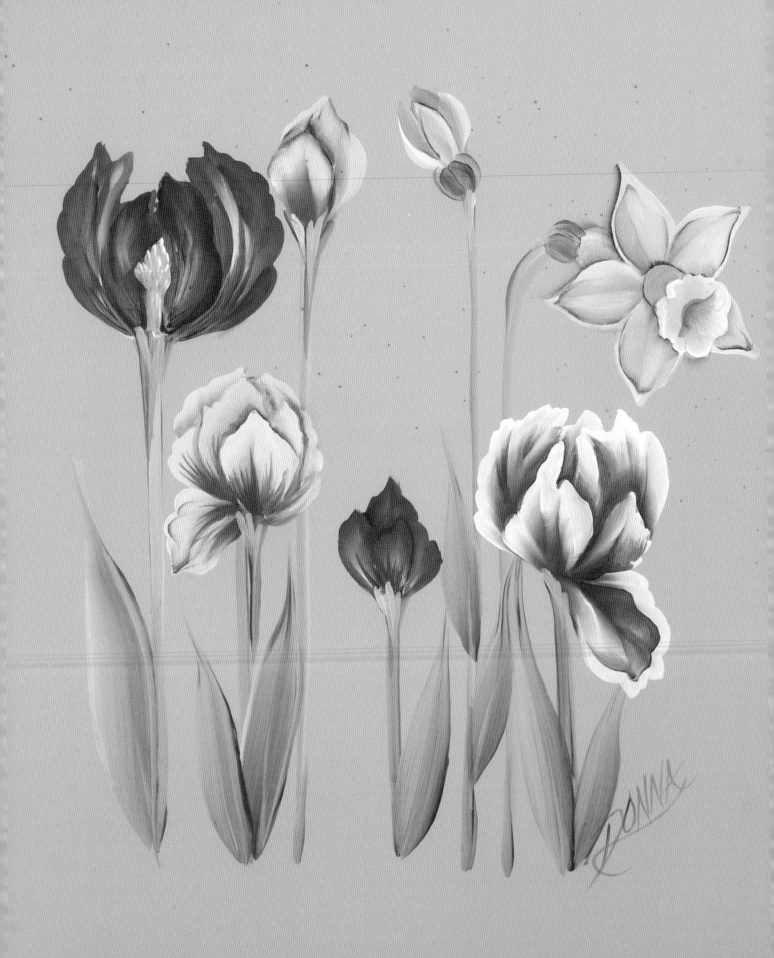

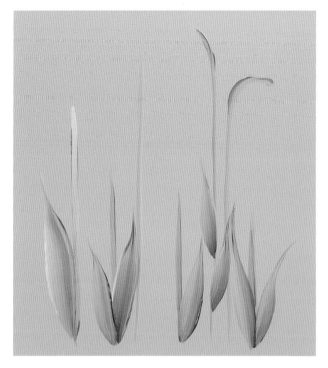

1. Basecoat your surface with two coats of Basil Green. Let dry. Establish the overall shape of the design with vertical stems for the tulips and daffodils. The tops of the daffodil stems should curve over. Soften the stems with some graceful leaves.

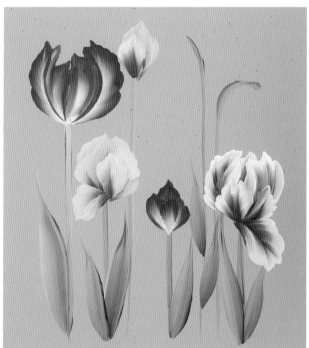

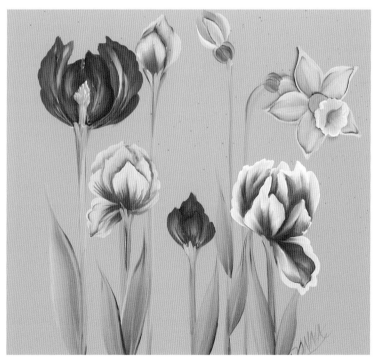

2. As you paint the parrot tulips, add interest to the design by letting a couple of the petals droop as they naturally would on fully open tulips. This will help relieve some of the stiffness of the vertical stems and prevent the flowers from looking frozen in place. Add a couple of buds in different stages of opening.

3. Finish with the daffodil blossoms—one fully open and nodding on its stem, and one opening bud. Detail the tulips with stamens that are in the same yellow color family as the daffodils to help tie the composition together.

BORDER DESIGN

1. Here's an unusual way to use lilies of the valley in a design—as a vertical border! Begin with a basecoat of Basil Green. Let dry. Place the long curving vine and pull shorter stems off the main vine using the chisel edge of your brush. Paint the large leaves, then use a script liner to paint the little stemlets for the blossoms.

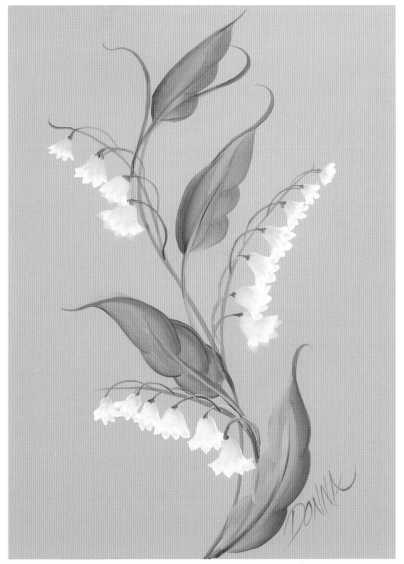

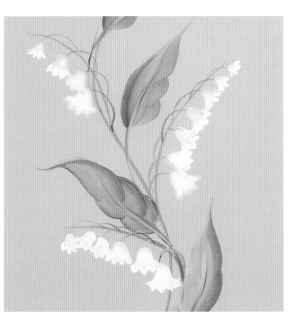

2. Paint the backs of all the lily of the valley bells using white with a touch of light green. Vary the number of blossoms and their direction.

3. Finish each little bell by painting the fronts. Pick up more white on the brush and keep the white side to the ruffly edge of the bell and the light green side to the base. This vertical border would look lovely alongside a window frame or doorway. For a long border, keep repeating the design shown here, curving the main vine back and forth in a graceful wave.

FOUR-SEASON ADDRESS SIGNS

Welcome guests to your home with a bright and colorful address sign you have painted yourself. There's a new one for each season in this project! When spring rolls around, you can paint these pretty spring flowers in soft pastels to echo the daffodils and tulips in your front yard. This wooden plaque can be hung on your front door or your porch wall, or displayed in your front yard. They're painted with durable Outdoor paints to hold up to all kinds of weather. Use Outdoor Opaque colors unless otherwise noted. For even more protection, give them a couple coats of spray lacquer in a satin or gloss finish.

brushes

¾-inch (19mm) flat
nos. 2, 6, 8, 12 and 16 flats

½-inch (12mm) scruffy

½-inch (12mm) mop
nos. 1 and 2 script liners

surfaces

arched-top wooden plaques
from Walnut Hollow

additional supplies

FolkArt Sponge Painters

FolkArt Flow Medium from Walnut Hollow

FOLKART OUTDOOR DIMENSIONALS

Fresh Foliage Wicker White Lemon Custard

FOLKART OUTDOOR OPAQUES

Fresh Foliage Yellow Ochre Wicker White School Bus Yellow Magenta

Purple Lilac Thicket Light Blue Pure Orange Engine Red

Berry Wine Burnt Umber Cobalt

1. Background. Basecoat sign with Wicker White Outdoor paint. Let dry. Dampen sponge painter, load Fresh Foliage Outdoor Opaque and Flow Medium, and sponge on the background.

2. Address numbers. Paint your address numbers with Fresh Foliage on a no. 8 flat. Freehand them or trace from a stencil.

3. Yellow rose. The yellow rose at the top is Yellow Ochre loaded on a ¾-inch (19mm) flat, side-loaded into Wicker White.

4. Yellow tulip. The large yellow tulip in the center and the hanging bud is Yellow Ochre + Wicker White on a ¾-inch (19mm) flat. Pick up a little School Bus Yellow on the Yellow Ochre side.

5. Pink flower. On the dirty brush, pick up a little Magenta and paint the pink flower with teardrop petals.

6. Lavender roses. Double-load Purple Lilac and Wicker White on the ¾-inch (19mm) flat and paint the lavender roses.

7. **Lavender daisy.** Pick up a little bit of Magenta on the dirty brush (Purple Lilac + Wicker White) and paint the large lavender daisy at the top. Pick up a little more Magenta for the daisy buds at the sides of the board. The large yellow daisy at top is School Bus Yellow + Wicker White.

8. **Yellow-pink tulip.** The yellow-pink tulip is Magenta + School Bus Yellow on a ¾-inch (19mm) flat, plus a little Wicker White. Double-load Magenta + Wicker White on a no. 12 flat and paint the jagged-edge petals of the dark pink flowers (see finished address board at the end of the demonstration).

9. **Flower centers.** Add the centers on the large daisies with the ½-inch (12mm) scruffy loaded with School Bus Yellow and Fresh Foliage. Highlight with Wicker White. Use dimensional Fresh Foliage and Wicker White to dot on the anthers. The leaves are Fresh Foliage on a no. 12 or no. 6 flat depending on size.

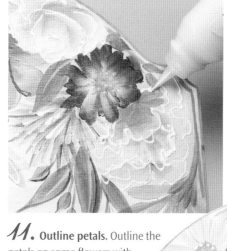

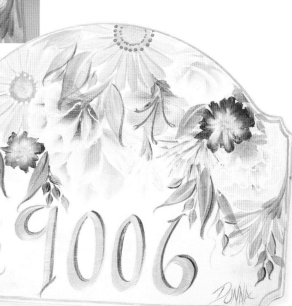

10. **Shading.** Use inky Thicket on a no. 2 script liner to shade the address numbers. Outline the plaque with inky Fresh Foliage on a script liner.

11. **Outline petals.** Outline the petals on some flowers with Wicker White Outdoor Dimensional paint.

1. **Background.** Basecoat the sign with Wicker White. Let dry. With a dampened sponge, streak lateral strokes of Light Blue thinned with Flow Medium for a blue-sky look.

2. **Tiger lily.** Pencil in where you want your design to go, referring to the finished sign at the end of the demonstration. Double-load School Bus Yellow and Pure Orange, then side-load into Engine Red. Paint the back petals of the tiger lily. Start at the base of each petal, slide smoothly to the tip, then slide smoothly back to the base.

3. **Tiger lily.** Add the backsides of the front petals that extend down from the top.

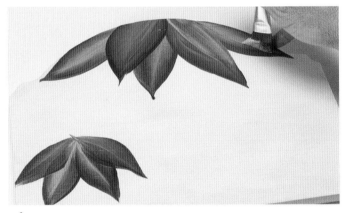

4. **Veins.** With Fresh Foliage on a ¾-inch (19mm) flat, chisel-edge the center veins on the petals.

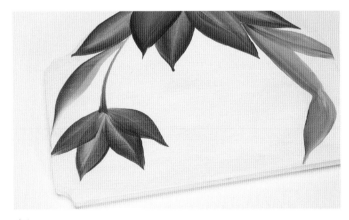

5. **Stem and leaves.** Pick up Thicket on your dirty brush and add a stem for the lower tiger lily and paint the large leaves.

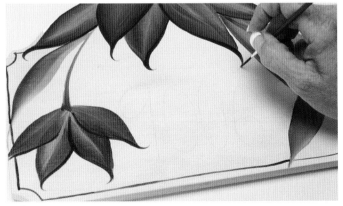

6. **Outlining.** Load inky Engine Red on a no. 2 script liner and outline the lily petals, ending with a little curve on the tip to add graceful form to the petals. Using the same brush, outline the edge of the plaque following the shape by bracing your little finger against the edge.

7. **Address numbers.** Load a no. 0 flat with Fresh Foliage and paint your address numbers.

8. **Shading.** Load a no. 1 script liner with Thicket and add a shaded edge to each number, embellishing the shading lines with extra loops and curves if you wish.

9. **Petal details.** Dab specks randomly on the insides of the lily petals with Berry Wine on a no. 2 flat.

10. **Anthers.** To add the anthers, use Fresh Foliage Outdoor Dimensional. Start at the outside tip and pull upward toward the flower centers. Add yellow pollen dots with Lemon Custard Outdoor Dimensional.

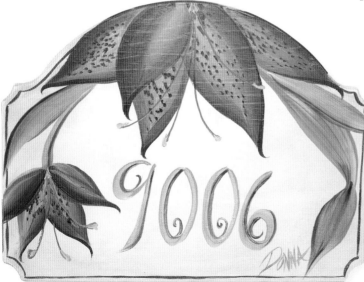

1. **Background.** Basecoat the sign with Wicker White. Let dry. Dampen a sponge painter, then pick up some Burnt Umber thinned with Flow Medium and paint the background with lateral strokes. Concentrate this color mostly around the edges, letting it fade off into the center.

2. **Address numbers.** Paint your address numbers with Burnt Umber on a no. 8 flat. Freehand them or use a number stencil.

3. **Branches.** Place the branches around the plaque with Burnt Umber and Wicker White double-loaded on a no. 12 flat.

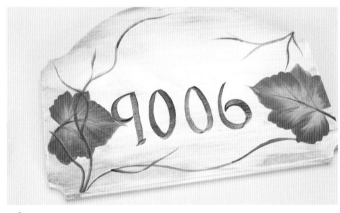

4. **Large autumn leaves.** Double-load a ¾-inch (19mm) flat with School Bus Yellow and Pure Orange. Paint the large leaves, keeping the orange to the outside. Pick up Burnt Umber on the chisel edge of the brush and pull stems into the leaves.

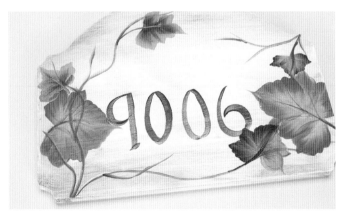

5. **Small autumn leaves.** Double-load a no. 16 flat with School Bus Yellow and Pure Orange, then pick up a little Engine Red on the orange side. Paint the four smaller autumn leaves, varying the colors by flipping the brush over so the Engine Red is on the outside for one or two of the leaves. Pick up Fresh Foliage or Thicket on your brush to introduce some green into a few of the leaves.

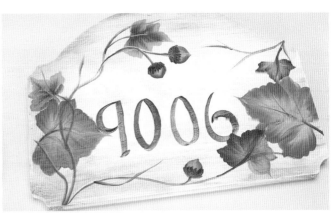

6. Acorns. Add a branch for the acorns at the top that runs over the top leaf, using Burnt Umber + Wicker White. With the same dirty brush, pick up School Bus Yellow and a little Pure Orange and work the colors into the brush. Then paint heart shapes that come to a point to create the acorns.

7. Acorn caps. Paint the acorn caps with the chisel edge of the brush and Burnt Umber.

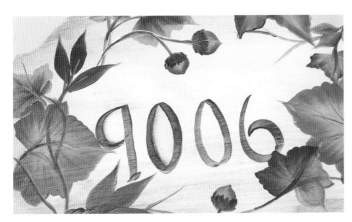

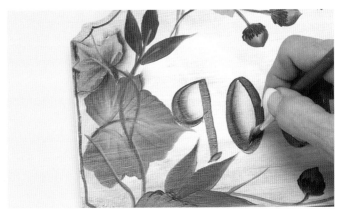

8. Filler leaves. Load a no. 12 flat with Engine Red and Burnt Umber and paint one or two clusters of long, slender, dark red leaves. Fill in the edges of the sign with different shapes and sizes of green leaves using Thicket and Fresh Foliage.

9. Shading. Load inky Burnt Umber onto a no. 2 script liner and paint the decorative border around the outside of the plaque. Load a no. 12 flat with Flow Medium, side-load into Burnt Umber and shade around the leaves and within the numbers.

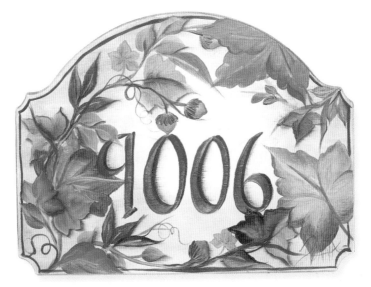

1. **Background.** Basecoat your sign with Wicker White and let dry. Dampen a sponge painter with water, dip the sponge edge into Flow Medium, then dip into a little Thicket. Sponge on the background color. Concentrate on the outside edges, fading into white in the center.

2. **Address numbers.** Paint your address numbers using a no. 8 flat loaded with Thicket + Flow Medium.

3. **Pine needles.** Stroke the long pine needles with Thicket and Fresh Foliage double-loaded on a no. 16 flat. Stay up on the chisel edge and lead with the lighter green. Refer to the finished sign at the end of the demonstration for placement of the pine needles.

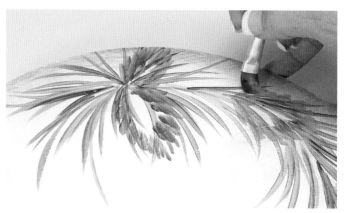

4. **Pine cones.** Work Cobalt and Thicket into your no. 12 flat and pick up a little Wicker White on the blue side of the brush. Chisel-stroke the first layer of the pine cones, starting with the outer tip and pulling your strokes upward toward the stem where the cone attaches to the branch.

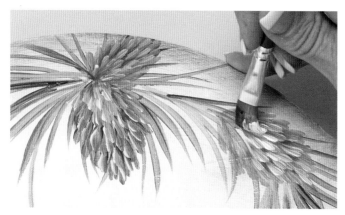

5. **Pine cone segments.** Reload your brush with Cobalt, Thicket and Wicker White and continue layering on the individual segments, overlapping them as you work upwards. Stroke randomly so the segments are not lined up—this gives a more natural look.

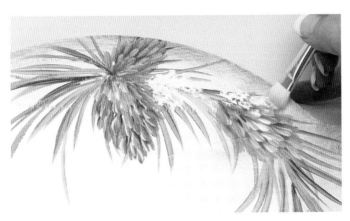

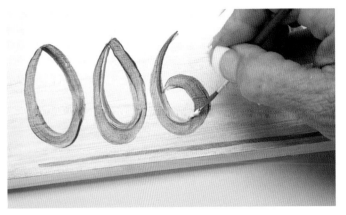

6. **Snow detail.** With a ½-inch (12mm) mop brush, lightly dab Wicker White on the pine cones and some of the needles to create a light dusting of snow here and there.

7. **Shading.** Load a no. 2 script liner with inky Cobalt and shade the address numbers, then paint a thin borderline around the rim of the plaque. Highlight parts of the numbers with Wicker White on the no. 2 script liner.

brushes

nos. 8, 12 and 16 flats

surfaces

Wooden butterfly houses available at garden and craft stores

additional supplies

FolkArt Sponge Painters

FolkArt Flow Medium

BUTTERFLY HOUSES

Wouldn't you love to have all kinds of beautiful butterflies flitting around in your garden? Placing wooden houses made especially for butterflies will help attract them to your area. Butterfly houses are different from bird houses—the openings for butterflies must be very narrow vertical slits. They fold up their wings to get inside, and the small openings protect them from predators. These wooden houses were handmade for me by a dear friend, but you can easily buy similar ones at garden and craft stores during the spring and summer months. In this project we'll paint three different designs on three different size houses. Place them around your garden near a shallow water source and you'll attract many colorful "flutterbys." Use Outdoor Opaques unless otherwise specified.

FOLKART OUTDOOR DIMENSIONALS

Fresh Foliage Wicker White Lemon Custard

FOLKART OUTDOOR OPAQUES

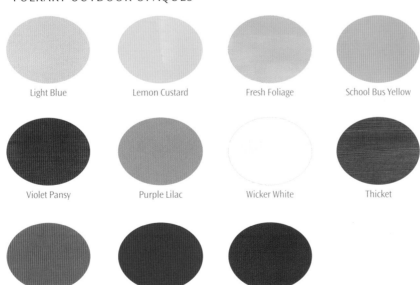

Light Blue Lemon Custard Fresh Foliage School Bus Yellow

Violet Pansy Purple Lilac Wicker White Thicket

Pure Orange Cobalt Magenta

1. **Background.** Basecoat the medium-size butterfly house with Wicker White and let dry. Using a sponge painter, sponge on Light Blue thinned with Flow Medium, fading out towards the top on the front and both sides.

2. **Roof.** On the roof, sponge on Lemon Custard and Fresh Foliage double-loaded on a sponge painter.

3. **Leaves and stems.** Double-load a no. 12 flat with Fresh Foliage and School Bus Yellow and paint the long upright leaves and stems

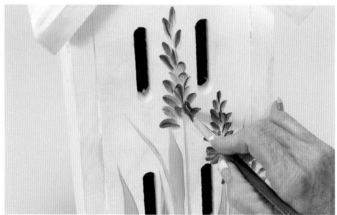

4. **Purple flowers.** Double-load Violet Pansy and Wicker White and paint the petals of the stalk flower with a push-down-and-pull motion.

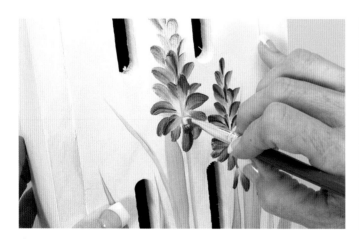

5. **Lower petals.** For the lower petals, touch the brush down at the outer tip of each petal and pull upward.

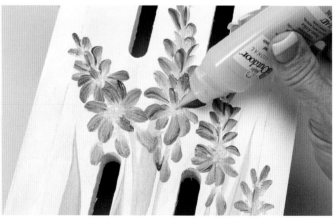

6. **Centers.** Dot in the purple flower centers with Lemon Custard Outdoor Dimensional paint.

Download a FREE bonus demonstration at artistsnetwork.com/Dewberry-Essential-Guide

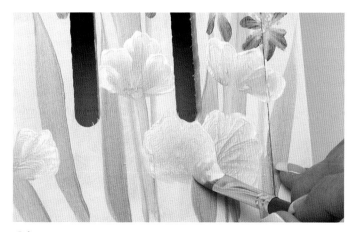

7. Yellow pansies. Paint the back petals of the yellow pansies with School Bus Yellow (occasionally lightened with Lemon Custard) double-loaded with Wicker White on a no. 12 flat. Keep the white to the outside edges on all the petals.

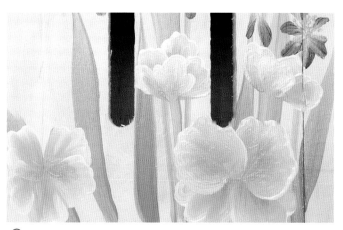

8. Lower petals. Paint the lower petals of the front pansies with the same brush and colors.

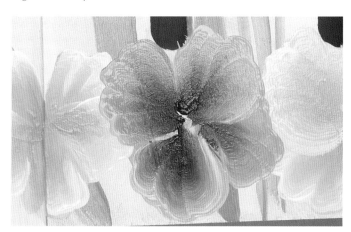

9. Purple pansy. Double-load a no. 12 flat with Violet Pansy and Wicker White. Touch into Lemon Custard with the white edge of the brush. Paint the purple pansy petals with seashell strokes.

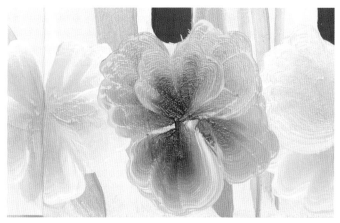

10. Top front petal. Add the top front petal to the purple pansy, overlapping the two side petals.

11. Hairline details. Use the chisel edge of the no. 8 flat and Violet Pansy to paint hairlines on the backs of the petals of the yellow pansies.

12. **Outline.** Dot Lemon Custard and Fresh Foliage Outdoor Dimensional paint in the pansy centers. Outline the petals with Wicker White Outdoor Dimensional using the tip of the bottle to draw on loose and wavy lines.

13. **Butterflies.** Paint the butterflies' wings with the same colors as the pansy petals. Zigzag the bodies and draw antennae with Fresh Foliage Dimensional paint. Detail the wings with Wicker White Dimensional.

Ask Donna

Q: If I can't find the exact same surfaces you painted on for these projects, what are some alternatives I can use instead?

A: Look for a shape that mimics the shape of the surface I painted on. Most of these designs can be altered to fit any shape, but laying out designs is the hardest part about painting. So if you are a beginner, choose a similar shape. For example, if you cannot find any butterfly houses, look for bird houses instead that have the same general shape. If you can't find the round clock shown in the Magnolias Outdoor Clock demonstration, paint on a charger plate or a round wooden plaque.

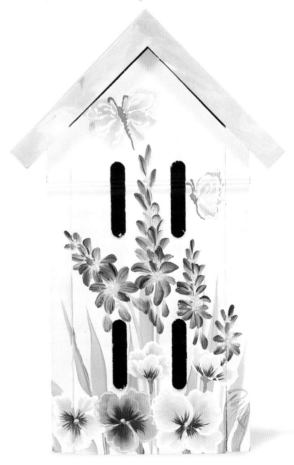

1. Leaves and daylilies. Basecoat the small house with Wicker White and let dry. Using a sponge painter, sponge Light Blue on the house. Double-load the sponge with Fresh Foliage and Lemon Custard and paint the roof. Paint the leaves and stems with Fresh Foliage and Thicket on a no. 12 flat. Double-load Pure Orange and Lemon Custard on a no. 12 flat and paint the back petals of the daylilies and the two buds.

2. Front petals. With the same colors and brush, add the front petals. Attach stems to the daylily blossoms with Thicket and Fresh Foliage.

3. Leaves. Paint large wiggle-edge leaves with Thicket and Fresh Foliage double-loaded on a no. 12 flat.

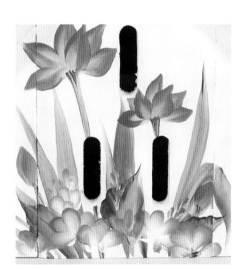

4. Blue flowers. Double-load Cobalt and Wicker White on a no. 12 flat and paint the back layers of the blue five-petal flowers and the taller stalk flowers.

5. Flower centers. Paint the front layers of petals with the same brush, flipped so the Wicker White is to the outside edge. Dot on the centers with Lemon Custard Dimensional paint.

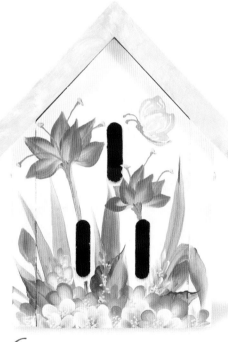

6. Final details. Paint the daylily anthers with Fresh Foliage Dimensional and add pollen dots with Lemon Custard Dimensional. Paint the butterfly wings with Lemon Custard and Wicker White. Make the body and antennae with Fresh Foliage Dimensional paint.

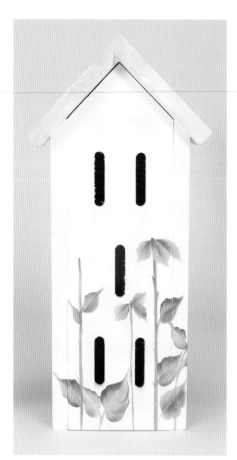

1. Stems and leaves. Basecoat the tall butterfly house with Wicker White and let dry. Sponge Light Blue on the house and Fresh Foliage and Lemon Custard on the roof. Paint the vertical stems and the rose leaves with Fresh Foliage and Thicket, adding a little Wicker White. Pick up a little Magenta and tint some of the rose leaves.

2. Roses. Double-load a no. 16 flat with Magenta and Wicker White and begin with the back petal of the open roses. Keep the Wicker White to the outside for all your rose petals.

3. Rose center. Paint the center buds in the open roses with a U-stroke and a C-stroke.

4. Front petal. The front petal of the open rose is shaped like a boat. Sweep the flat brush across the front of the center bud, starting on the chisel at the left side and ending on the chisel on the right side.

5. Petal layers. For the next layer, "grab" the back petal, then roll the brush in your fingers as you cross over the front.

6. Side petals. Fit the side petals in underneath, pulling toward the center and lifting to the chisel.

7. Hanging petals. The hanging petals have slightly ruffled edges. Keep the Wicker White to the outside edge.

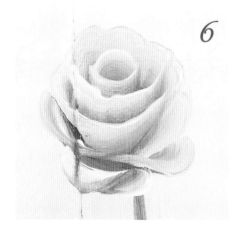

6

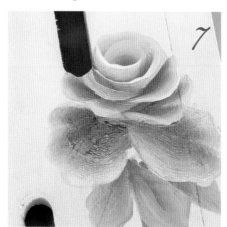

7

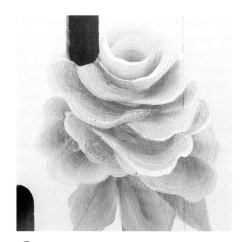

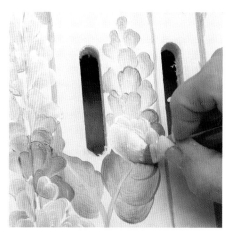

8. **Final rose petals.** Chisel-edge some more petals coming in from each side until you have enough layers.

9. **Purple flowers.** Double-load Purple Lilac and Wicker White and paint the lavender petals with a teardrop stroke that is slightly wiggled.

10. **Purple flowers.** Flip the brush over so the Wicker White is more predominant and paint more petals.

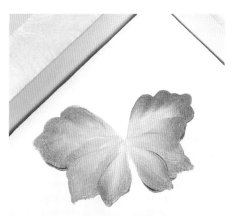

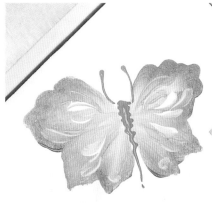

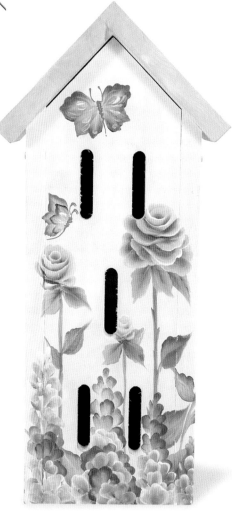

11. **Butterflies.** Double-load Violet Pansy and Wicker White and paint the open wings using ruffled-edge strokes.

12. **Butterflies.** Detail the wings with comma strokes of Lemon Custard and Wicker White. Paint the bodies and antennae with Fresh Foliage Dimensional paint.

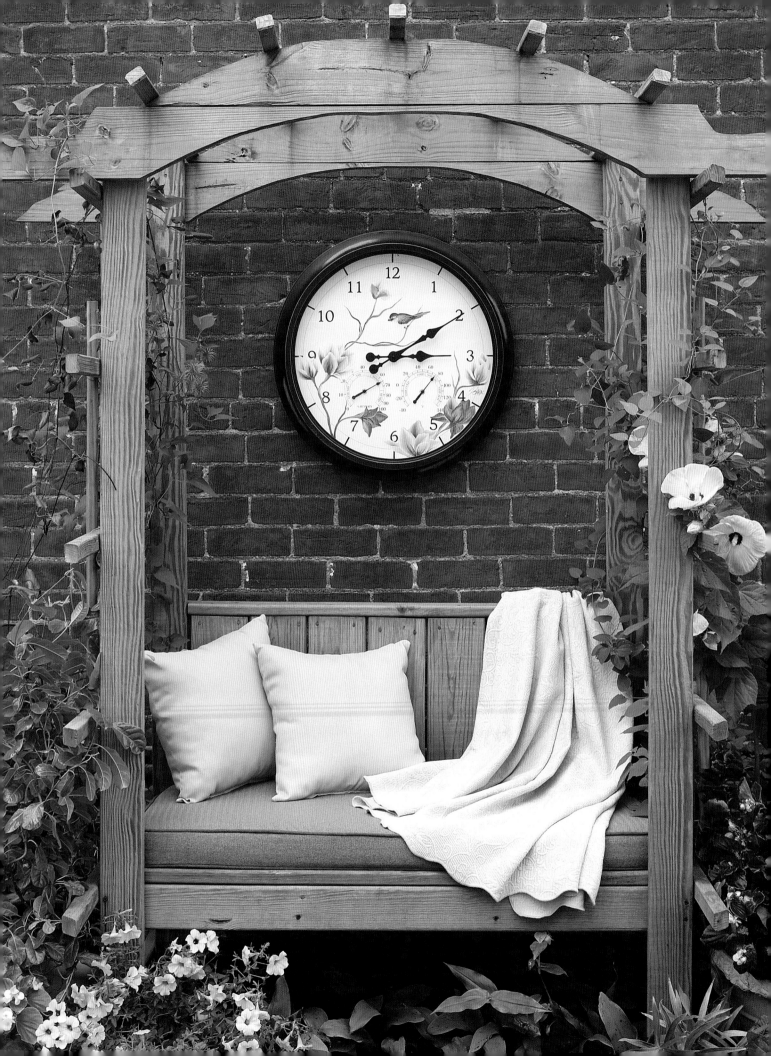

MAGNOLIAS OUTDOOR CLOCK

A beautifully painted clock like this one can make a strong decorative statement in areas such as covered porches, sunrooms and patios. The design is simple—just some pink magnolia blossoms and a little brown sparrow—but the large size and bronze-toned metal frame of the clock make it a memorable and impressive accessory for your outdoor decor. Because the clock face is protected under glass, you can use regular acrylic paints, but I would keep it out of direct sunlight to prevent heat buildup behind the glass. Also, the delicate colors of the flowers will show up better if it's not in the glare of bright sunlight. If you don't have room for a large clock such as this one, a smaller round one will work just as well—just reduce the overall size of the design or cut back on the number of magnolia blossoms you paint.

brushes

¾-inch (19mm) flat

nos. 2 and 10 flats

no. 2 script liner

surface

Large round clock with bronze finish

metal frame

additional supplies

FolkArt Floating Medium

FOLKART ACRYLICS

Fresh Foliage

Wicker White

Berry Wine

Burnt Umber

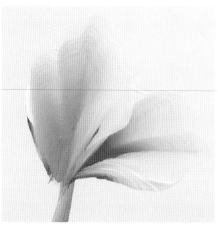

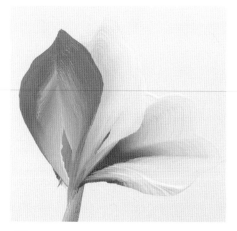

1. **Branches.** Double-load a ¾-inch (19mm) flat with Burnt Umber and Wicker White. Stay up on the chisel edge and paint the magnolia tree branches within the circle of the round clock face for placement of the design. Here we're painting on a plain surface so the design is easy to see and you're not distracted by the clock's numbers and gauges.

2. **Magnolia bud.** Double-load a ¾-inch (19mm) flat with Berry Wine and Wicker White. Paint the back two petals of the flower bud, keeping Wicker White to the outside. Start with the side petal, then lay the upright petal over it. These petals are painted similarly to a wiggle-edge leaf.

3. **Magnolia bud.** Flip the brush so the Berry Wine side is to the outside, and paint the back side of the bud's front petal. The contrast between the darker pink and the light pink brings this petal to the front.

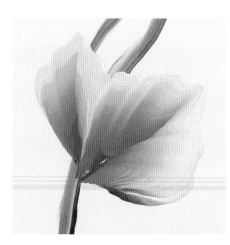

4. **Opening blossom.** On the opening blossom located beneath the bud you just painted, start with the back two petals. Double-load a ¾-inch (19mm) flat with Berry Wine and Wicker White. Keep the Wicker White to the outside.

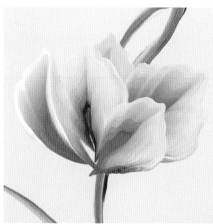

5. **Middle petals.** Using the same brush and colors, paint the next layer of three petals; start these petals lower so you can still see the tops of the back petals. Pick up more Wicker White to create the lightest edges on some of the petals.

Ask Donna

Q: When you paint flowers, where do you get your ideas? What are you inspired by?

A: When I'm looking for a new flower to paint, I study the photos in floral reference books, gardening magazines and seed catalogs. Sometimes I take my own pictures with a digital camera to get close-ups of the flowers as well as the leaves. Most of the time when I paint a flower, I am going for an effect rather than trying to make it anatomically perfect in every detail. I prefer to work from a picture rather than an actual flower. This is because a picture is flat and one dimensional, and so is a painting. I use color, highlighting and shading all in one stroke to differentiate one petal or layer from another instead of mixing lots of colors.

6. Turned-edge petal. In front of the petals you just painted in Step 5, paint a petal with one turned or curled edge. Using the same brush and colors and keeping the Wicker White to the outside, paint the first half of the petal, wiggling and sliding up to the tip. As you slide back down the other half, pivot your brush to the left to bring the white side of the brush over and across the front.

7. Drooping petal. Finish with a petal that droops off to the right side. Attach the blossom to the branch with Burnt Umber and Wicker White chisel-edge strokes.

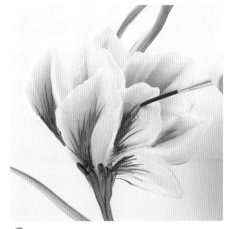

8. Detail lines. Detail the magnolia petals and deepen the shading at the base of the petals with inky Berry Wine on a no. 2 script liner.

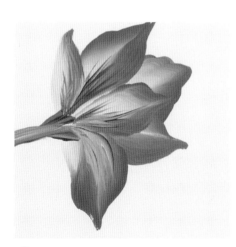

9. Dark pink magnolia. The dark pink magnolia, located at the bottom of the clockface below the bird, is painted the same way as the blossom you just painted. To get the dark pink color, keep the Berry Wine side of the brush to the outside edges of the petals.

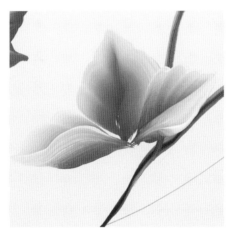

10. Fully open magnolia. To begin the fully open light pink magnolia to the right of the dark pink one, double-load a ¾-inch (19mm) flat with Berry Wine and Wicker White and start with the two back petals. Keep the Wicker White side of the brush to the outside. Add a curled petal to the left. Paint the back half of the petal first, then overlap it with a smooth horizontal stroke from base to tip, keeping the Wicker White to the top edge of the petal.

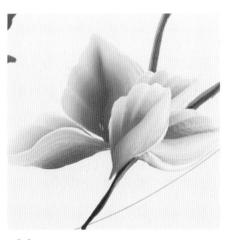

11. Middle petals. Add another layer of two more petals to the right, one laying sideways and one more upright.

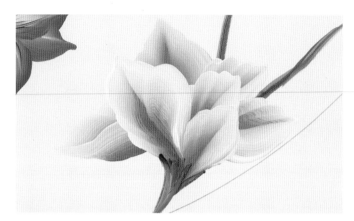

12. Final petal layer. Add the final two petals to the light pink open magnolia, then attach the blossom to the branch with chisel-edge strokes of Burnt Umber and Wicker White.

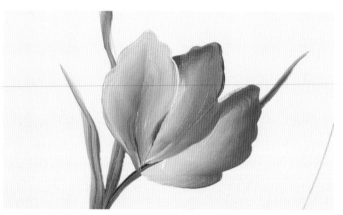

13. Largest magnolia. The final dark pink magnolia blossom is at the 4 o'clock position on the clockface. Start with two dark pink back petals: keep the Berry Wine to the outside. Work a little more Wicker White into the brush and paint the lighter petal in front.

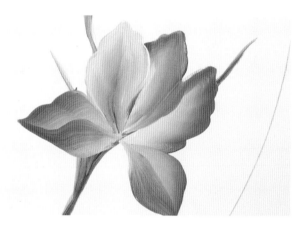

14. Side petals. Turn your brush so the Berry Wine is to the outside and add two hanging petals at either side of the back petals.

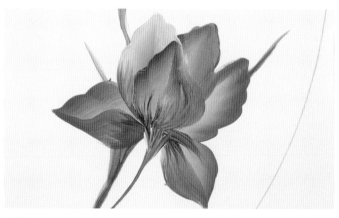

15. Final magnolia petal. Paint a dark pink upright petal in front to complete the blossom. Load a no. 2 script liner with inky Berry Wine and paint the detail lines at the base of the petals to shade them. Finish with a stem of Burnt Umber and Wicker White.

16. Bird's head and back. The little brown sparrow is painted entirely with Burnt Umber and Wicker White double-loaded on a no. 10 flat. Use a half-circle stroke for the head and a long, smooth stroke for the back.

17. Cheek and belly. With the same colors and brush, turn the brush so the Wicker White is on the outside edge. Paint the cheek and belly with short choppy strokes pulled out to the end to get a feathery effect.

18. Tail feathers. Paint the tail feathers starting with the longest one and tapering down on both sides. Don't curve these strokes; keep them straight. Tail feathers are always straight.

19. Wing. Add a few more shorter feathers to the tail. Stroke the wing with one smooth motion from neck to tail, keeping the Burnt Umber to the top.

20. Wing feathers. Pull short chisel-edge strokes of Burnt Umber starting at the outside edge and layering inward.

21. Feet, eye and beak. Load a no. 2 script liner with inky Burnt Umber and paint short curving lines for the feet. Double-load a no. 2 flat with Burnt Umber and Wicker White and work in a lighter brown where the eyes are. Add the beak with the Burnt Umber side of the brush. With a no. 2 script liner add the eye with Burnt Umber. Add highlights to the eye, face and beak with Wicker White on a no. 2 script liner.

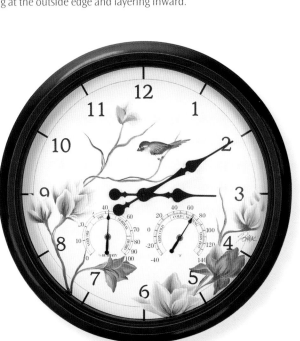

EVENING LIGHTS

enamels brushes

nos. 8, 10, 12 flats

⅛-inch (3mm) scruffy

surfaces

Tall and short drinking glasses available from any home store

additional supplies

Dip 'n Etch by Etchall, available at any craft supply store

sturdy disposable plastic container

When the sun dips low in the sky and the cool breezes of evening signal the end of the day, you can add a relaxing glow to your patio or porch with these pretty little votive candle holders. These are so simple and inexpensive to paint, you may want to set dozens of them along the railing of your back deck. Place fine white sand in the bottom of each glass for weight and stability and to absorb the melting candle wax. I used regular drinking glasses bought at a home store and gave them a frosted finish, or you can buy already-frosted glasses. Paint a simple flower on each one and light up the evening!

FOLKART ENAMELS

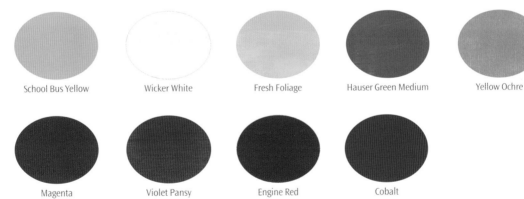

School Bus Yellow Wicker White Fresh Foliage Hauser Green Medium Yellow Ochre

Magenta Violet Pansy Engine Red Cobalt

1. **Materials needed.** If you want to frost the outside of your glasses before painting on them, here's an easy and inexpensive way to do it. Purchase a jar of Etchall Dip 'n Etch at any craft store, and gather up a sturdy plastic container and the glasses you want to frost.

2. **Determine etch line.** Fill the plastic container halfway with water and place the glass down in. Use weights such as marbles or stones in the glass to keep it from floating. Add or remove water until the waterline is where you want the top of the frosted area on the glass to be. Leave about 1 inch (25mm) at the top clear.

3. **Mark Etch Line.** Remove the glass. Mark the outside of the container with a line that's level with the height of the water.

4. **Add Dip 'n Etch.** Remove the water and dry the container. Fill it with Dip 'n Etch up to the level line you marked on the outside.

5. **Place in Dip 'n Etch.** Place the weighted glass down in the Dip 'n Etch and leave it there for 15 minutes.

6. **Rinse and dry.** Remove the glass from the etching solution, rinse under running water and dry thoroughly. Pour the Dip 'n Etch back into its jar—it can be reused over and over.

1. **First petal.** Double-load a no. 12 flat Enamels brush with School Bus Yellow and Wicker White. Paint the first petal by sliding smoothly up to the tip, and sliding smoothly back down. Keep the Wicker White to the outside.

2. **Four more petals.** Add four more ruffled-edge petals to complete the flower. Turn the glass to make painting each petal easier. Make sure the Wicker White side of the brush is always to the outside edge of each petal.

3. **Stem.** Add a branching stem coming from the back of the blossom with Fresh Foliage and Hauser Green Medium on a no. 10 flat Enamels brush.

4. **Center.** Pick up a little Yellow Ochre on the chisel edge of the no. 10 flat and add fine lines radiating up and outward from the center for shading and depth. Dot Fresh Foliage in the center for a stamen. Let the paint dry for 24 hours before using the glass.

1. **Petals.** Double-load a no. 8 flat Enamels brush with a little Magenta and a lot of Wicker White. Begin the coneflower petals using a daisy petal stroke. Start at the outside edge and pull each petal in toward the center, lifting to the chisel edge to form a point.

2. **Layer petals.** Add more petals to the first layer, then add a second layer of shorter petals on top of the first. This is a sideview flower so you will not be painting a complete circle of petals like a daisy.

3. **Center.** Double-load Yellow Ochre and School Bus Yellow on a ⅛-inch (3 mm) Enamels scruffy and pounce on the coneflower center. Highlight with a little Wicker White on the top.

4. **Stem.** Add a chisel-edge stem with Fresh Foliage and Hauser Green Medium double-loaded on the no. 8 flat. Let the paint dry for 24 hours before using the glass.

1. **Petals.** Double-load Violet Pansy and Wicker White on a no. 8 flat Enamels brush and pull some chisel-edge petal strokes that angle down toward the stem.

2. **Layer petals.** Pull more petals along the sides to fill in the layers. As you reload the brush, pick up more Violet Pansy sometimes and more Wicker White other times to vary the petal colors and add depth and roundness to the lavender blossom.

3. **Stem and leaves.** Double-load the no. 8 flat with Fresh Foliage and Hauser Green Medium and pull a curving stem, leading with the lighter green. Add little leaves with the same brush and colors, using a chisel-edge petal stroke. Let the paint dry for 24 hours before using the glass.

Ask Donna

Q: What is your favorite flower to paint? Why? What does it mean to you?

A: My current favorite flower was not always my favorite, either to paint, pick, or grow. Now it has become all three. It is the rose. The one-stroke rose is also known as my "signature flower." People in the painting world easily recognize my rose. Whenever I am painting a demonstration the rose is always requested. What makes it my favorite now? Its versatility. I haven't found a surface yet that can't have a rose painted on it. Roses also come in almost every color and shade so they can be painted to work with any decor. In this book, you'll find several roses on very different surfaces—and they all work!

1. Petal. Double-load School Bus Yellow and Engine Red on a no. 8 flat Enamels brush and paint a long, pointed petal. Start on the chisel edge at the base, push down on the bristles to widen the center part, then lift back up to the chisel and slide to the tip. Slide back down the other side without turning or pivoting the brush.

2. Blossom. Fill out the daylily blossom with four more petals, keeping the Engine Red to the outside for all. Turn the glass as you work to make painting easier. Make sure the outside tip on each petal is a sharp, distinct point.

3. Stamens. Load a no. 8 flat with Fresh Foliage and use the chisel edge to paint the stamens, stroking them inward toward the center. Shade the center with Hauser Green Medium, and touch on pollen dots with Wicker White.

4. Stem. Pull a stem with Fresh Foliage and Hauser Green Medium on the chisel edge of the no. 8 flat. Let the paint dry for 24 hours before using the glass.

Download a FREE bonus demonstration at artistsnetwork.com/Dewberry-Essential-Guide

BLUE WILDFLOWER

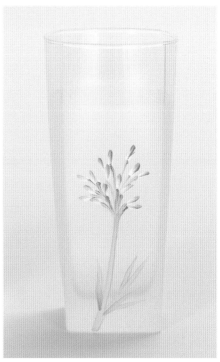

1. **Petals.** Double-load a no. 8 flat Enamels brush with Cobalt and Wicker White and touch on the little petals with the chisel edge of the brush.

2. **Stemlets.** Load a no. 2 script liner with Hauser Green Medium and pull little stemlets from the petals by grabbing the bottom of the petal and pulling downward in a slight curve. Keep these stemlets very thin and delicate.

3. **Main stem and leaves.** The main stem is Fresh Foliage and Hauser Green Medium double-loaded on a no. 8 flat. Lead with the lighter green. Pull long, slender leaves out from the stem with the chisel edge. Let the paint dry for 24 hours before using the glass.

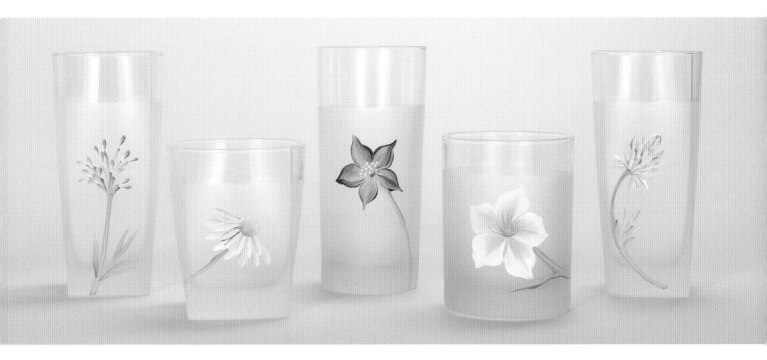

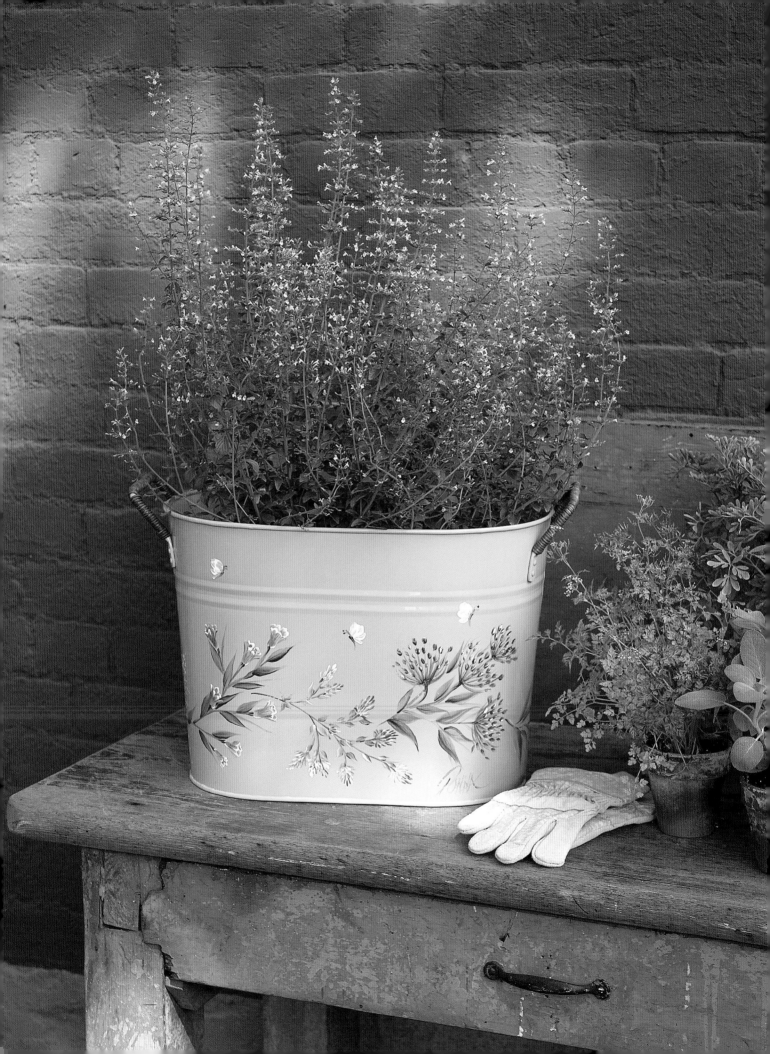

WILDFLOWER PLANTER

enamels brushes

nos. 2, 6, 8 and 12 flats

no. 2 script liner

147

surface

enameled metal planter with handles,
available at Target

additional supplies

FolkArt Clear Medium

Planters come in all shapes, sizes and materials, but the ones I like to paint on most are the sturdy metal ones with a smooth enameled finish. Because the surface is slick and nonporous, I use the Enamels paints and brushes to make painting quick and easy. For this project I painted some simple wildflowers dancing around the sides of the planter. The design is simple and airy, and won't detract from the flowers that are planted inside. I suggest placing potted plants in the planter rather than filling it with soil. That way you don't have to drill drainage holes in the bottom and you can change out your plants as the seasons change.

FOLKART ENAMELS

Fresh Foliage

Thicket

Pure Orange

Wicker White

Cobalt

Magenta

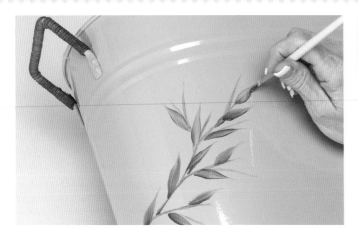

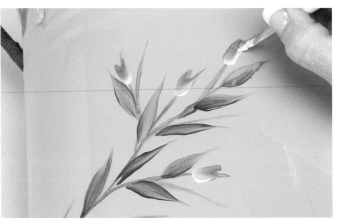

1. **Stems and leaves.** Paint the main stems and branches with a no. 12 flat double-loaded with Fresh Foliage and Thicket. Add long, slender leaves—not too many; leave room for the flowers.

2. **Trumpet flowers.** Paint the backs of the trumpets with Pure Orange and Wicker White double-loaded on a no. 8 flat. These are tight little C-strokes, with the Wicker White at the base.

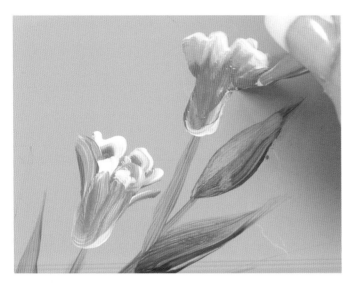

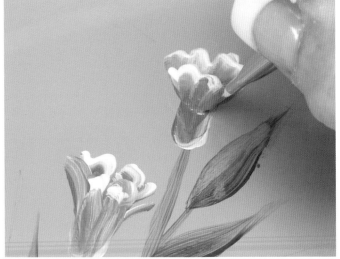

3. **Ruffled edges.** Ruffle the back of the trumpet keeping the Wicker White to the top of the trumpet.

4. **Front petals.** Add the front part of the trumpet with the Wicker White to the top of the ruffled edge. Paint this part of the trumpet lower so you can still see the back petal. This is what makes the trumpet seem rounded and open at the top.

Ask Donna

Q: What is an inexpensive way to include painted items in my garden or yard?

A: A common saying in the decorative painting world is, "If it doesn't move, paint it!" What this means to me is that almost any surface is fair game (except for husbands napping in their recliners). You just have to take into consideration how the surface will be used. Start with some objects that are looking a little worn out; if you don't want to discard them, then a little paint might just be the answer. Here are some possible surfaces I'm sure you have laying around: Lawn chairs and chaise longues, tables, patio umbrellas, terra cotta pots, landscape bricks or lumber, doors and fence support posts. See what I mean? You might have to clean them off or spray them with a basecoat first, but painting a few flowers or leaves on them will give them new life and will get your garden blooming even if the plants aren't.

BLUE FLOWERS & MAGENTA BUDS

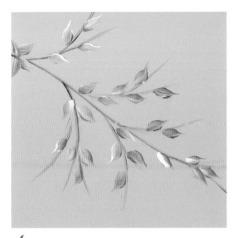

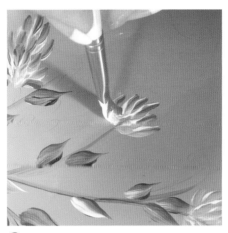

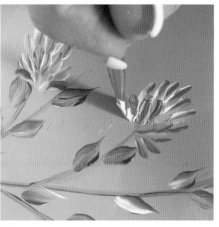

1. **Stems and leaves.** Paint a thin stem and branches with Thicket on the chisel edge of a no. 8 flat. Load a no. 2 flat with Thicket and lots of Wicker White and paint tiny one-stroke leaves.

2. **Blue flowers.** Double-load a no. 6 flat with Cobalt and Wicker White and begin painting little chisel-stroke petals, pulling each petal toward the stem and leading with the Wicker White.

3. **Vary the blues.** Finish the blue flower with lots of chisel-edge petal strokes overlapping the first layer. Flip your brush so the Cobalt leads for some darker blue petals here and there. Attach the stems to the bottoms of the blue flowers.

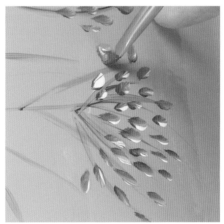

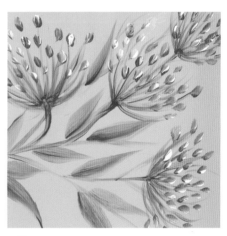

4. **Magenta flower stems.** Double-load Fresh Foliage and Thicket on a no. 8 flat and paint the main stems and branching stems, then the little stemlets at the ends.

5. **Magenta buds.** Double-load Magenta plus a little Wicker White on a no. 6 flat. Dab on little buds at the ends of the stemlets using the chisel edge of the brush.

6. **Leaves.** Double-load a no. 8 flat with Fresh Foliage and Thicket and paint slender little leaves along the main stems.

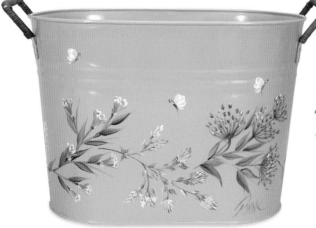

7. **White butterflies.** Finish with little white butterflies hovering over the wildflowers. These have Wicker White wings and Thicket bodies and antennae.

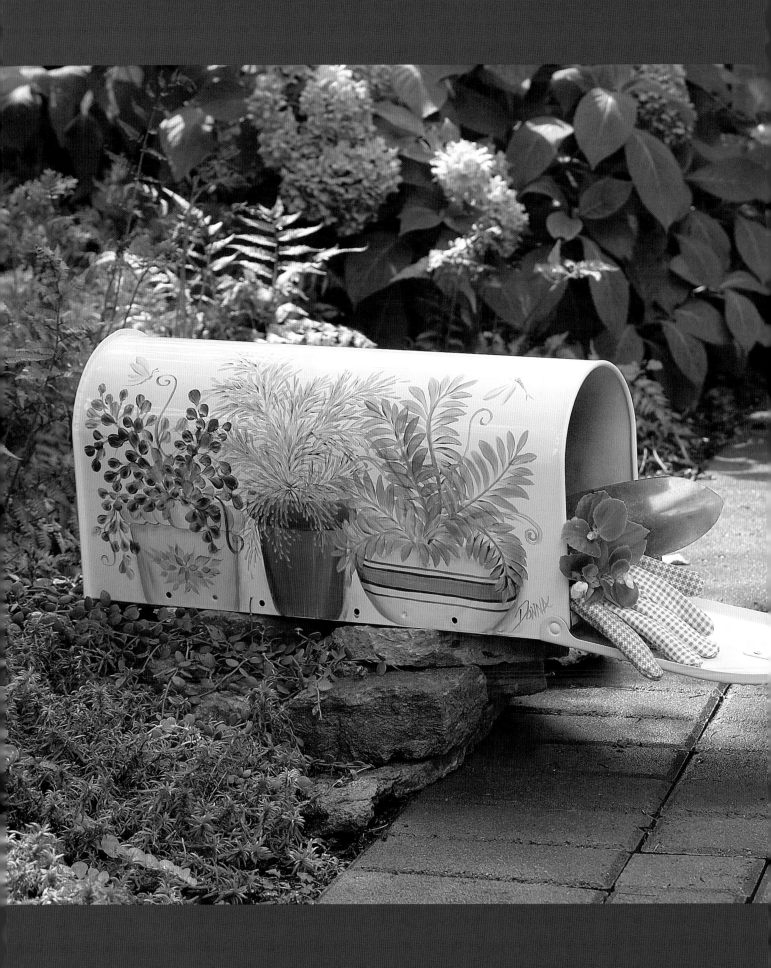

GARDEN TOOLS MAILBOX

Have you ever walked out to the yard ready to do some serious gardening, and then realized you left your pruners in the garage? Here's a great way to keep your garden tools handy just where you need them—in the garden! This is a standard rural mailbox which can be found at any home improvement store. I just repurposed it as a small storage container for my most-used gardening tools. Now I don't have to run back and forth gathering up what I need. I painted this with brightly colored pots and added quiet green ferns and a couple of shimmery dragonflies. It looks right at home in my garden.

enamels brushes

¾-inch (19mm) flat

no. 12 flat

nos. 1 and 2 script liners

surface

white enameled rural mailbox from a home improvement center

additional supplies

FolkArt Flow Medium

FOLKART OUTDOOR METALLICS

Metallic Blue Sapphire

Metallic Emerald Green

FOLKART OUTDOOR OPAQUES

Soft Apple Yellow Ochre Lemon Custard Engine Red

Thicket Fresh Foliage Wicker White Barnwood

1. Pots. Use a ¾-inch (19mm) flat to basecoat the pots. The blue pot is Metallic Blue Sapphire. The green pot is Soft Apple shaded with Metallic Emerald Green. The rim is a series of curved strokes. The yellow bowl is Lemon Custard shaded with Yellow Ochre.

2. Yellow bowl. Stripe the yellow bowl with Engine Red thinned with Flow Medium for the wide stripe and Metallic Sapphire Blue for the fine pinstripes. Outline the wide red stripe with straight (unthinned) Engine Red on a no. 2 script liner.

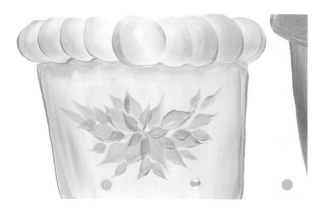

3. Green pot. On the green pot, shade under the rim and paint a cluster of one-stroke leaves with Metallic Emerald Green.

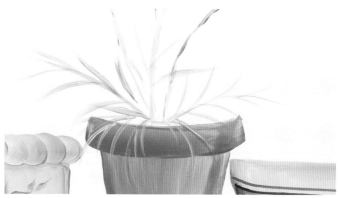

4. Lacy fern stems. Place the fern stems in the blue pot with the chisel edge of a no. 12 flat double-loaded with Thicket and Soft Apple. Let them extend out over the other two pots for a full look.

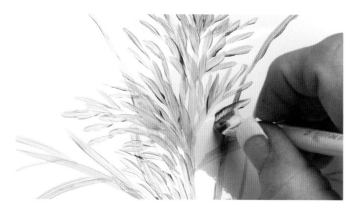

5. Lacy fern leaves. With the same brush and colors, add chisel-edge strokes for the lacy fern leaves, angling them inward toward the stems. Keep these ferns light and airy so they'll contrast well with the other, more substantial ferns.

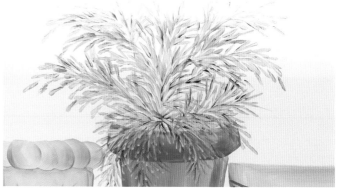

6. Fern fronds. Let some of the fern fronds drape over the rim of the pot, and extend the tallest ones upward to the top of the mailbox.

Download a FREE bonus demonstration at artistsnetwork.com/Dewberry-Essential-Guide

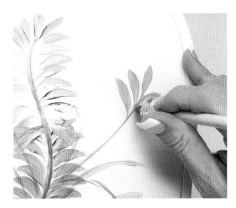

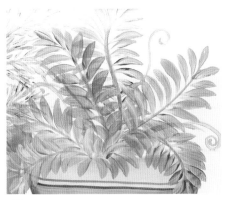

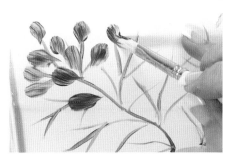

7. **Wide leaf fern.** For the yellow bowl, the fern has wider leaves. Double-load Fresh Foliage and Thicket on a no. 12 flat and paint pairs of leaves that are opposite each other on the stem.

8. **Stems.** Where the ferns overlap, pick up more Fresh Foliage on your brush so the ferns in front will show up better. As you finish the leaves on each stem, re-stroke the stem to clean it up. Finish with a curled stem or two using Fresh Foliage on a no. 1 script liner.

9. **Round leaf fern.** Place the fern stems in the green pot with Thicket on a no. 2 script liner. Double-load a no. 12 flat with Thicket and Soft Apple and dab on the rounded fern leaves, pulling to a point where they attach to the stems.

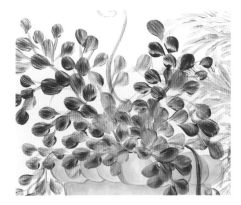

10. **Stems.** Fill out all the stems of this fern with more rounded leaves. Finish with some curling stems using Thicket on a no. 2 script liner.

11. **Dragonflies.** The wings are painted with Metallic Blue Sapphire and the body and antennae are Metallic Emerald Green.

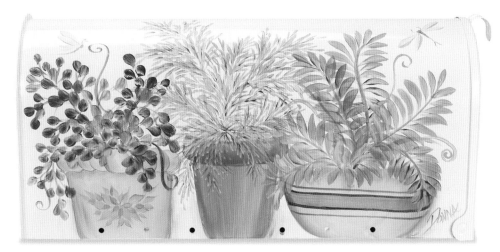

12. **Shading.** Load a ¾-inch (19mm) flat with Flow Medium and side-load into Barnwood. Shade around and between the pots to make them look dimensional and lift them from the background. Shade underneath the ferns in the yellow bowl with a side-load float of Yellow Ochre.

WINDOW BOX WITH DAYLILIES

Window boxes are back in style! There are many kinds to choose from, such as lightweight resin foam, wrought-iron "hayracks" and wooden ones like this, which was made for me by my talented husband. It's a simple rectangular box made from exterior grade plywood, dressed up with beadboard and trim molding and painted white. Since it is a large piece, I painted larger-than-life daylilies in brilliant colors. The size of the flowers makes it easier to paint them right over the grooves of the beadboard with a large flat brush. Daylilies come in many shades so choose the colors you like best. Use Outdoor Opaques unless otherwise specified.

brushes

1-inch (25mm) flat

⅜-inch (10mm) angular

surface

homemade wooden window box, 36 inches (91cm) long, 7 inches (18cm) high and 9 inches (23cm) wide
Holds five 6-inch (15cm) pots

FOLKART OUTDOOR DIMENSIONALS

Fresh Foliage

Lemon Custard

FOLKART OUTDOOR OPAQUES

Engine Red

Yellow Light

Fresh Foliage

School Bus Yellow

Yellow Ochre

Lemon Custard

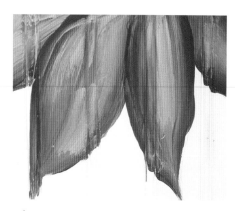

1. **Orange petals.** Double-load Engine Red and Yellow Light on a 1-inch (25mm) flat. Paint the large petals of the orange daylily, stroking downward toward the pointed tip. Keep the Engine Red to the outside. Refer to the finished window box at the end of the demonstration for placement of the flowers.

2. **Detail lines and leaf.** Using a ⅜-inch (10mm) angular brush and Engine Red, pull streaks out from the flower center. Also clean up the edges of the petals, extending the pointed tips of the petals slightly. Add a green leaf with Fresh Foliage and School Bus Yellow double-loaded on a 1-inch (25mm) flat.

3. **Veins.** Pull a green vein down the center of each petal with Fresh Foliage, using the chisel edge of the flat brush.

4. **Stamens.** Use Fresh Foliage Outdoor Dimensional paint to draw stamens starting at the outside and pulling in toward the center.

5. **Outlining.** Use Fresh Foliage Outdoor Dimensional to outline the leaf. Add anthers to the tips of the stamens with Lemon Custard Outdoor Dimensional.

Ask Donna

Q: When you paint on items that will be displayed outdoors, what kind of paints and brushes do you use?

A: For most of these pieces I'm using FolkArt Outdoor paints. This paint has a sealer already in it. Another paint I use is the FolkArt Enamels paint, made for glass, ceramic, metal, and other smooth, nonporous surfaces. After the surface has dried overnight, it can be baked in a warm oven to cure the paint, which makes it washable. If you cannot find the Outdoor paints in your area and you are going to paint on a nonporous surface, then use the Enamels. If neither Outdoor nor Enamels paints are available to you, then use the acrylic paints. Keep in mind that the acrylics will not stay on glass or ceramics, and they will need to be sealed with several coats of spray lacquer if you use them on wood or metal.

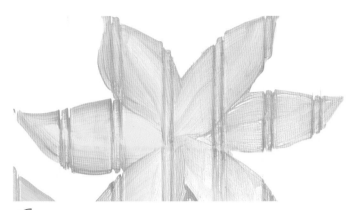

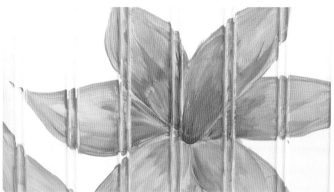

6. Yellow petals. Paint a leaf and stem with Fresh Foliage and School Bus Yellow double-loaded on a 1-inch (25mm) flat. (Refer to the finished painting at the end of the demonstration for placement of leaves, stems and flowers.) Double-load the flat with Yellow Ochre and Lemon Custard and paint the petals. Keep the Yellow Ochre to the outside.

7. Shade the center. Pick up a tiny bit of Engine Red on the same flat brush you had loaded with Yellow Ochre and Lemon Custard for step 6. Place the flower center with a U-stroke. Pull shading from the red center upward onto each petal.

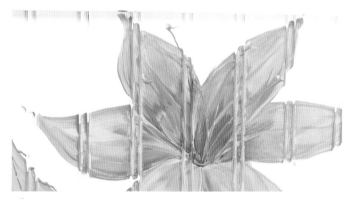

8. Veins. Chisel on a Fresh Foliage vein in each petal and pull Fresh Foliage Outdoor Dimensional stamens and Lemon Custard anthers. Outline the leaf with Fresh Foliage Outdoor Dimensional.

9. Trim. Paint the trim with Fresh Foliage on a 1-inch (25mm) flat.

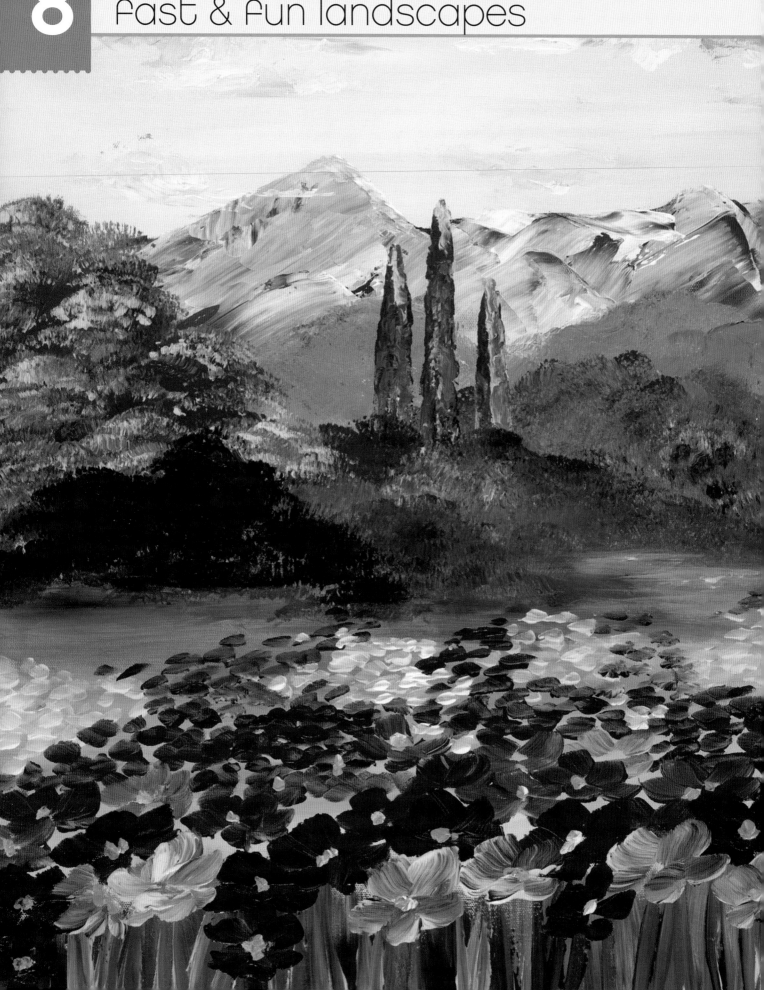

POPPIES IN THE SIERRA

One of my favorite things to paint is a landscape with large, detailed flowers in the foreground, as if I were nestled in among them and looking out onto a grand scene. The flowers set the stage and lead your eye into the painting, giving the feeling of great distance.

brushes

no. 4 fan

1-inch (25mm) flat

¾-inch (19mm) flat

nos. 10 and 16 flats

surfaces

two 18" × 24" (46cm × 61cm) stretched canvases, with 1½-inch (4cm) thick, staple-free edges, by Fredrix Creative Edge

additional supplies

FolkArt Sponge Painters

FolkArt HD Clear Medium

wide palette knife

narrow palette knife

FOLKART HIGH DEFINITION ACRYLIC PAINT

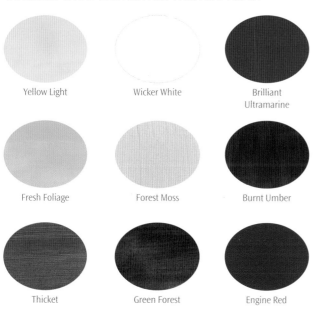

Yellow Light Wicker White Brilliant Ultramarine

Fresh Foliage Forest Moss Burnt Umber

Thicket Green Forest Engine Red

Yellow Citron Periwinkle

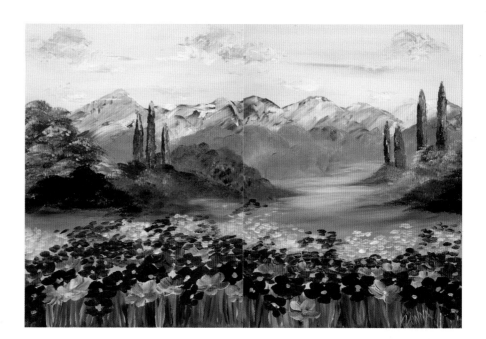

The image opposite is a detail of the completed project on the right.

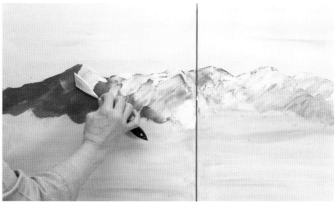

1. Double-load Yellow Light and Wicker White on a sponge dressed with Clear Medium and dip into a little Brilliant Ultramarine. Stroke in the sky color using horizontal motions across the canvas. Pick up more yellow sometimes and more blue sometimes to get color variations. Carry this sky color a third of the way down the canvas. Pick up Fresh Foliage and medium on a sponge and block in the green area on the lower two-thirds of the canvas.

2. Pick up Brilliant Ultramarine and Wicker White on a wide palette knife and paint the shapes of the distant mountains. Use diagonal motions with the flat of the knife to achieve the slant of the mountain slopes. Pick up more white on the knife and stroke over the blue slopes to give the appearance of snow.

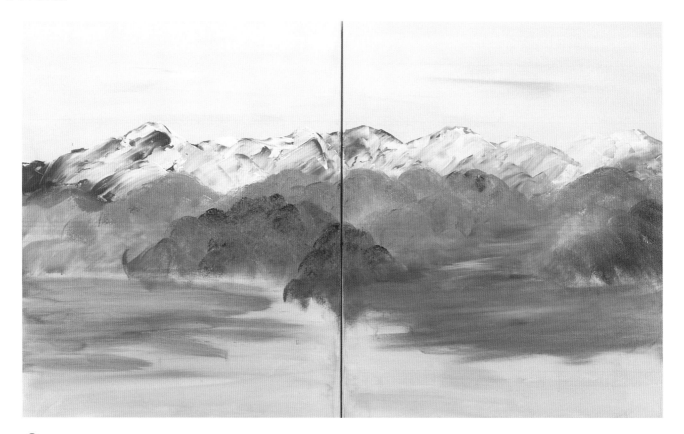

3. Sponge on the midground hills in front of the mountains with Forest Moss and Burnt Umber. If your blue mountains are still wet, use the sponge to tap on the green color so you don't lift the blue and white paint. At the base of the green hills, smooth the paint with the sponge using curving motions to indicate the hills flattening out into the fields. The closer hills are sponged on with Thicket and a little Yellow Light. Blend the greens with lateral motions of the sponge to indicate a pathway in the distance coming into the foreground. Finish the background with areas of Green Forest for the grassy areas of the valley.

4. With a narrow palette knife, pick up Green Forest and a little Yellow Light and pat in the tall, columnar cedar trees on both sides of the canvas (see the Step 5 photo for placement of the three cedar trees on the left side). Hold your palette knife vertically and just touch it to the canvas to deposit thick paint. Start at the pointed top of the tree and tap downward, widening the tree as you go. While this color is wet, come back with a little more yellow and highlight the sunlit sides of these trees.

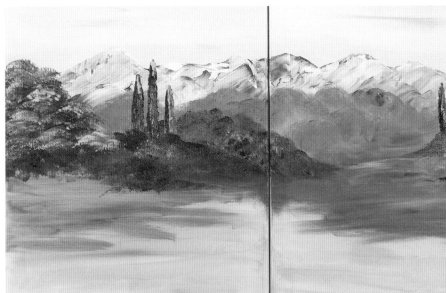

5. Load a no. 4 fan brush with Green Forest and tap in the shrubs on the right side below the cedar trees and the tall deciduous trees on the far left side. Come back with Yellow Light on the fan brush and tap highlights into these areas.

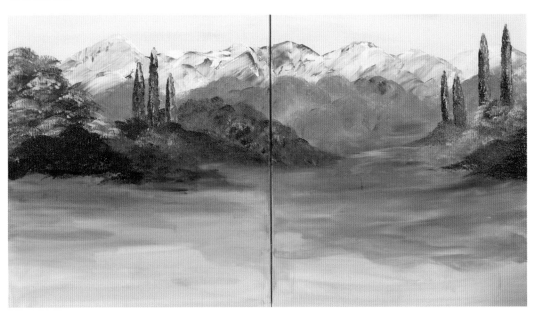

6. Enrich the colors of the shrubs in the midground on both right and left sides of the canvases with Engine Red and Green Forest on a no. 4 fan. Brighten the colors of the fields and valley floor using Yellow Citron and Yellow Light on a sponge. Come back with a little Green Forest to deepen the green color in some areas of the fields. Shade under the red shrubs in the background on the left side with Green Forest as well.

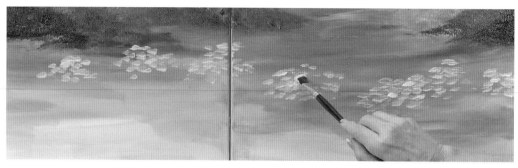

7. Load a no. 16 flat with Yellow Light, occasionally picking up some Wicker White for variety, and tap in clusters of yellow poppies in the midground fields, holding your brush parallel to the horizon so the strokes are wide rather than round.

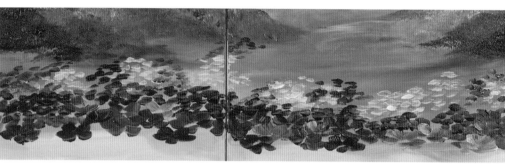

8. Pick up Engine Red on the dirty brush and tap in clusters of red poppies in the distance. Occasionally pick up yellow with the red to make some orange poppies. As you work your way forward, start picking up a little Burnt Umber as well on your flat brush. As the poppies get closer to the foreground, start painting them with a touch-and-pull stroke because you can start to see the individual petals more clearly.

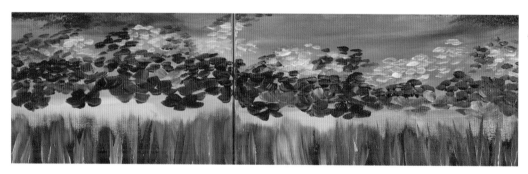

9. With Green Forest on a 1-inch (25mm) flat, pull a mass of green stalks along the bottom of both canvases all the way across. Stroke upward from the bottom using the flat of your brush. Detail this area with stalks and leaves by picking up Yellow Light on the dirty brush and using the chisel edge to stroke upward. Occasionally pick up some Engine Red for color variation.

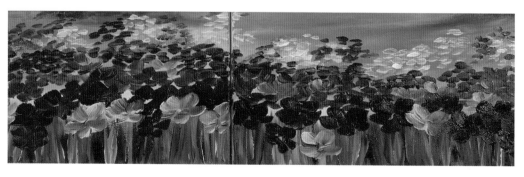

10. To paint the details of the poppies in the front row, load a ¾-inch (19mm) flat with Engine Red and pick up some Green Forest to darken the red somewhat. Paint the five petals of each poppy, using a short curved stroke for each petal. For the brighter red poppies, pick up more Engine Red. For the yellow poppies, pick up Yellow Light on the dirty brush. For orange poppies, pick up a little red on your yellow brush.

FILL IN WITH THE DETAILS

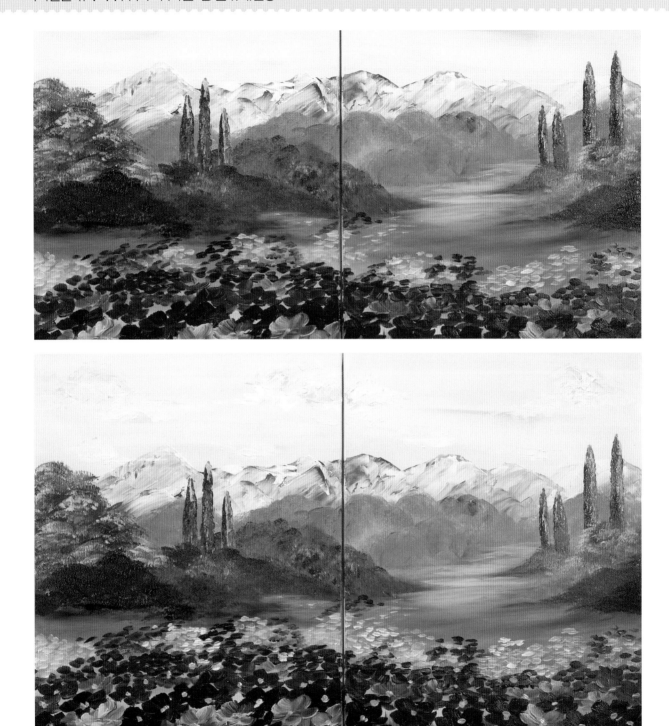

11. Lighten the colors of the valley floor in the background using Yellow Light and Wicker White on a ¾-inch (19mm) flat. Stroke this across the valley using slightly curving horizontal motions, and pull some of the darker greens into it from the foliage areas on the sides.

12. Paint the clouds in the sky using Brilliant Ultramarine and Wicker White on the narrow palette knife. Leave them very thick and textured. With a no. 10 flat, load Periwinkle and Wicker White and dot in the centers of some of the poppy flowers. Don't do this on all the poppies, that would be boring. Just do them here and there for little sparks of contrasting color among all the red.

THROUGH THE GARDEN

Painting lush gardens like these is not only fun to do, it's fast and easy because I use the scruffy and the fan brush to paint the trees and most of the flowers. This is a springtime scene with lots of pinks and purples which contrast beautifully with the big white cosmos in front.

brushes

1-inch (25mm) flat

¾-inch (19mm) flat

nos. 10 and 16 flats

large scruffy

no. 4 fan

no. 2 script liner

surfaces

two 18" × 24" (46cm × 61cm) stretched canvases, with 1½-inch (4cm) thick, staple-free edges, by Fredrix Creative Edge

additional supplies

FolkArt Sponge Painters

FolkArt HD Clear Medium

FOLKART HIGH DEFINITION ACRYLIC PAINT

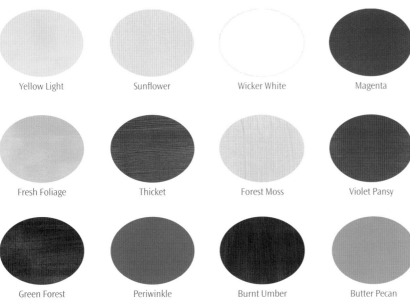

Yellow Light Sunflower Wicker White Magenta

Fresh Foliage Thicket Forest Moss Violet Pansy

Green Forest Periwinkle Burnt Umber Butter Pecan

Lavender Yellow Citron

Brilliant Ultramarine Pure Orange

The image opposite is a detail of the completed project on the right.

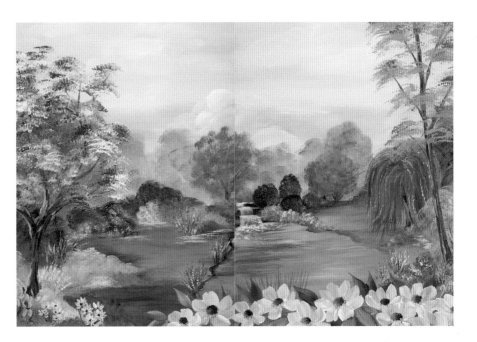

SPONGE ON THE BACKGROUND

1. On a sponge painter dressed with Clear Medium, load Yellow Light, Sunflower and Wicker White. Stroke in the sky color using horizontal motions across the two canvases. Pick up Magenta sometimes to get color variations. Carry this sky color over the top half of the canvases. Pick up more Yellow Light to brighten the upper sky here and there.

2. Load a medium-dressed sponge painter with Fresh Foliage and pick up a little Thicket. Block in the green grass area across the lower half of the two canvases. Leave a space unpainted for the pond to come.

3. Pick up Wicker White on the sponge plus a little Magenta or Sunflower and use the edge of the sponge to draw puffy clouds in the sky. Tap the paint out and pull across it with the flat of the sponge to soften the edges and blend them out. Use a sponge dressed in lots of medium plus Forest Moss to tap in a few of the background trees in the far distance. Use Violet Pansy on the same dirty sponge for the rest of the background trees.

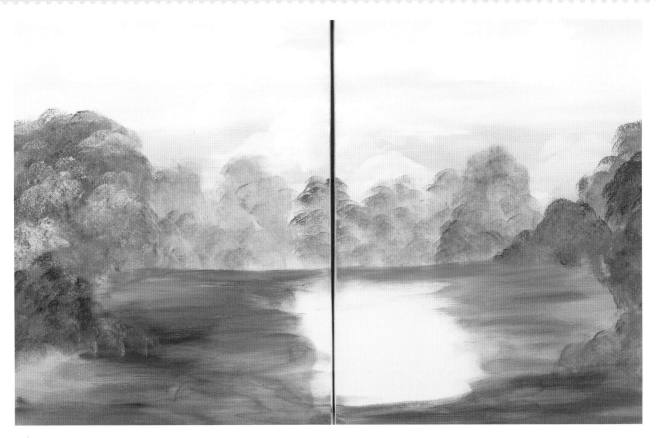

4. Double-load Thicket and Fresh Foliage on a sponge and dab in the foliage of the large green trees on the left and right sides of the canvases. Highlight the foliage here and there with Yellow Light on the left-side tree. With the same sponge and colors, use the flat of the sponge to darken the green grassy areas that surround the pond. Tap in a very dark green tree on the right with Green Forest.

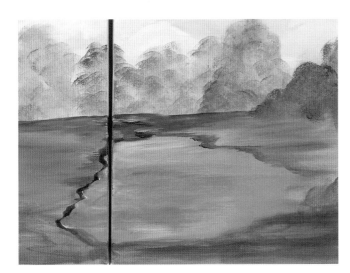

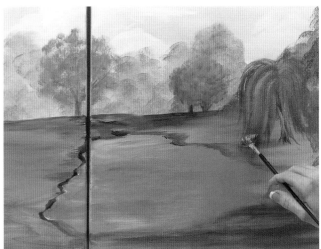

5. Block in the blue water of the pond using Periwinkle on a sponge dressed in medium. With Burnt Umber and Butter Pecan on a 1-inch (25mm) flat, establish the higher ground in the background from which the little waterfalls will drop. Also place in the muddy shoreline around the pond.

6. For the small flowering trees in the background, draw in the trunks and branches with the same brown using the chisel edge of a no. 16 flat. Pounce on the foliage and flower color at the same time using the scruffy loaded with Fresh Foliage and Lavender. The weeping willow tree at the right is painted with a no. 4 fan brush and Thicket and Green Forest, highlighted with Fresh Foliage and a little Wicker White.

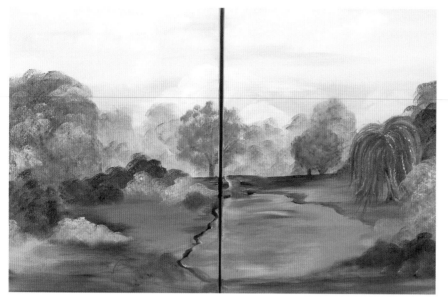

7. Pick up Yellow Citron and Yellow Light on a sponge painter and dab in the flowering shrubs at the far right side in front of the willow tree, and on the left. The dabbing motion leaves good texture on your canvas. Add more green shrubs to the background to the left of the pond and also at the bottom right. These will serve as backgrounds for the colorful flowers to come. Load a no. 16 flat with Brilliant Ultramarine and Wicker White and paint the blue water cascading down the slope in the background.

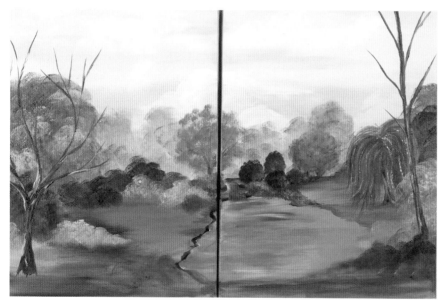

8. Add more green foliage to the right of the cascades and along the stream banks below the cascades, using the scruffy brush loaded with Thicket and Fresh Foliage. Use the chisel edge of a 1-inch (25mm) flat and Burnt Umber to draw in the trunks and branches of the very tall trees on either side of the painting. Highlight with Wicker White. Leave the paint thick to indicate rough bark.

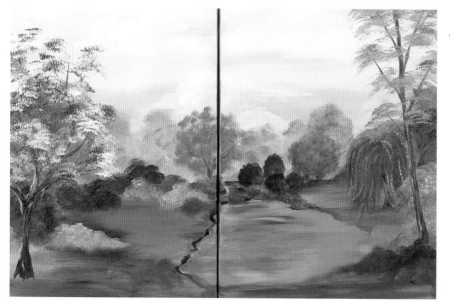

9. The foliage of the large flowering tree on the right is tapped on with a no. 4 fan brush and Yellow Citron and Fresh Foliage. Tap on the flowers with Lavender. The pink flowering tree on the left is Magenta and Wicker White tapped on with a no. 4 fan.

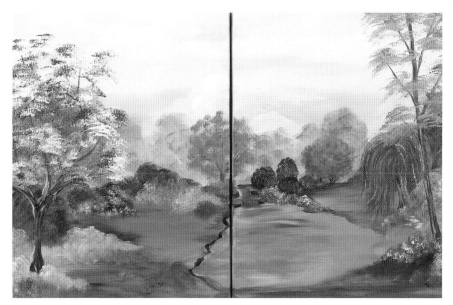

10. Pounce in a few red flowers on the trees behind the cascades using Magenta on the scruffy brush. Tap in a tiny bit of Wicker White to highlight. Use the same brush and colors to add the small mounds of pink flowers at the left and right sides below the two tall trees. Pounce on dark purple flowers using Lavender and Brilliant Ultramarine double-loaded on the scruffy. Highlight with a few light taps of Wicker White. Also highlight the low row of bushes along the pond shoreline.

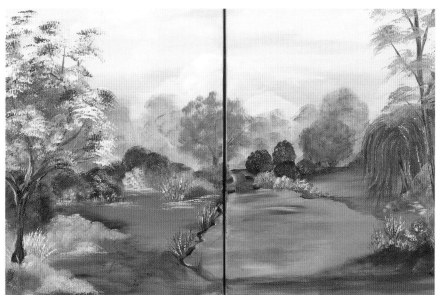

11. Load a no. 10 flat with Green Forest and use the chisel edge to pull spiky leaves in the background and along the shoreline. Add flowers to the spiky leaves in the background with Lavender and Wicker White, then Yellow Light and just a tiny bit of Pure Orange. Tap in the white flowers throughout with Wicker White using the tips of the fan brush.

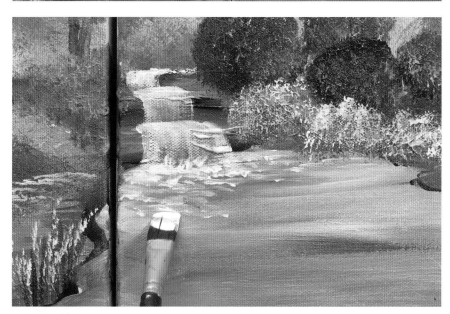

12. With a no. 16 flat and Wicker White, indicate the whitewater flowing over the falls and the foamy water at the bottom. Keep the white thin and translucent so the blue still can be seen.

PAINT THE FOCAL POINT

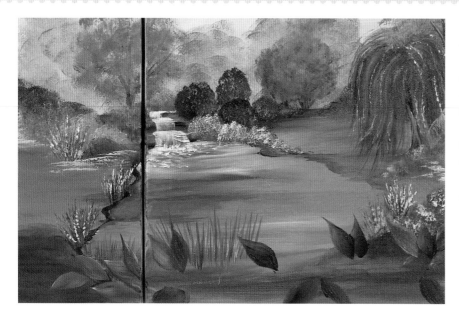

13. Load a 1-inch (25mm) flat with medium and Green Forest and indicate the shadow being cast over the water by the trees on the left. With the same brush, pick up some Yellow Citron and use the chisel edge to pull thin leaves vertically at the foreground shoreline of the pond. Pick up Thicket on the dirty brush and paint the large one-stroke leaves that are in the extreme foreground along the bottom of the canvases.

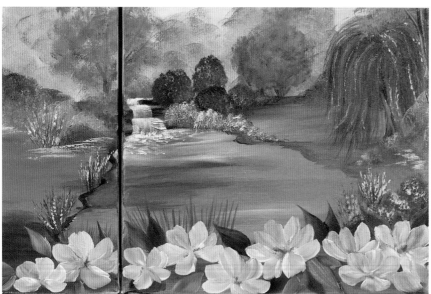

14. To begin the large white cosmos flowers in the foreground, use a ¾-inch (19mm) flat. Load it with Thicket on one flat side, flip the brush over and pick up Wicker White on the other flat side. Paint each petal with the white side of the brush (the green will come through enough to tint the white a little bit). Use a short curving stroke for the more cupped petals, and a touch-and-pull stroke for the straight petals. Let one or two blossoms extend off the bottom edge of the canvas and don't forget to take them around the sides and bottoms of the canvases.

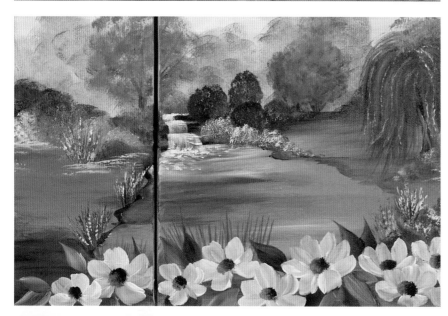

15. Add the centers to the large white cosmos using Burnt Umber and Yellow Citron pounced on with the scruffy brush.

FILL IN WITH THE DETAILS

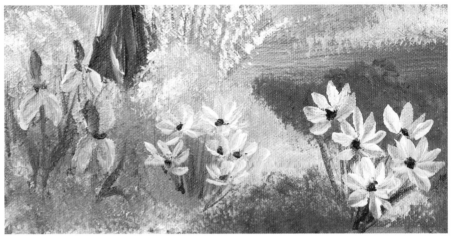

16. Highlight the cosmos centers with Sunflower and a little Yellow Light using a no. 2 script liner and tapping on dots of color along one side.

17. The tiny yellow and white flower clusters in the foreground at the far left are painted with little chisel-edge strokes using a no. 10 flat, double-loaded with Yellow Light and Wicker White for the yellow flowers and Sunflower and Wicker White for the white flowers. Their stems are Green Forest and their centers are Burnt Umber.

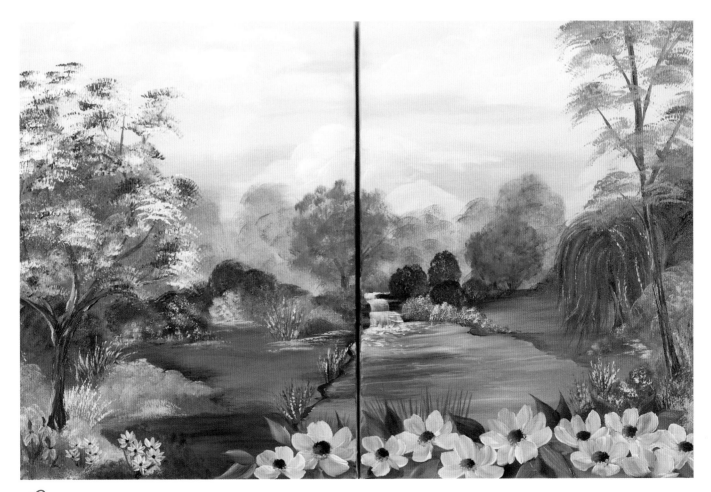

18. The final details in the water are painted with a no. 10 flat loaded with Periwinkle and Wicker White. Use the chisel edge and short back-and-forth horizontal strokes to indicate water movement. Keep a light touch on your brush for this. Finally, shade under and around the flowering shrubs using a 1-inch (25mm) flat dressed in medium and side-loaded into Burnt Umber.

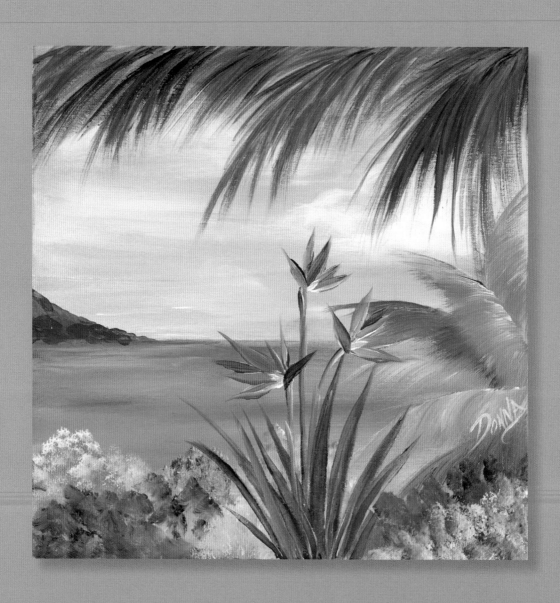

POSTCARD FROM HAWAII

Panoramic scenes like this are absolutely breathtaking when painted horizontally across a set of three square canvases! The extreme width gives you the feeling of a never-ending sky and a vast ocean view.

FOLKART HIGH DEFINITION ACRYLIC PAINT

Periwinkle

Wicker White

Brilliant Ultramarine

Yellow Citron

Thicket

Green Forest

Engine Red

Magenta

Pure Orange

Forest Moss

Yellow Light

Calypso Sky

Violet Pansy

brushes

¾-inch (19mm) flat

nos. 10 and 16 flats

1-inch (25mm) flat

no. 4 fan

large scruffy

canvases

three 16" (41cm) square stretched canvases, with 1½-inch (38mm) thick, staple-free edges, by Fredrix Creative Edge

additional supplies

FolkArt Sponge Painters

FolkArt HD Clear Medium

wide palette knife

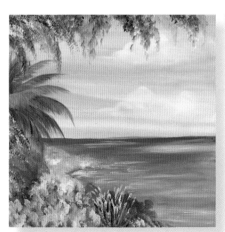
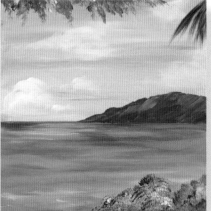
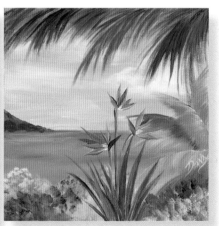

The image opposite is a detail of the completed project above.

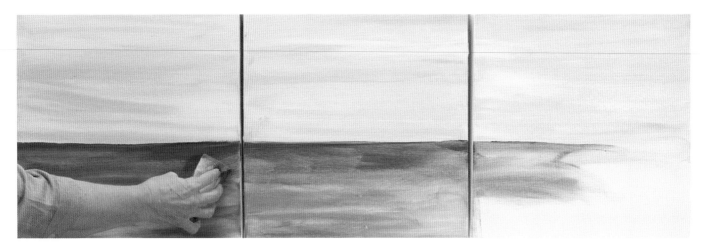

1. Begin with the sky area, and always pick up Clear Medium on your sponge painter first when painting large areas like this that cross over all three canvases. Using horizontal motions of the sponge and Periwinkle plus Wicker White, stroke in the sky colors. For the open ocean, pick up Brilliant Ultramarine on your dirty sponge and use long horizontal strokes that cross the two left canvases and extend over to the right one.

2. Using a wide palette knife, pick up thick Brilliant Ultramarine and place the island off in the distance. Use the edge of the knife to shape the ridgeline. Fill in with the flat of the knife using diagonal strokes that begin at the ridgeline and angle downward to the base. Add green to the island's slopes with Forest Moss on the knife. With Forest Moss and Yellow Citron on a sponge painter, dab on foliage on the far left side of the leftmost canvas.

3. Draw in white clouds with Wicker White using the curved edge of a sponge painter. Use the flat of the sponge to sweep lightly across the clouds to soften their edges.

4. Paint the overhanging palm fronds in the upper right using a ¾-inch (19mm) flat double-loaded with Thicket and Green Forest. Pick up Yellow Citron occasionally for warmer color. Stay on the chisel edge as you stroke each curving frond. To get a feathered and airy look to some of the leaves, use the same colors on a no. 4 fan and lightly stroke some very thin curving lines. Use the same brushes and colors for the palm at the far left. Paint a curving line for the center stem of the frond, then pull the leaves downward using the chisel edge. Pick up Yellow Light to highlight these palms. The palm at the far right is painted with Yellow Citron, Wicker White and a little Thicket to shade, using a no. 4 fan.

5. With a 1-inch (25mm) flat, dab on all the greenery around the canvas. This green will provide the background for all the bright flower colors. Alternate picking up Green Forest, Thicket, Yellow Citron, Wicker White and Yellow Light on your brush to achieve all the different shades shown here.

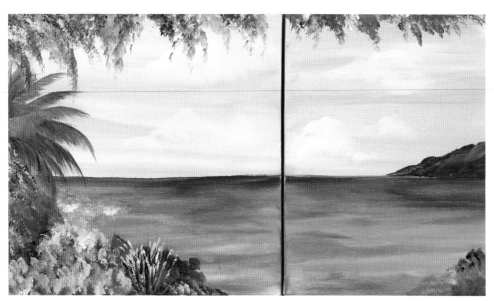

6. Double-load the scruffy brush with Violet Pansy and Wicker White, and pick up a little Brilliant Ultramarine. Pounce on the wisteria blossoms hanging down along the upper left of the canvases. Double-load a no. 4 fan brush with Engine Red and Yellow Light and dab on the red and yellow honeysuckle flowers on the far left side. Use the chisel edge of the 1-inch (25mm) flat and Wicker White for some white stalk flowers at the lower left side. Load the scruffy with Yellow Light and Wicker White and pounce on the bright yellow flowers at the bottom left. Finish by re-stating some of the green in this area.

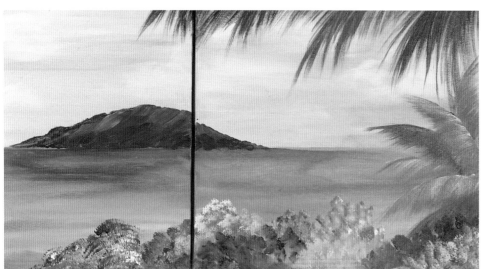

7. For the pink flowers along the center bottom, use a no. 4 fan brush loaded with Magenta and Wicker White. The smaller pink flowering shrub is pounced on with the scruffy. Pick up just Wicker White on the scruffy for the white flowering shrub, then pick up Brilliant Ultramarine for the blue flowers at the bottom right corner.

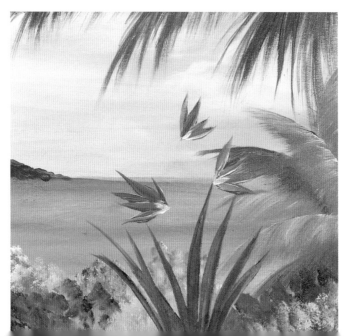

8. To begin the large bird-of-paradise plant at the right side, draw the spiky leaves with the chisel edge of a no. 16 flat using Green Forest and some Yellow Light. Begin the pointed flower petals with a no. 10 flat double-loaded with Pure Orange and a little Wicker White. The purple petals are Violet Pansy and a little Wicker White.

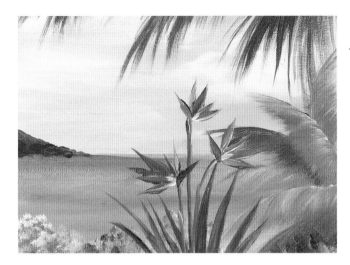

9. Draw the stems of the flowers downward using the chisel edge of a no. 10 flat and Green Forest plus Yellow Light. Using the dirty brush, pick up a little Engine Red and paint the pointed red petals on the bird-of-paradise blossom.

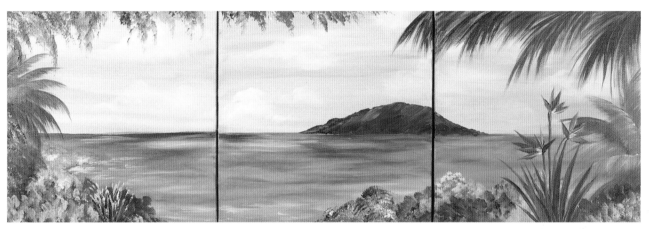

10. Using the 1-inch (25mm) flat, work some tropical colors into the ocean water. Dress the brush with lots of medium, then pick up Magenta, plus a little Brilliant Ultramarine and Wicker White. Use short, lateral, chisel-edge strokes to indicate moving water and to show some of the colors reflected from the clouds and the sky. Pick up some Calypso Sky on the same brush and paint the shallow water close to the foreground shore. Pick up more white on the brush and streak in the waves that are closer to the shore as well.

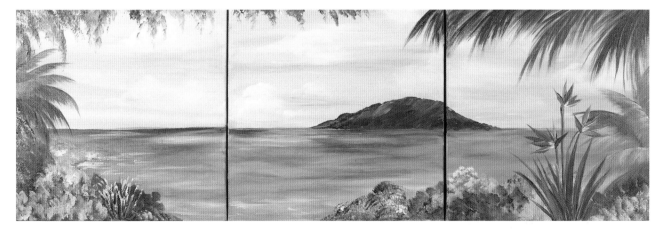

11. Add some color to the sky and along the edges of the clouds using a little Yellow Light on a 1-inch (25mm) flat dressed with lots of medium. For the pinkish color, pick up a little Magenta and Wicker White. Use back-and-forth horizontal motions to apply these subtle colors and don't overdo it to keep the illusion of great distance.

WATER LILIES

Painting reflective water that has some depth and movement is a bit different from painting reflections in still water. Where there is movement in the water, the colors of the trees and flowers on the shoreline are reflected using vertical strokes of a sponge, but the shapes are only suggested.

brushes

1-inch (25mm) flat

¾-inch (19mm) flat

no. 10 flat

no. 4 fan

surfaces

four 14" × 14" (36cm × 36cm) stretched canvases, with 1½-inch (4cm) thick, staple-free edges, by Fredrix Creative Edge

additional supplies

FolkArt Sponge Painters

FolkArt HD Clear Medium

wide palette knife

narrow palette knife

FOLKART HIGH DEFINITION ACRYLIC PAINT

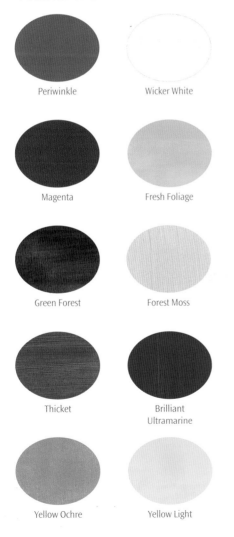

Periwinkle

Wicker White

Magenta

Fresh Foliage

Green Forest

Forest Moss

Thicket

Brilliant Ultramarine

Yellow Ochre

Yellow Light

The image opposite is a detail of the completed project above.

SPONGE ON THE BACKGROUND

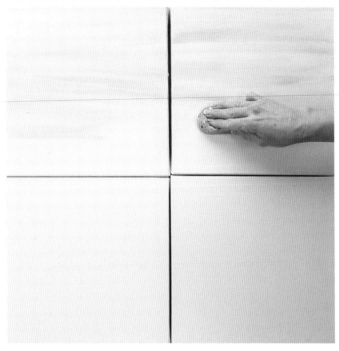

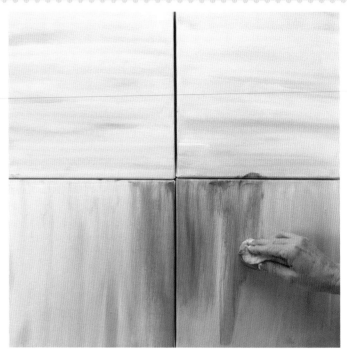

1. Double-load Periwinkle and Wicker White on a sponge painter dressed with Clear Medium. Stroke in the sky color using horizontal motions across the top two canvases. Carry this color around the top and side edges of the canvases.

2. On the bottom two canvases, use the same colors but make vertical strokes with the sponge to block in the water area. Then pick up more medium and some Green Forest and begin stroking in the green color in the water using vertical strokes of the sponge.

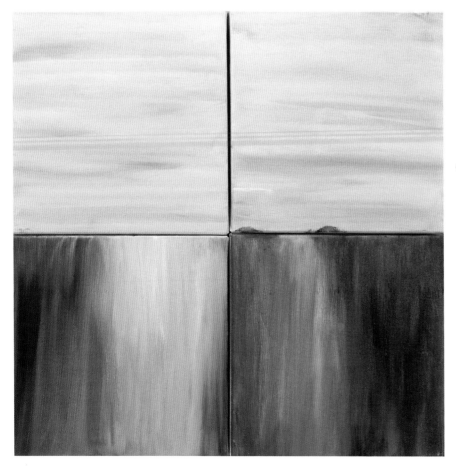

3. Finish the green water area, picking up Thicket sometimes for the darker areas and Wicker White sometimes for the lighter areas and reflections. Keep your strokes vertical for the water area. This is what gives the look of reflections in moving water as opposed to the glassy "mirror image" reflections you would see in still water.

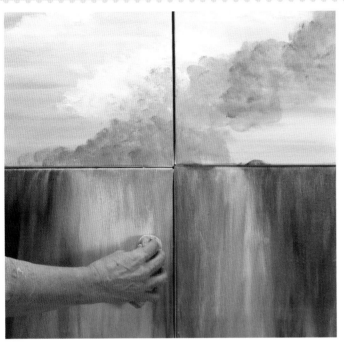

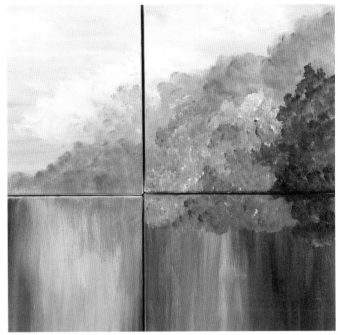

4. Using a wide palette knife and Wicker White, place in the white clouds using thick paint. Leave the clouds textured, don't smooth them down. The background shadow trees are dabbed on with a sponge dressed with medium, using Forest Moss and Green Forest for some, and picking up a little Periwinkle for others. Pick up some Magenta and medium on the dirty sponge and dab on some very subtle pink color into the trees in the center. Drag this color down into the water area using vertical strokes of the sponge to create reflections.

5. With a 1-inch (25mm) flat loaded with Green Forest and Periwinkle, picking up a little Fresh Foliage sometimes, dab in the foliage of the large green tree on the right. Highlight with Wicker White and shade with Green Forest. For the shorter trees in front, use the dirty brush and pick up Forest Moss, Wicker White and Magenta.

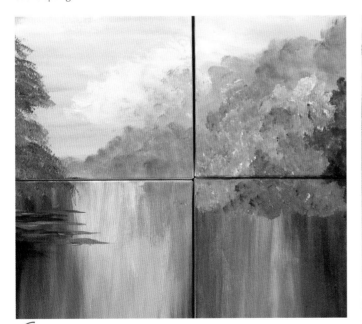

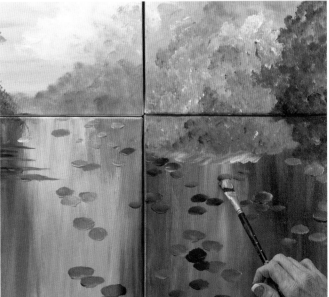

6. At the far left side, use a no. 4 fan brush and Thicket and Fresh Foliage to tap in the foliage of the tall tree. Load a 1-inch (25mm) flat with Green Forest and Fresh Foliage and use the chisel edge to indicate water movement at the left side.

7. Use a ¾-inch (19mm) flat double-loaded with Fresh Foliage and Wicker White to paint the lighter lily pads in the water area. Pick up Green Forest sometimes for darker green pads. Lily pads are round but because they are laying flat on the water, due to perspective they will have an oval or elliptical shape in the painting.

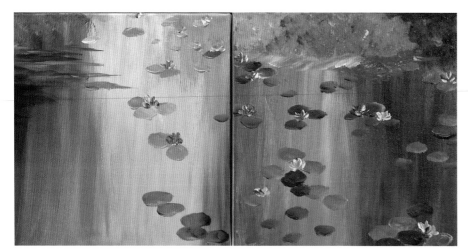

8. The water lily flowers are stroked in with a no. 10 flat double-loaded with Magenta and Wicker White. Keep the paint very thick for these flowers as you want them to stand up from the canvas surface.

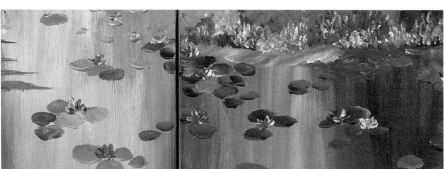

9. The row of flowers along the shoreline on the right side is painted with the no. 10 flat. The colors are Brilliant Ultramarine, Magenta, Yellow Ochre, each highlighted with Wicker White.

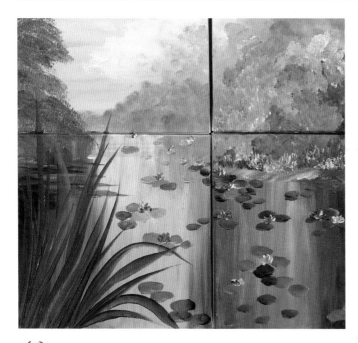

10. With Green Forest and Periwinkle on a 1-inch (25mm) flat, pull a mass of spiky green iris leaves up from the bottom left corner. Pick up Fresh Foliage sometimes to highlight, and Magenta once in a while for color variation and to echo the color of the pink iris blossoms.

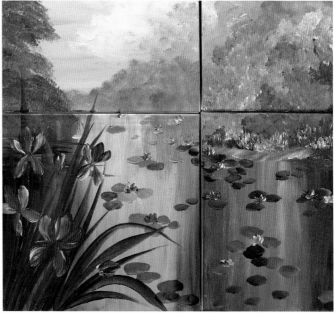

11. To paint the details of the foreground irises, load a ¾-inch (19mm) flat with Magenta and Wicker White. Stroke three upper petals (the "standards") and two lower petals (the "falls") for each iris blossom. Pick up more Magenta sometimes and more white other times for color variations in the petals. Paint a couple of buds with one or two strokes.

Download a FREE bonus demonstration at artistsnetwork.com/Dewberry-Essential-Guide

FILL IN WITH THE DETAILS

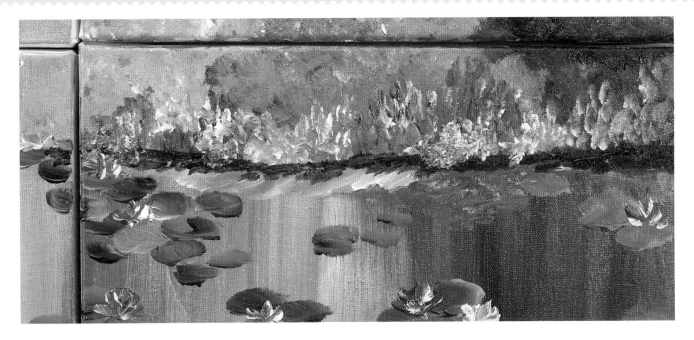

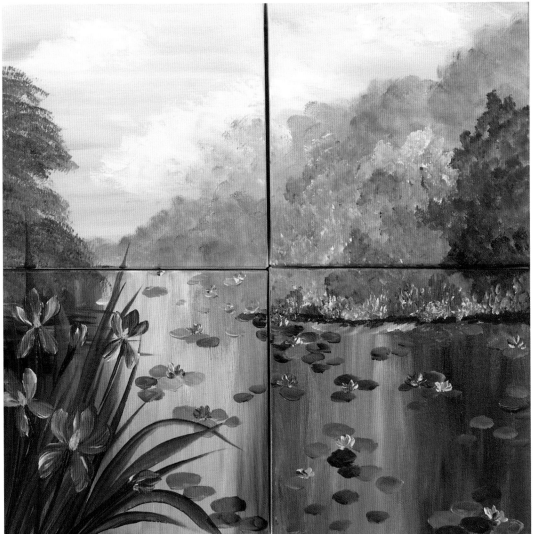

12. Establish the shoreline under the row of flowers with Green Forest on a ¾-inch (19mm) flat.

13. Paint the yellow beards in the centers of the irises with Yellow Light. Stroke the ¾-inch (19mm) flat through Green Forest and touch into Magenta, and paint the stems of the irises with long vertical strokes.

FIELDS OF DAISIES

Here's another example of a landscape I painted on four square canvases that are arranged into a larger square. It's almost like I'm looking through a window at this lovely scene. The bright spring colors and clear blue sky are fresh and inviting, and yellow daisies are such fun to paint!

brushes

nos. 10 and 16 flats

1-inch (25mm) flat

no. 4 fan

large scruffy

surfaces

four 16" × 16" (41cm × 41cm) stretched canvases, with 1½-inch (4cm) thick, staple-free edges, by Fredrix Creative Edge

additional supplies

FolkArt Sponge Painters

FolkArt HD Clear Medium

wide palette knife

185

FOLKART HIGH DEFINITION ACRYLIC PAINT

Brilliant Ultramarine

Wicker White

Calypso Sky

Fresh Foliage

Thicket

Yellow Citron

Yellow Light

Burnt Umber

Periwinkle

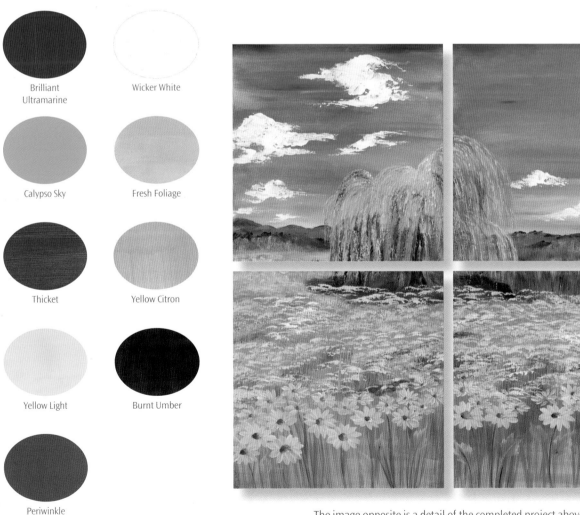

The image opposite is a detail of the completed project above.

SPONGE ON THE BACKGROUND

1. Double-load Brilliant Ultramarine and Wicker White on a sponge dressed with Clear Base medium. Pick up some Calypso Sky on the sponge and stroke in the sky color using horizontal motions across the top two canvases. Carry this color around the top and side edges of the canvases. Pick up more Calypso Sky and deepen the sky color along the top and left sides. If the lower sky area along the horizon line is too dark, wipe off some of the blue. Dress a clean sponge painter in Clear Medium and block in the green field with Fresh Foliage using long horizontal strokes across both lower canvases. Extend this green color up into the bottom of the upper two canvases. Don't forget to carry this color around the top, bottom, and side edges of the lower two canvases.

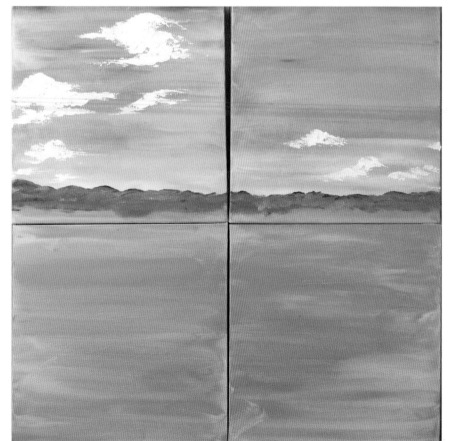

2. Using a wide palette knife and Wicker White, place in the white clouds using thick paint. Leave the clouds textured, don't smooth them down. The dark background trees along the horizon line are dabbed on with a sponge dressed with medium, using Fresh Foliage and Brilliant Ultramarine to get a bluish green.

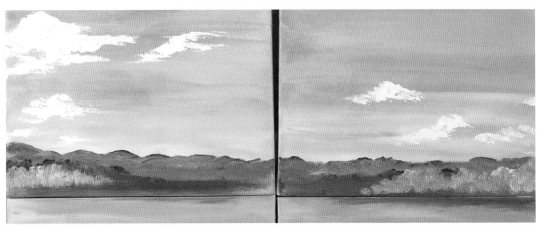

3. Pick up Thicket on a sponge painter dressed with medium and darken the green field area in front of the background trees. With Fresh Foliage and Wicker White on a scruffy, add the lighter green shrubbery on either side of the background trees.

4. Use a no. 4 fan brush and Thicket, Yellow Citron and Yellow Light to stroke in the tall grasses on the right with upward strokes. While this is wet, pick up Yellow Citron on a no. 16 flat and use the chisel edge to stroke individual stalks of tall grass. With Yellow Light and Wicker White on a no. 10 flat, dab on the light yellow foliage at the left side.

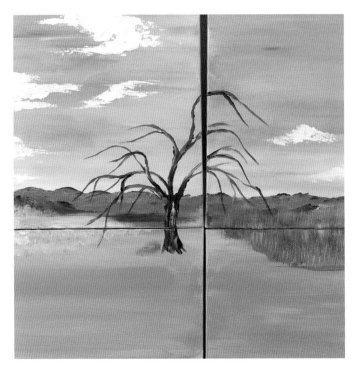

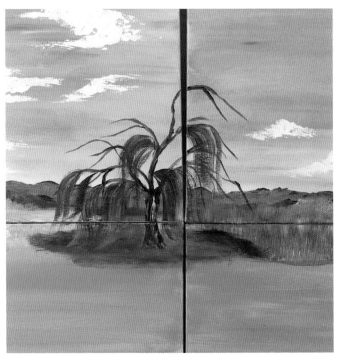

5. Double-load a no. 16 flat with Burnt Umber and Wicker White and draw in the shapes of the willow tree's trunk and branches. This is an asymmetric tree so let the branches have irregular shapes and lengths for more interest.

6. Load a no. 4 fan brush with Thicket and pick up medium. Dab on the darker, shaded foliage of the willow tree, then use a downward stroking motion to indicate the darker hanging branches.

PAINT THE FOCAL POINT

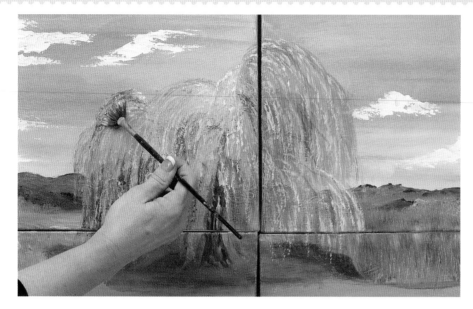

7. Using the same dirty brush, pick up Yellow Citron and begin painting the lighter green willow branches, again using curving downward strokes. The lightest individual leaves are lightly tapped on with just the very tips of the fan brush bristles. Re-establish the darker, shaded areas if needed with Thicket on the same brush.

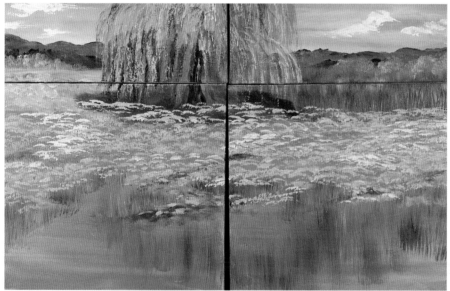

8. Double-load the no. 4 fan with Yellow Light and Wicker White and begin tapping on tiny spots of yellow for the drifts of daisies in the far field in front of the willow tree, working your way forward into the foreground. Every once in a while, pick up some Yellow Citron to indicate the green leaves and stems of the daisies. Pick up more white sometimes to indicate white daisies in among the yellow ones. Also pick up Thicket sometimes for shadows. To begin the foreground daisies, load Thicket and Brilliant Ultramarine on a fan brush and pick up medium. Use light vertical strokes to suggest clusters of stems. Pick up Yellow Light and Wicker White on the tips of the fan brush bristles and tap in the daisy blossoms on the tops of these stems.

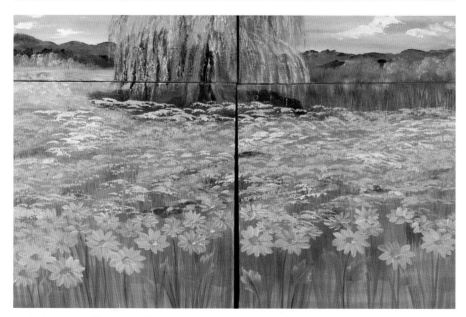

9. Using a 1-inch (25mm) flat dressed with medium, alternate picking up a little Thicket, a little Periwinkle, and a little Yellow Citron and use the chisel edge to paint the tall stems of the closest daisies in the foreground. To paint the petals of the closest daisies, double-load a no. 10 flat with Yellow Light and Wicker White and paint little chisel-edge strokes for the petals. As you work your way forward, use a larger flat brush to paint larger petals. For interest and a more natural look, paint some of the daisies facing upward and some facing forward. Overlap the blossoms here and there. Add some wiggle-edge leaves using the same greens used for the background foliage. Dab in the daisy centers with Periwinkle and Wicker White.

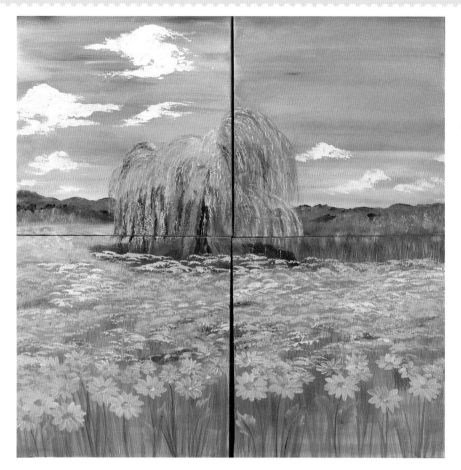

10. So they don't compete so much with the willow tree, knock back the yellows in the background tree line by dabbing on a little Thicket for better contrast. Tie in the blues of the sky by dabbing in Periwinkle in among the background daisies.

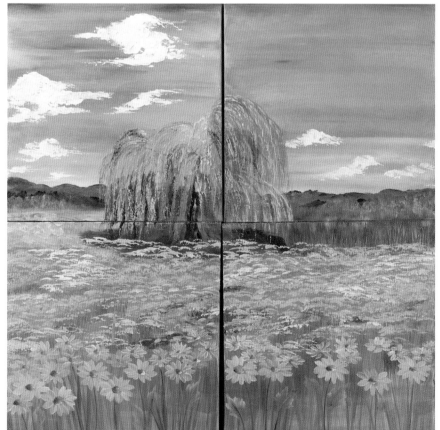

11. Shade the centers of some of the foreground daisies with tiny dabs of Brilliant Ultramarine, again tying in the sky colors with the foreground colors to make a cohesive painting, which is especially important when you're working on multiple canvases.

ABOUT THE AUTHOR

Donna Dewberry is the most successful and well-known decorative painter ever. Since 1998, she has created ten full-size instructional books for North Light. She is a popular television presenter on the Home Shopping Network, and her program, *The Donna Dewberry Show*, can be seen weekly on PBS stations nationwide. Her one-stroke designs are licensed for home decor and quilt fabrics, wallpapers, borders, stencils, etc. Donna's most recent North Light Books are *Fabric Painting With Donna Dewberry* (2008) and *Donna Dewberry's Essential One-Stroke Painting Reference* (2009).

get a free bonus demonstration!

Download a FREE bonus demonstration from *Painting Fabulous Flowers with Donna Dewberry* at artistsnetwork. com/Dewberry-Essential-Guide.

Donna Dewberry's Essential Guide to Flower and Landscape Painting. Copyright © 2013 by Donna Dewberry. Manufactured in China. All rights reserved. No part of this book may be reproduced in any form or by any electronic or mechanical means including information storage and retrieval systems without permission in writing from the publisher, except by a reviewer who may quote brief passages in a review. Published by North Light Books, an imprint of F+W Media, Inc., 10151 Carver Rd., Suite 200, Blue Ash, OH 45242. (800) 289-0963. First Edition.

Other fine North Light Books are available from your favorite bookstore, art supply store or online supplier. Visit our website at www.fwmedia.com.

17 16 15 14 13 5 4 3 2 1

ISBN-13: 978-1-4403-2833-6

DISTRIBUTED IN CANADA BY FRASER DIRECT
100 Armstrong Avenue
Georgetown, ON, Canada L7G 5S4
Tel: (905) 877-4411

DISTRIBUTED IN THE U.K. AND EUROPE
BY F&W MEDIA INTERNATIONAL
LTD Brunel House, Forde Close, Newton Abbot, TQ12 4PU, UK
Tel: (+44) 1626 323200, Fax: (+44) 1626 323319
Email: enquiries@fwmedia.com

DISTRIBUTED IN AUSTRALIA BY CAPRICORN LINK
P.O. Box 704, S. Windsor NSW, 2756 Australia
Tel: (02) 4500-1600, Fax: (02) 4577-5288
Email: books@capricornlink.com.au

Metric Conversion Chart

To convert	to	multiply by
Inches	Centimeters	2.54
Centimeters	Inches	0.4
Feet	Centimeters	30.5
Centimeters	Feet	0.03
Yards	Meters	0.9
Meters	Yards	1.1

PRODUCTION EDITED BY MARY BURZLAFF BOSTIC
DESIGNED BY KELLY O'DELL
PRODUCTION COORDINATED BY MARK GRIFFIN

INDEX